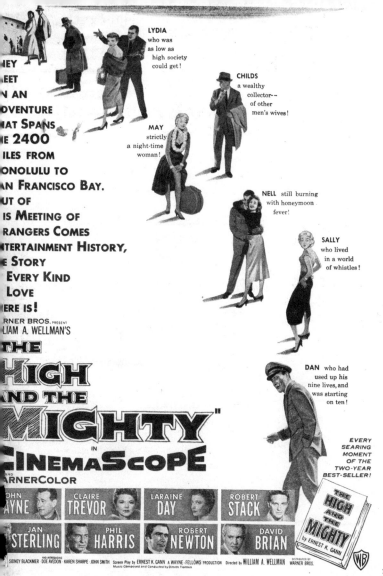

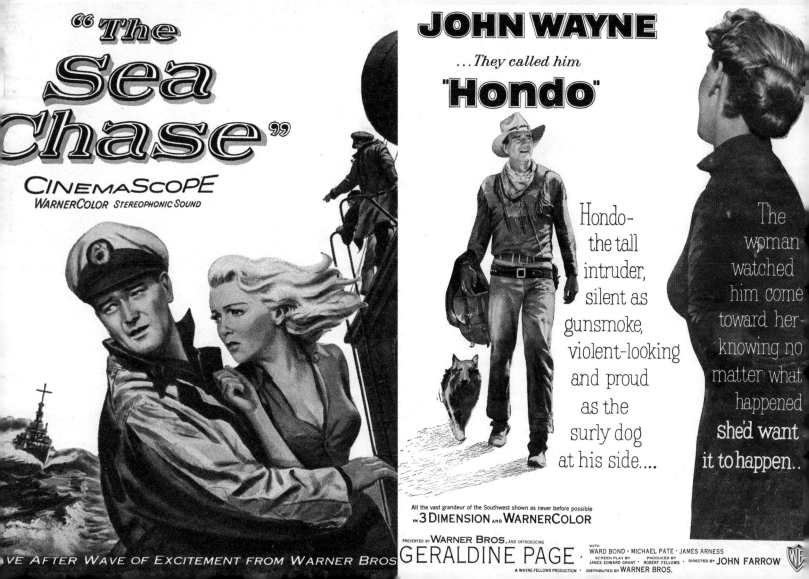

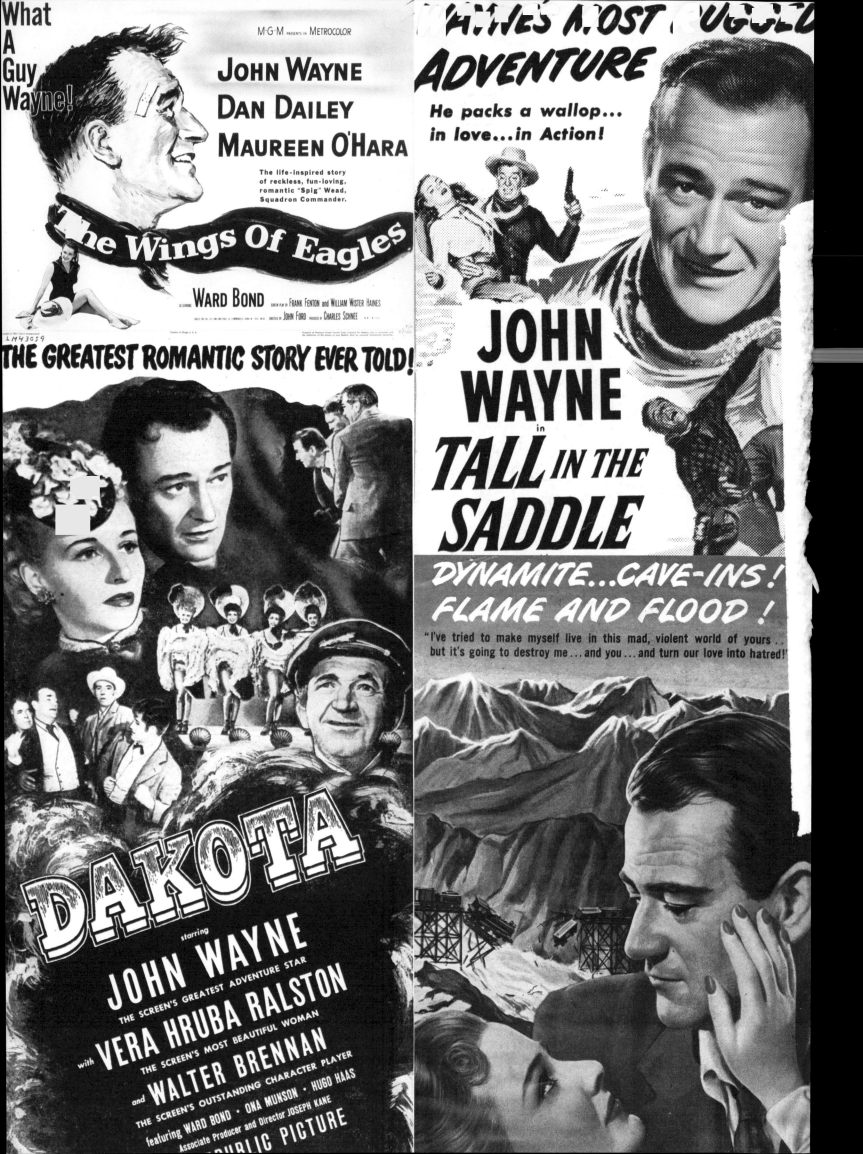

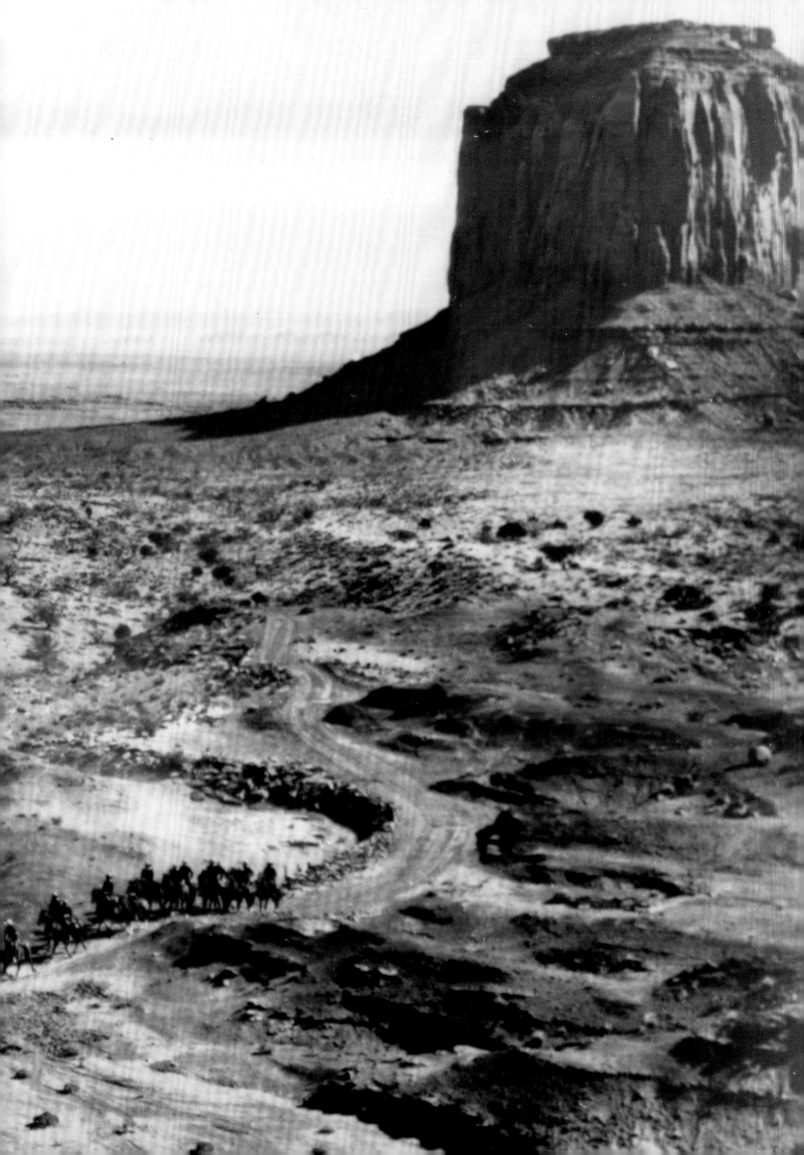

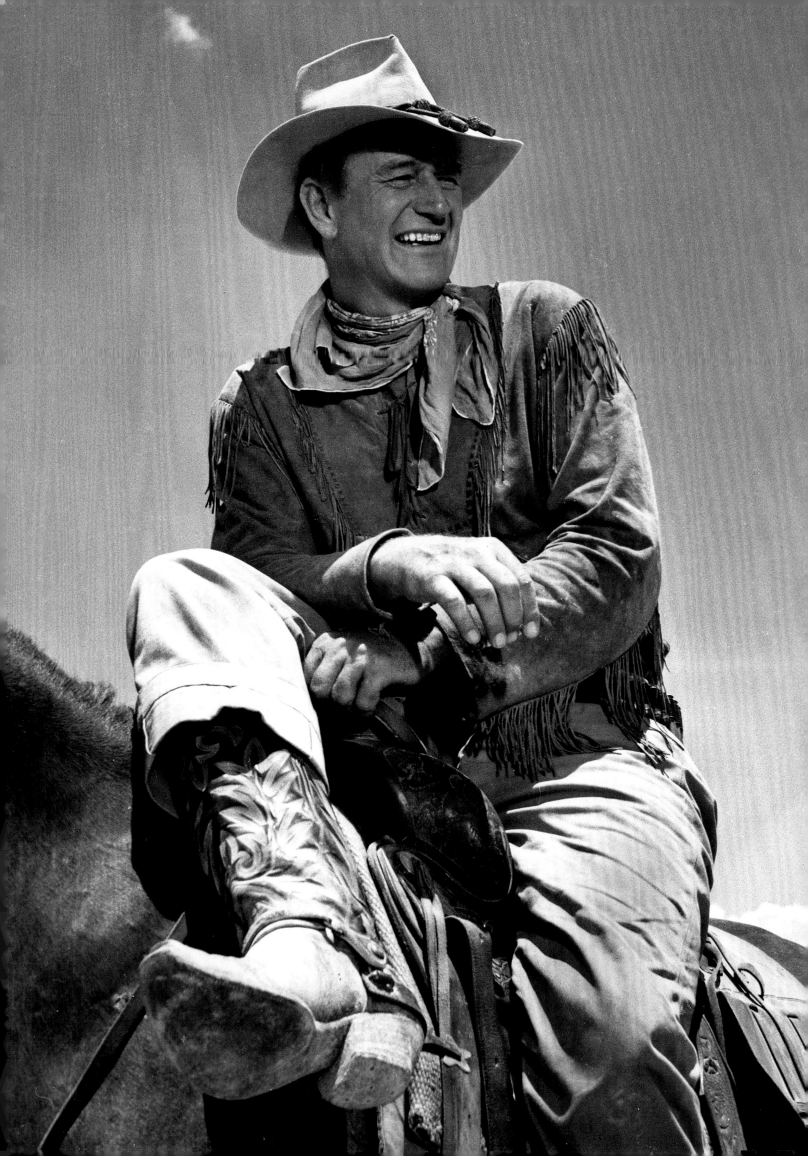

CONTENTS

TITLE PAGE A young John Wayne in costume wearing neckerchief, gun belt, dungarees, and boots on the set of one of his early films.

PREVIOUS SPREAD Filming of *Stagecoach* (1939), Monument Valley, Utah.

OPPOSITE PAGE John Wayne in *Hondo* (1954).

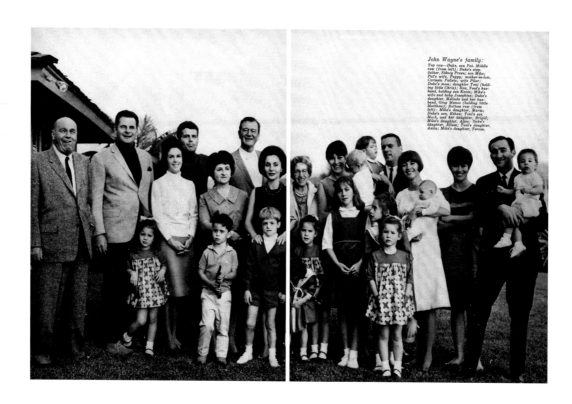

John Wayne's family:
Top row—Duke, son Pat. Middle
row (from left): Duke's step-
father, Sidney Preen; son Mike;
Pat's wife, Peggy; mother-in-law,
Carmela Pallete; wife Pilar;
Duke's mom; daughter Toni (hold-
ing little Chris); Don, Toni's hus-
band, holding son Kevin; Mike's
wife and baby Josephine; Duke's
daughter, Melinda and her hus-
band, Greg Munoz (holding little
Matthew); Bottom row (from
left): Mike's daughter, Maria;
Duke's son, Ethan; Toni's son
Mark, and her daughter, Brigid;
Mike's daughter, Alicia; Duke's
daughter, Aissa; Toni's daughter,
Anita; Mike's daughter, Teresa.

ABOVE Four generations of the
Wayne family in a magazine
photo-essay from the 1970s.

PREFACE

Welcome to an inside look on our privileged life—privileged in having a true American Icon as a father, a mentor, a coach, a best friend. A dad we shared with America in some of its finest cinematic moments. I think you will find this book appealing because it provides a glimpse into his personal life; a life that many people have not seen. Its personal effects and best-remembered film moments are our memories and yours.

— Ethan Wayne
President, John Wayne Enterprises
Director, John Wayne Cancer Foundation

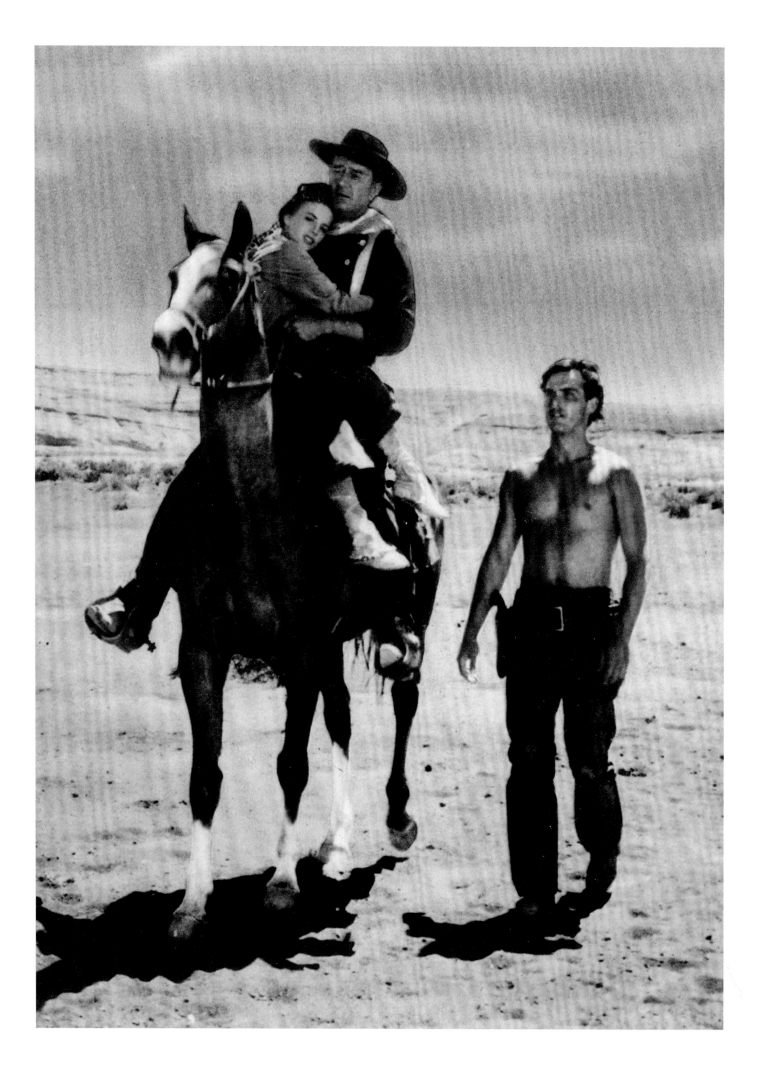

MARTIN SCORSESE

There was a time when John Wayne and America seemed more or less synonymous. When I was young, Wayne was the ideal of American manhood. His grace, his power, his ease, his beauty—there was something remarkable about his authority and the respect he commanded.

As I grew older and the country became more divided, many of us realized that it was actually a certain *idea* of America that he represented, an idea that many young people found hypocritical and brutally insensitive to the rest of the world.

But John Wayne the figurehead and John Wayne the actor were two very different entities. Sometimes they converged, though not as often as people once imagined. Many people during the Vietnam era chose to see the cinema through a strictly political lens, but those of us who loved movies knew that art could never be encompassed by politics. Jean-Luc Godard once wrote that when Wayne picked up Natalie Wood and cradled her in his arms in *The Searchers*, he could forgive him for supporting Barry Goldwater for president. Unlike politics, art could embrace the mysterious, the indefinable, the contradictory. And we knew the truth: that John Wayne was a genuinely great actor who had worked with several great directors—including William Wellman, Raoul Walsh, Don Siegel (who directed his last picture), Howard Hawks and, across five decades, John Ford—to fashion some of the finest pictures ever made.

This wonderful collection of photographs gives us John Wayne the figurehead, John Wayne the actor, and John Wayne the human being. It's a rich experience to look through these pages and see where Wayne's three roles converged and diverged. Wayne appears to have enjoyed rugged sports, just like the characters he played. But you also get a glimpse of another side. Dick Cavett once wrote a little piece in which he remembered Wayne telling him how much he admired Nöel Coward's writing, revealing that he knew his plays backward and forward and regretting that he could never convince anyone to cast him in *Private Lives*. In a few of these photos, you can see a dapper, urbane side to Wayne, and feel his longing to explore that kind of emotional register. You can see the toughness but the tenderness as well, without which his performances in *Rio Bravo* or *The Searchers*, not to mention the rich emotional textures of the films themselves, would have been unthinkable.

And in all the photos, you see another, earlier America with different ideas of glamour, beauty, fashion, and behavior, a world that now feels as distant as the Renaissance.

A movie-made hero...a superstar, one of the very first...an image of manhood...and a great American artist. This book affords us a generous look at John Wayne from every angle.

OPPOSITE PAGE John Wayne with Natalie Wood and Jeffrey Hunter in John Ford's classic film *The Searchers* (1956).

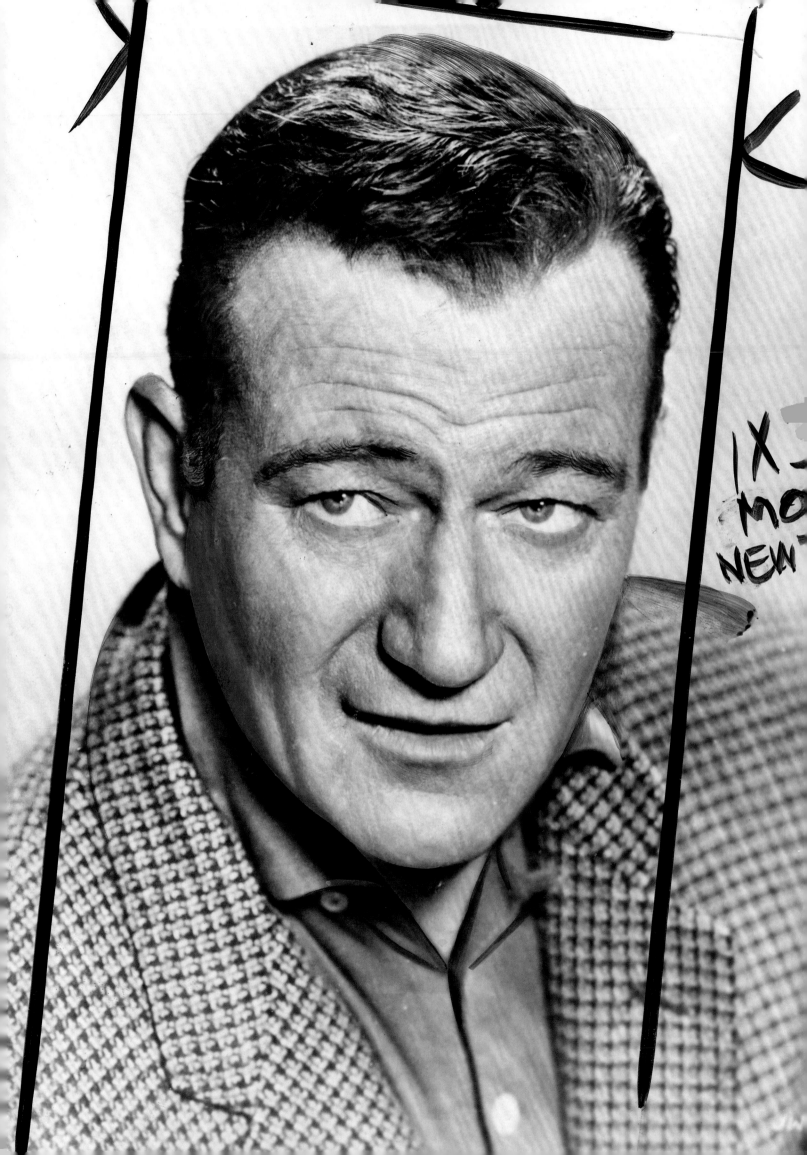

John Wayne, Larger Than Life

PATRICIA BOSWORTH

I eat as much as I ever did. I drink more than I should and my sex life is none of your damn business. —JOHN WAYNE, *Playboy* interview, May 1971

I met John Wayne when I was a little girl and the sight of him made me gasp. By the time I met him in 1953, he'd made over one hundred films (like *Red River* and *She Wore a Yellow Ribbon*), and by 1978 he'd made a hundred more (like *True Grit* and *The Shootist*). He didn't create the western (with its clear-cut conflicts of good and bad, right and wrong), but he remains the definitive western star.

As recently as 2010, in fact, John Wayne was listed as America's third-favorite movie star in a Harris Poll (Johnny Depp and Denzel Washington being numbers one and two, respectively). Only Wayne has the distinction of being on the Harris Poll's list since 1994. Obviously, the public still relates to the characters he played on the screen. Indeed, as I finish this piece on his birthday, May 26, Turner Classic Movies has been running a virtual marathon of Wayne films, so I've been able to catch *The Searchers*, *Stagecoach*, and *Rio Bravo*, not to mention countless others. He's on late-night all the time. Thousands of fans continue to be reassured and inspired by his authentic Americanism.

My father Bartley Crum, who was an entertainment lawyer, loved John Wayne in westerns and everything else he did, so while I was growing up I got a crash course in all sorts of Wayne films like *Reap the Wild Wind* (one of my father's favorites, a flamboyant tale of sea scavengers that we saw over and over.) Daddy especially liked the idea that Wayne was able to transform himself from cowboys to war heroes to patriarchs, men who lived long enough to learn there was more to life than battles. He always played characters that were fallible in different ways, sometimes wrongheaded, sometimes ruthless, sometimes shy or bad-tempered, but never mean-spirited or petty.

We lived in San Francisco then. One vacation, our family spent a weekend in Hollywood and as a treat we were given a whirlwind tour of the studios—MGM, Warner Brothers, Republic. Suddenly on some huge, echoing soundstage we saw John Wayne coming toward us.

"Why there's the Duke!" my father exclaimed, and sure enough it was Wayne, appearing very tall—he was over 6'4"; he was wearing jeans, a work shirt, and a battered cowboy hat, and as he ambled toward us I thought I had never seen anyone, man or woman, walk with such authority and grace.

Most movie stars are disappointments when you meet them—diminished somehow. I'd been introduced to Alan Ladd and was shocked at how small he was. "He has to stand on a box to kiss his leading ladies," my father told me. As for Elizabeth Taylor, she was beautiful but

OPPOSITE PAGE John Wayne film studio publicity head shot, crop-marked for print publication.

her head was too large for her rather squat body. John Wayne surpassed my expectations. He was larger than life as he towered over me. It wasn't just his size or his bulk; he had a magnetism that was almost palpable, an authority that radiated from his immense frame. He looked indomitable.

For a while he exchanged pleasantries with my parents (they went to some of the same parties in Beverly Hills), so I had a chance to listen to Wayne's reassuring husky drawl and note how handsome and pleasant his face was, although his heavy-lidded eyes didn't seem to express much emotion.

Before he left us he suddenly took my hand in his big paw and murmured, "So long little lady." With that I curtsied as I'd been taught to do with grownups and he roared with laugher—"Old-fashioned gal!"—and then he sauntered off. My heart was beating so loud I was sure he could hear it.

I never saw him again but that memory has stayed with me forever, so when I was asked to write this essay I jumped at the chance. Since then I have been able to mine John Wayne's great legend, see some of his movies again, and pore over these photographs: a family album second to none.

He was born Marion Robert Morrison in 1907 in Winterset, Iowa, the first-born son of Clyde L. Morrison, a druggist who was a quiet, serious man, often called "Doc," and Mary A. Brown (known as "Molly,") a former telephone operator. Molly was petite, vivacious, and red-haired. She had a hot temper and loved to tell stories with a rich Irish vocabulary. Still, she was hard to deal with; she and Doc never got along. Even after they had a second son, Robert, who was his mother's favorite, the Morrisons kept on fighting.

So little Marion grew up anxious; there was no harmony at home. He worshipped his father and couldn't understand why there was no peace between his parents. He thought his father was more than a druggist; he was the town philosopher and medical advisor. He helped people a lot until he came down with tuberculosis and was coughing up blood. His doctors said he had to move to a warm

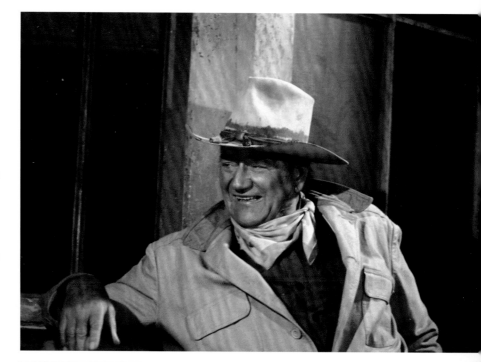

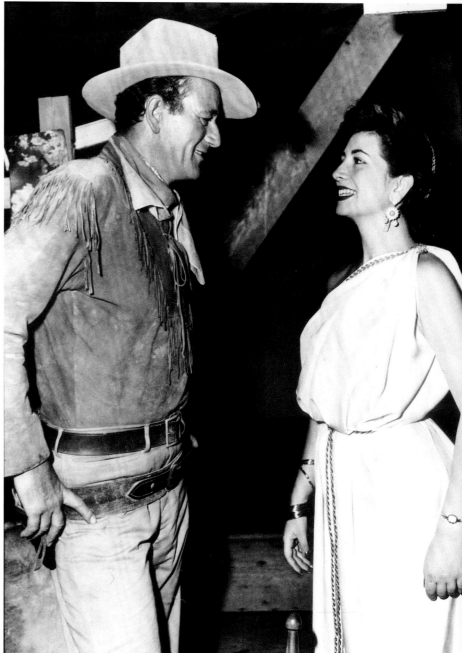

climate, so in 1914 Morrison sold his drugstore and bought land in California—first in Palmdale, with the idea of becoming a rancher, and when that didn't work they moved to Glendale, a booming suburb of Los Angeles filled with orange groves. Doc got a job in a pharmacy. It seemed that things were settling down for everybody. Marion got a job on a paper route and he calmed down a lot. He became really happy after he was given a dog, an Airedale named Duke. Duke followed Marion as he worked on his paper route and delivered medicine from the pharmacy around town.

The tall, skinny, nine-year-old boy with his frisky dog became a familiar sight in the neighborhood. They would often pass the local firehouse and visit with the firefighters. The men referred to the dog as "Big Duke" and the boy as "Little Duke." The nickname stuck. "Marion," which he'd always hated, was replaced by a name that really fit his dreamy, independent personality.

He learned to play chess; he became a boy scout; for a while he worked in an ice cream parlor. He was a good student and a born leader, first vice president then president of his class at Glendale High. Young as he was, he had the ability to listen and absorb. He'd inherited his mother's hot temper and would explode when crossed. And he could fight like Jack Dempsey, one of his friends remembers. Outside of football, his favorite hobby was acting; he performed in various Shakespeare plays with an amateur group and he attended movies four times a week. The cowboy star Tom Mix became a favorite. Duke loved escaping into fantasy. He became movie crazy.

In May 1925, Duke graduated from high school. He'd received a football scholarship from the University of Southern California and was planning to study law. He became a tackle for USC and a member of Sigma Chi. His parents had gotten a divorce, and he hated what it was doing to them. So he removed himself emotionally by getting lost in school, work, and football. The summer of his sophomore year, he broke his shoulder bodysurfing and lost his scholarship, so he had to quit college. Cowboy star Tom Mix suggested he get a job at Twentieth Century Fox propping (placing items such as napkins, flower vases, etc. on sets), and he did. Directors John Ford and Raoul Walsh both noticed him, this tall, handsome guy who moved like a cat and chain-smoked and could always hold his liquor no matter how much he drank (which cemented their friendship).

In 1929, Ford gave him his first speaking part in a movie called *Salute*. He was twenty-two. Duke played a naval officer and did double duty on the submarine-themed film, which was shot on location off the island of Catalina. When the regular stuntman refused to go into the rough seas, Ford asked Duke to do the stunt—being shot out of a torpedo tube. Wayne eagerly obliged, did the job well and Ford was pleased. They became buddies. After work, Duke would join Ford on his boat and they would play cards and drink each other under the table.

"Pappy" Ford, as he was called, eventually became Wayne's acting coach and mentor, although after that movie Wayne went back to propping pictures until Raoul Walsh decided to cast him as a cowboy in 1930 in *The Big Trail*. Ford had recommended him; both directors sensed he had great star potential. He took a screen test and a voice test (it was just the beginning of talking pictures) and studio executives were impressed by his physical presence and his husky drawl. He was alive inside the frame and he owned his own space. The camera loved him. He seemed perfect for the role of a youthful leader of an ill-fated wagon train headed west. The only thing everybody objected to was his name, Duke Morrison; it didn't sound American enough. Raoul Walsh came up with John Wayne.

The day Duke won the part in *The Big Trail* he began training for the role. He took acting, voice, and horseback riding lessons. He learned to shoot, rope, and throw a knife. When principal photography began he was well prepared to star in what Fox was calling "the most impressive western ever made."

The Big Trail launched him as an actor. Fox quickly signed him to a contract. From 1933 to 1939 he made forty B movies—all westerns. He did many of his own stunts with the help and guidance of expert stuntman Yakima "Yak" Canutt. Together they invented stunts and worked out routines on horseback and off which they'd use over and over again. Wayne developed a technique for throwing a punch so nobody got hit. He was held in awe by the wranglers and riders and other stuntmen in his movies, because he was so dedicated to his work. And his face was either smiling or tired under tan makeup. He always believed in using makeup. "And I knew I wasn't an actor," he kept pointing out to reporters. "How many times do I have to tell ya I don't act at all... I react," and then he'd elaborate, "so I went to work on this Wayne thing. It was very deliberate. I figured I needed a gimmick so I dreamed up the drawl, and the squint, and a way of moving to suggest I wasn't looking for trouble but would just as soon throw a bottle at your head as not. I practiced in front of a mirror."

It was his walk that made him so distinctive: a rolling, graceful gait. Whenever he was in a picture his entire character seemed to be an extension of the calm authority of that walk. It became part of the Wayne persona and he held onto it for two hundred movies.

Unbeknownst to Wayne, John Ford was furious with him for starring in *The Big Trail*. Ford had suggested him for the film, but he had underestimated his appeal, and Ford saw Wayne's rise to fame under the guidance of a director other than himself as a betrayal. Ford always viewed himself as the talent who should be nurturing Wayne's career; he wanted to star his protégé in a picture when he felt the time was right. As punishment for his success, Ford refused to speak to Wayne for the next two years. Wayne ignored his animosity.

Then in 1939, Ford offered him the part of the Ringo Kid in *Stagecoach*. It's an epic adventure involving eight outcasts traveling to various destinations across Monument Valley and trying to avoid Geronimo and his Apaches along the way. With this film Ford took the western from pulp status into one of the greatest American movie genres of the twentieth century. Who can forget the climactic stagecoach chase, with Yak Cannut jumping from coach to coach through the line of galloping horses? And Wayne was mesmerizing as the naïve young outlaw seeking redemption, but Ford baited him cruelly during the shooting and made fun of all the B movies he'd been in. Among them were various "horse operas," cheapie westerns like *Westward Ho* and *Three Texas Steers*.

Nobody could ever figure out why Duke took so much abuse from Ford (although Ford was a pioneer in film; he'd directed sixty silent films and would go on to make such classics as *The Grapes of Wrath*. His legendary efficiency, his ability to craft films that combined artfulness with strong commercial appeal, won him great renown. In any event, Wayne hero-worshipped Ford and acted like a little boy with him even after he was the biggest star in the world. He would come running if Ford wanted him for a picture. He made twenty-four films for Ford, and he would even agree to less money if it was for Pappy.

Years later, Wayne told his biographer Maurice Zolotow that he thought Ford was simply after artistic perfection, which is why he behaved in such sadistic ways. "Sure he got me angry," he said about the making of *Stagecoach*. "He would turn me inside and out. First of all he was making me feel emotions and he knew he wouldn't get a good job out of me unless he shook me up so damn hard I'd forget I was working with big stars like Thomas Mitchell and Claire Trevor. I was insecure. He knew I was ashamed of being a B western cowboy in the company of these big stars, and don't forget, he couldn't be sure that after years of working in those cheapies that maybe I'd ruined my acting... He also knew that putting a relatively unknown actor like me in a key role, well, there's an unconscious resentment among the veteran actors; there has to be. Mr. Ford wanted to get these veterans rooting for me and rooting for the picture, not resenting me. He deliberately kicked me around, but he got the other actors on my side. Mr. Ford wanted to do one thing only—make a good picture." For reasons that remain mysterious, Ford at his most creative was often at his cruelest.

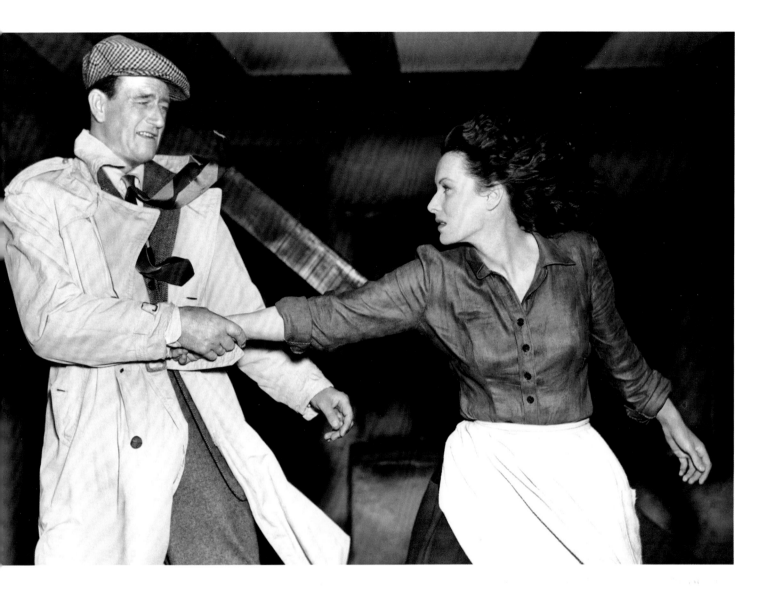

Wayne worked for him for over three decades and the atmosphere on location or on the set surrounding Ford was always the same. Pilar Wayne (the third Mrs. John Wayne) recalls how Ford would invariably arrive late by chauffeur-driven limousine. An accordionist who was part of his entourage, Danny Borzage, would immediately begin to play "Bringing in the Sheaves" as he got out of his car. A secretary would bring him a mug of steaming coffee. He would strut onto the camera range like a general. He would immediately begin to bait and insult various members of cast and crew, setting one person against another. He was always a looming presence no matter how many superstars were around, including Dean Martin and Jimmy Stewart. Wayne in particular put up with Ford's strange rituals and he accepted his drinking, his anger, his black moods.

By 1939 Wayne had married his longtime sweetheart Josephine Saenz. They'd had a six-year engagement before they tied the knot in an elaborate ceremony in Beverly Hills. Duke's mother Molly came to the ceremony and bluntly told him she didn't think it would last; they had waited too long to get married. Even so, they tried to make things work. They had four children in quick succession: Michael, Toni, Patrick, and Melinda; they lived in a beautifully decorated, fashionable house on Highland Avenue in Hollywood. Josephine was very social and held many dinner parties. Duke did not feel at home. He once plopped down on a French antique chair and it collapsed. He preferred lying on a big comfortable couch so he could stretch out.

Wayne's life was his career, so he spent most of his time away from his family working. He worked continuously under contract to various studios. Throughout World War II, he starred in a succession of war movies like *Flying Tigers* and *They Were Expendable*. He was single-minded

ABOVE John Wayne and Maureen O'Hara in *The Quiet Man* (1952).

about his career and very ambitious. He had almost superhuman energy and when he wasn't working he was traveling or hunting or fishing.

In 1942 his agent, Charlie Feldman, got him a new contract with Republic; Wayne was to be paid 10 percent of the gross, an almost unheard of proposition in Hollywood at that time. This was in addition to a salary of $100,000. Duke's share of the profits from *Wake of the Red Witch* was $260,000, for *Sands of Iwo Jima* $380,000.

Meanwhile, he had fallen in love with a volatile beauty named Esperanza "Chata" Baur whom he'd met in Mexico. Josephine found out about the romance. He felt guilty about not seeing his children; he felt guilty about hurting his wife. He knew he should deal with his problems, but instead he just continued to make movies—more and more movies: *Tall in the Saddle*, *Back to Bataan*, *The Fighting Seabees*, *They Were Expendable*.

John Wayne was an avid supporter of the men and women of the armed forces. He

ABOVE Head shot from a Fox Films series, 1930s.

contributed to the morale of war efforts by portraying strong heroes and courageous characters in memorable films. General Douglas MacArthur believed he was the model of the American soldier by virtue of the soldiers he played on the screen, and he wrote to Wayne saying just that: "Young man, you represent the cavalry officer more than any man in uniform." He has been recognized by every branch of the armed forces for his support and contributions. Furthermore, the Veterans of Foreign Wars honored him with a gold medal, and generations of baby boomers joined the service, using his movie heroics as their inspiration.

In 1945 Josephine gave him a divorce and three weeks later he married Chata. He was crazy about her and determined they would have a happy life together. He wanted more children; he wanted to create a home.

Instead they quarreled and made up and drank through the filming of *Red River* and *Sands of Iwo Jima*. "We had pretty good times, except when she tried to kill me," Wayne told gossip columnist Hedda Hopper. In 1947 Chata had convinced herself Wayne was having an affair with co-star Gail Russell during filming of *Angel and the Badman*. After the film wrapped there was the usual party for cast and crew and Wayne returned home very late. Chata was in a drunken rage by the time he arrived and attempted to shoot him as he walked in the door. A bullet grazed his leg. Chata's mother then wrestled her daughter to the floor and took the gun away from her.

In 1952 they began divorce proceedings, which were finalized in 1954. (Chata died of a heart attack brought on by acute alcoholism in March 1961.)

During this emotionally difficult period, Wayne came into his own. Between 1948 and 1959 he starred in twenty-five pictures. His performances in five of these films rank among the most powerful of that decade: *Rio Grande, The Quiet Man, The Wings of Eagles, Rio Bravo,* and *The Horse Soldiers*. He was number one at the box office from 1953 on, and intermittently among the top five draws for over twenty years thereafter. He actually set a record unequalled by any other movie star: twenty-three years on top. The closest to Wayne in frequency of appearances were Clark Gable (twenty-two times) and Gary Cooper (sixteen).

Clearly he was more than a superstar. He was evolving from the naïve Ringo Kid in *Stagecoach* to the fierce Indian fighter of *Fort Apache*, the peacemaker of *She Wore a Yellow Ribbon*, the laconic ex-gunfighter in *The Man Who Shot Liberty Valance*. He was always a man that audiences could identify with and care about. "Longevity and durability allowed him to play both Achilles-like warriors and Odyssean survivors," the film critic Molly Haskell wrote.

It was director Howard Hawks who convinced Wayne to tackle the role of the obsessed hero Dunson in *Red River*, a ruthless, lonely, womanless man who longs for a son. He adopts the rebellious Matt Garth (a charismatic Montgomery Clift). Together they lead a cattle drive though storms and rain from Missouri to Texas. Before the movie ends, they have fought and almost killed each other. *Red River* established the kind of role Wayne would be playing in different variations from 1948 on: the authority figure, the mentor to younger men, the melancholy rancher weighed down with responsibility, a character schooled in adversity.

The most memorable example is his disturbing character Sergeant Stryker in *Sands of Iwo Jima*, the quintessential flag-waving film, made in 1949, for which he earned an Oscar nomination. Stryker was a tough-as-nails character greatly disliked by his men for his rigorous training before going into battle.

With this movie, Wayne's persona entered the mythology of conservative America. Onetime Speaker of the House Newt Gingrich told Elizabeth Drew that *Sands of Iwo Jima* "was the most formative movie of my life." (He said as a teenager he had watched the movie over and over. His tough attitude with Republican insurgents was inspired by Stryker's example. He was determined to shape his men for battle, even if that involved making them hate him.) Oliver North used Stryker's rallying cry of, "Saddle up, lock and load," in his senate campaign of the nineties. So did director Oliver Stone; when he filmed *Platoon* in 1986 (part of his Vietnam

trilogy), he had his psychopathic Sergeant Barnes use Wayne's catchphrase.

The emotional climax of *Sands of Iwo Jima* is the raising of the American flag over Mt. Suribachi. That was the scene that, according to legend, led veteran activist Ron Kovic to enlist and go to fight in Vietnam. *Sands* was made while the excitement of the Suribachi flag raising was still going on. (As a matter of fact the actual flag from the event was used in Wayne's film, courtesy of the U.S. Marines.) *Sands* represented a trend—to present war films as psychological studies of men under stress—and it is said to be Wayne's most famous film.

He was becoming famous for other reasons too. By the 1950s he became involved in politics. It was the height of the "red scare" in Hollywood, a shameful epoch in our country when hundreds of writers, directors, and actors were "blacklisted" if they were suspected of being Communists. Wayne's good friend Ronald Reagan was then president of the Screen Actors Guild. He was sure a small group of writers and actors who were "Commies" wanted to infiltrate the unions and control American movies. Reagan saw a possible takeover of the Screenwriter's Guild as particularly ominous, because he believed that a picture begins and ends with a good screenplay and he didn't like polemics.

Wayne imagined his politicization would take him out of his so-called celebrity bubble. He helped organize the Motion Picture Alliance for the Preservation of American Ideals (a group formed by Hollywood conservatives to defend against "Communist infiltration") with over a thousand people from every craft union and economic stratum of the movie industry, and he became its president. The organization put Wayne into the center of a Cold War sensibility. He didn't say much; he had trouble formulating the issues at stake, but it didn't matter. The Alliance wanted Wayne's celebrity and prestige more than his rhetorical skills.

In 1949 the Soviets had exploded their first atom bomb and Communists had won the war for China. In 1950 President Truman escalated nuclear competition and decided to create the hydrogen bomb. "The image of cavalry units surrounded by hostile Indians echoed the fears of Americans trying to remain steady as peril increased," Garry Wills wrote. "John Wayne became the cool but determined model for Americans living with continual danger." In the 1950s he made movies for billionaire Howard Hughes like *Jet Pilot* and *Flying Leathernecks* and *Big Jim McLain*, written by Jimmy Grant, his favorite screenwriter, who had more to do with crafting Wayne's blustery style of patriotism than anyone else. Grant helped Duke define his particular brand of Americanism in *The Alamo* and *The Green Berets*. These films were ridiculed by critics, but earned back their considerable production costs. They confirmed Wayne's hardcore fans in their belief that he represented the power and resolution of America.

He was so popular, and his status as the most famous Republican movie star so huge, that in 1968 a group of Texas Republican fund raisers asked Wayne to run for president. He guffawed; who'd believe an actor could ever be in the White House?

In the late 1950s and early 1960s Wayne was at his creative peak, making big-time money with films such as *Hondo, The Quiet Man, Rio Grande, Blood Alley, The Sea Chase*, and *The Wings of Eagles*. He relaxed whenever he could, hunting and fishing and drinking it up in Argentina, Chile, Mexico, and Brazil, sometimes traveling with family, sometimes with Howard Hughes, who'd become a friend (they'd bonded in their fight against Communism and their love of Mexican vacations). The Duke was having a good time. He enjoyed spending money; always picking up the check, even loaning money to friends when they needed it. He invested in a motel, a fast food processing factory, he bought apartment houses and oil wells and once he even bought an island.

On one vacation in Lima in 1952 he visited a movie set on the edge of a Peruvian jungle. He was scouting movie locations after his bitter divorce battle with Chata. Barefoot and wearing a low-cut gypsy costume, Pilar Palette, an exotically beautiful young Peruvian actress with long black hair, had just finished filming a dance scene in the firelight. She was still flushed and out of breath when the director introduced her to Wayne.

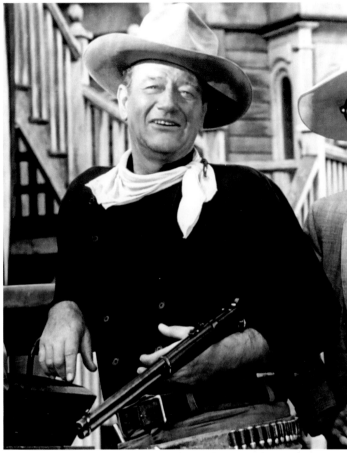

"That was quite a dance," he drawled, giving her a head-to-toe glance. Later they had dinner. He found her beguiling; they chatted about this and that. "I was a very good guitar player," she says. "Near the end of the evening I played guitar and sang and Wayne listened and he was entranced." When he rose from the table he towered over her. Pilar recalls, "I felt as if I'd been hit by a telephone pole."

The next day he sent her an absolutely beautiful new guitar as a gift. But he didn't see her again for awhile. He couldn't stop thinking about her—she'd made him feel wonderful—but he thought he was too old for her (he was forty-two, she was twenty-one). He'd had two failed marriages and was scared to try a third time. So their courtship was intermittent. They wrote letters; they phoned. He was working all the time and she knew his work was his life. Wayne could be stubborn, domineering, insensitive, Pilar wrote in a memoir. He loved to drink with his cronies and he compulsively made movie after movie. She and Wayne did marry in late 1954 and she became the ideal wife: devoted, caring, a real companion. She redecorated the house in Encino; she brought in all Peruvian servants who were instructed to serve Wayne his favorite avocados whenever he wanted and steaks no matter what time of the day or night. They eventually had three children, Aissa, Ethan, and Marisa.

"He could be the sweetest, most caring man," Pilar recalls. "He could be so tender." She remembers how he would wrap her Christmas presents personally for her and would trim the tree himself. One birthday, when they were on location in Honolulu and he didn't even bring a gift, she was upset and went to bed early, only to be awakened by an orchestra playing. Then the door opened and cast and crew burst in and there was singing and a big cake was brought in and champagne was served. Duke had planned the entire party.

"He was a loving father," his daughter Marisa remembers. "He was a great father. He loved having his kids around all the time. He wanted us to be with him on the set, at home, on vacation, or on our boat *The Wild Goose* (a converted 136-foot Navy minesweeper). He always wanted me to come and hug him whenever I walked into the room. We were with him a lot

ABOVE LEFT John Wayne on the set of *Rio Lobo* (1970).

ABOVE RIGHT John Wayne in *The Man Who Shot Liberty Valance* (1962).

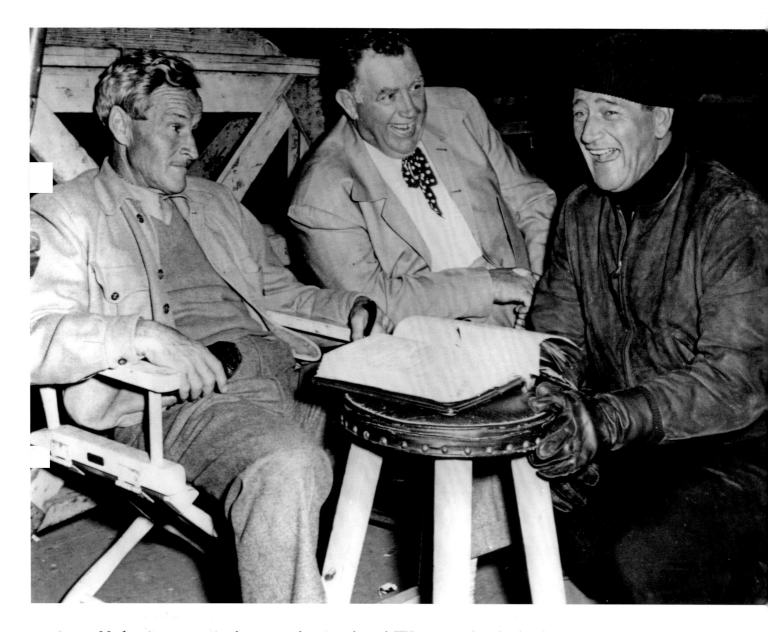

growing up. My favorite memory is when we used to sit and watch TV reruns and eat big bowls of cereal together."

Pilar invariably accompanied him on location filming. To the Sahara, Japan, and Africa. She was with him on his most arduous shoots like *The Alamo* in 1959, an ordeal from start to finish. For years it had been a dream of Wayne's to immortalize the battle of the Alamo inside the old mission compound where Texans fought the Mexican army. The story of the Alamo "had become his touchstone of all the essential American values," Garry Wills wrote. And Wayne would not only be directing and producing the movie, he would also be starring in the movie as Davy Crockett, an archetypal figure who, like Buffalo Bill, stands for the whole frontier experience.

From the beginning *The Alamo* attracted chaos. At the start, a flash flood destroyed the thousands of adobe huts that had been made for early scenes. The needs of staff and cast called for miles of water pipes and huge electrical installations. Expenses rose daily and it didn't help that the script was lumbering; Wayne had to call for constant rewrites. A fire destroyed many of Wayne's files. One of the actors broke his foot. Then an actress was murdered by her boyfriend.

Throughout Wayne was determined to prove to the world that he was more than a cowboy star. His dedication to the film was heroic. He worked twelve-hour days. He never stopped smoking—three or four packs of cigarettes a day. And he never stopped coughing either—violent, convulsive coughs that exhausted him. Pilar wanted him to see a doctor but he refused.

ABOVE John Wayne photographed with Director, William Wellman (left) and co-star, Andy Devine, in *Island in the Sky* (1953).

When *The Alamo* opened in October 1960, it got very mixed reviews, which was deeply disappointing to him, as was the fact that he now had huge personal debts to pay because the movie had gone so over budget. However, Wayne was so hugely popular as a star that the movie recouped its huge costs.

By then he was suffering from serious emphysema, but he went on working and starring in eight more movies, and continuing to smoke and drink. His idol had always been Winston Churchill, who smoked cigars and drank copiously up until the day he died. Wayne, like Churchill, had been born with a huge capacity for absorbing alcohol without any destructive effects on the liver and kidneys and heart. Churchill could "drink like a man" (it could have been Wayne's motto), so Wayne kept on drinking and smoking and making more movies until September 1964, when he was in such bad shape that he ended up in Good Samaritan Hospital where he underwent surgery to remove his left lung. He had to stay home for six months recuperating. He longed for a cigarette. He begged Pilar to make him a cigarette sandwich. But he never smoked a cigarette again.

He and the family spent time on his boat *The Wild Goose*. They sailed down to Mexico. Duke gained weight and got some of his color back. He began drinking again. He was his old self, he said.

In December 1964 he called a press conference to announce to the world that "John Wayne had licked the big C," and he admitted he had prayed to God. He had never acknowledged it before, but he now believed in a supreme being. His wife Pilar was now involved with Christian Science. Eventually, he returned to work before he should have and made four more movies including *The Sons of Katie Elder* with Dean Martin. That was his one-hundred-sixty-fifth movie; he was fifty-seven, he had a bad cold and a hacking cough and he kept an oxygen inhaler on the set. He would soon start chewing tobacco and smoking cigars.

Protests against the Vietnam War were infuriating him. In 1966, he visited the troops in Southeast Asia to cheer them on; he was haunted by the vision of Marines lonely and confused, doing what they believed had to be done. He knew that President Johnson equated Vietnam with the Alamo. By 1968 he decided to make a movie about the Green Berets. So he optioned Robin Moore's collection of short stories about the special forces, thinking its bestseller status would be automatic promotion for the film; he didn't know the Defense Department did not like Moore's work (it portrays the Green Berets as sadistic, lawless, and racist.)

Wayne was proud to star in, direct, and produce this particular movie. He believed the special service of the Green Berets was a symbol of excellence and a mark of distinction in the fight for freedom. Those who worked with him and visited him on location at Fort Benning in Georgia remember he behaved like a man possessed. He shot day and night; the weather was damp and cold. His conjunctivitis was bothering him and sometimes he worked with one eye closed. His aging body was wracked with coughs. Breathing was hard and sometimes impossible, except when he had oxygen. But he wore out younger actors; he seemed to have inhuman energy. Between takes he was on the phone to senators and generals in Washington demanding more help, calling on Jack Warner in Los Angeles. The picture was overlong; it was too talky, too ideological. Wayne's excessive zeal as an American patriot earned him a lot of enemies, but however wrongheaded his ideas might have been, he never seems to have acted for ulterior or opportunistic reasons. His son Ethan defends his father: "There's a misconception about my dad's political views. He was not a rubber-stamp conservative. He was an independent thinker. He had an enormous love for America, because it offered so much in terms of opportunities, if you knew how to work for them and take advantage of them. He always loved his work."

His appreciation and love for moviemaking were expressed by the collection he amassed of the majority of his legendary films. In his garage, there were shelves and shelves of 35-mm motion-picture canisters, all holding original prints of his greatest movies such as *Red River*, *The Quiet Man*, and *She Wore a Yellow Ribbon*, as well as *Stagecoach*. He told writer Peter Bogdanovich

it was part of his regular deal at the time. "The studios gave me prints off the original negatives." Knowing that the original print of *Stagecoach* had either been lost or destroyed, Bogdanovich told Wayne that his print, which did turn out to be a mint copy, could be used to create a new negative with better results than anything that currently existed. So Wayne contributed his print to the American Film Institute, a new negative was made, and that's how the legendary *Stagecoach* was saved.

In 1969, he made his masterpiece, *True Grit*, playing the drunken, one-eyed, over-the-hill U.S. Marshal, Rooster Cogburn. It was directed by Henry Hathaway, who thirty years earlier had directed Duke in *The Shepherd of the Hills*. The story is told against a vivid backdrop of Colorado's wild landscapes and changing terrains and there are plenty of rousing action sequences, including one where Rooster ambushes some criminals in a cabin by a river.

Then there's Wayne's hoarse emotional rendering of the biggest monologue in the movie, where he rambles on about his old life and how his wife had run off with another man and how he never ever wants to settle down again. And the amazing ending, when Kim Darby, playing the little girl Mattie Ross, reminds Rooster he's too old and too fat to jump his horse over a fence. With that Wayne sweeps his hat off, turns his horse around, and appears to leap away into eternity.

When *True Grit* opened, *The New York Times* declared that, "Wayne has delivered the richest performance of his entire career." He won the Golden Globe and the Academy Award for Best Actor. He shed a tear after he accepted the Oscar from a tremulous Barbra Streisand, and then he uttered his famous line, "If I'd a known that, I'd have put that patch on thirty-five years earlier." The entire audience stood and cheered and bravoed him.

He made fewer movies after that, he really wasn't well. But he remained ambitious to the end. He even lobbied for the part of Dirty Harry, a vicious homicide detective based in San Francisco who is hunting a crazed killer. Warner thought Wayne was too old (he was sixty-three); they gave the part to Clint Eastwood.

Between movies he'd try to relax. His sons Ethan and Patrick were with him a lot. Patrick says, "I loved him. He was a great father. He never gave advice. And yes, I have to admit, even though I felt at ease with him, he could still be intimidating. He *was* John Wayne, after all. Whenever we'd enter a room together, the room would go completely silent when he appeared. He had that kind of presence."

Ethan remembers, "Growing up I was a normal kid. I rode my bike all over the neighborhood. I went to public school." Ethan says he realized he was different from other kids when he visited a school buddy's house. "His parents only had three letters in their mailbox. We had bags and bags of mail delivered to our home every day for my dad. There were three secretaries working full-time, five days a week, reading them. Dad tried to answer all the letters."

In 1976 Wayne caught pneumonia before filming his last movie *The Shootist*. He played J. B. Books, a legendary gunfighter who's dying of cancer. Between takes Wayne played chess with the film's still photographer and he was interviewed by various journalists. He kept telling them, "I had the script changed; it was too cynical, too brutal." He refused to allow Books to shoot a man in the back. By then he'd reached a point where he would never compromise his screen image. "I've made 250 pictures and have never shot a guy in the back," he said.

John Wayne died of stomach cancer on June 11, 1979, fifteen years after his initial struggle with lung cancer. He was buried at Pacific View Memorial Park in Newport Beach. He had converted to Catholicism shortly before his death. He requested his tombstone be engraved with the motto "Feo, fuerte y formal," a Mexican epitaph, which is translated as, "Ugly, strong and dignified." However, the grave remained unmarked.

After his death, the family grieved and they went their own ways. "My father always allowed us to be who we wanted to be, whatever that was. I loved that man," says his daughter Melinda.

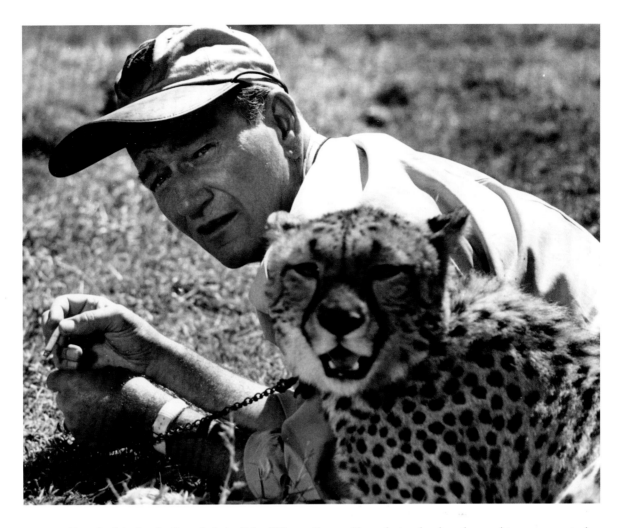

In 1985, his family founded the John Wayne Cancer Foundation both to honor his memory and to support groundbreaking cancer research and education.

Meanwhile, John Wayne the icon and legend lived on, and his persona attained more mythic proportions as the years rolled by. In 1979 he was posthumously given the Congressional Gold Medal and the Presidential Medal of Freedom. Monuments appeared around the country, including a life-size bronze statue of Wayne atop a horse at a corner on Wilshire Boulevard in Beverly Hills. Various public locations have been named in memory of Wayne, including the John Wayne Airport in Orange County, California; the John Wayne Pioneer Trail in Washington State; and in Arizona, part of the AZ-State Highway 347 is named the John Wayne Parkway.

In 2003, Michael Wayne, Duke's oldest son, died, and Ethan Wayne became head of John Wayne Enterprises. Ethan says that he and the rest of the family had long wanted to create a personal tribute to their father. He and some of his other siblings began going through the vast treasure trove of John Wayne memorabilia that was in storage, such as movie posters, costumes, and old cowboy hats. And then there were the photographs—candids, snapshots, portraits, hundreds of them.

Duke had always taken photographs. He had all sorts of cameras and so did Pilar, and for twenty years they had documented their life in images. And eventually the kids took pictures too, photographing their gardens, the swimming pool, fishing trips, their 23,000-acre ranch in Stanfield, Arizona, and of course their boat *The Wild Goose*. This book is the combined effort of all the Waynes to illuminate their experiences with a very special man.

Thirty-two years after his death, John Wayne's grave is no longer unmarked. Now there's a quote on it from his 1971 *Playboy* interview. It reads: "Tomorrow is the most important thing in life. Comes to us at midnight very clean. It's perfect when it arrives and puts itself in our hands. It hopes we've learned something from yesterday."

ABOVE Promotional still from *Hatari!* (1961), Paramount Pictures.

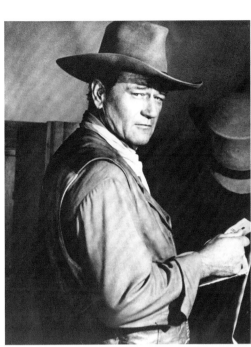

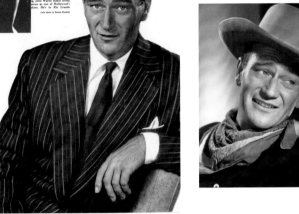

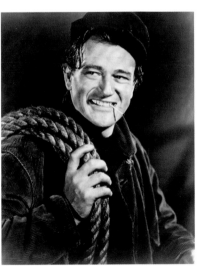
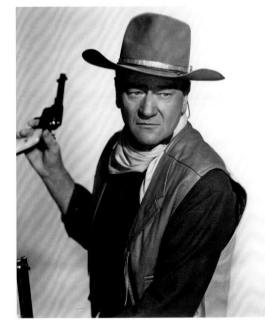
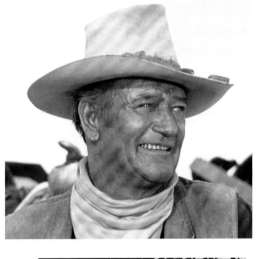
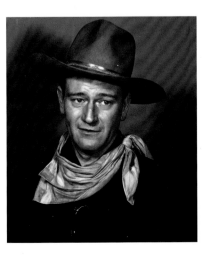

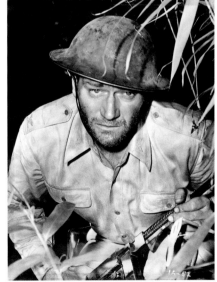

"I've always followed my father's advice: he told me, first to always keep my word and, second, to never insult anybody unintentionally. If I insult you, you can be goddamn sure I intend to. And, third, he told me not to go around looking for trouble."

John Wayne

OPPOSITE PAGE, TOP RIGHT John Wayne's maternal grandfather, Robert Emmett Brown.

OPPOSITE PAGE, BOTTOM RIGHT John Wayne's maternal grandmother, Mrs. Robert Emmett (Margaret) Brown.

OPPOSITE PAGE, LEFT Marion Robert Morrison, was born on May 26, 1907, in Winterset, Iowa, the first child of Clyde "Doc" Morrison and Mary "Molly" Brown Morrison. Birth records show that he weighed 13 lbs. He was named after both grandfathers: Marion Mitchell Morrison (paternal) and Robert Emmett Brown (maternal).

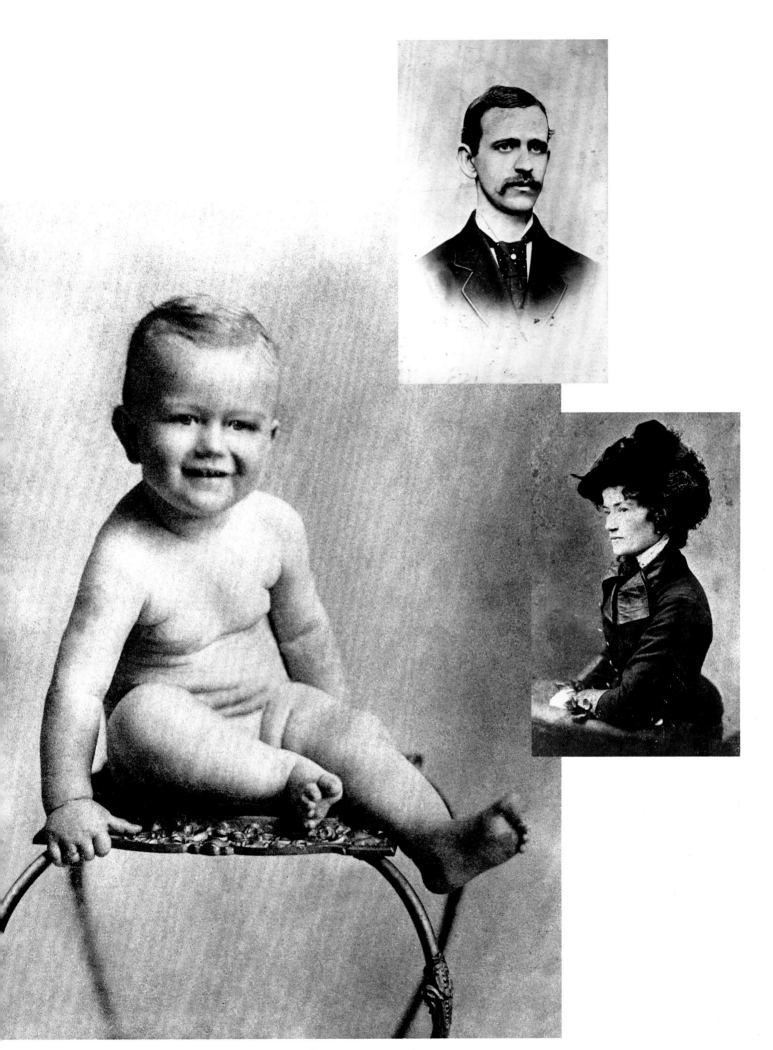

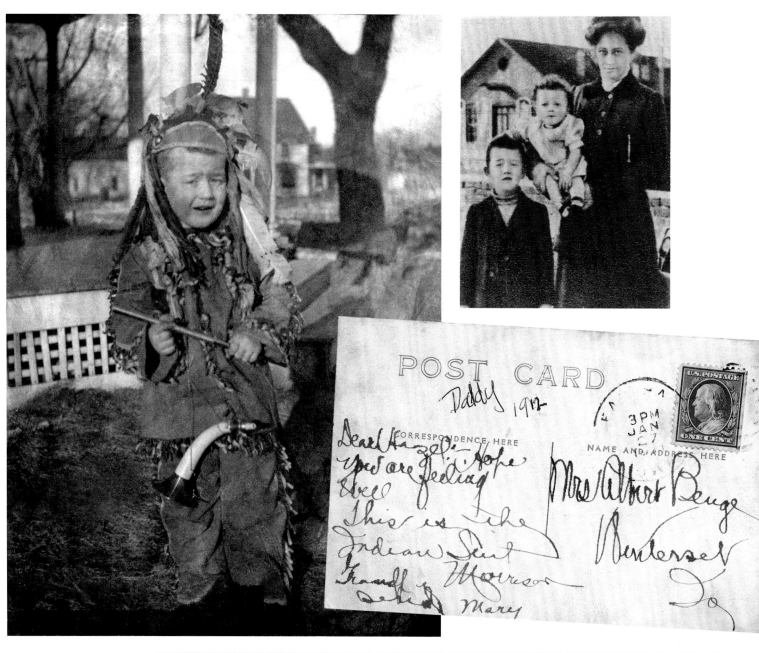

ABOVE LEFT A photograph postcard of a young Marion Morrison in costume.

ABOVE RIGHT Marion Morrison with his mother and baby brother, Robert. After the birth of his younger brother, whom his mother named Robert Emmett Morrison, Marion's middle name was changed from Robert to Mitchell. From this time on, official documents bearing his name most often list him as Marion Mitchell Morrison.

RIGHT A childhood studio portrait of Marion Morrison and younger brother Robert.

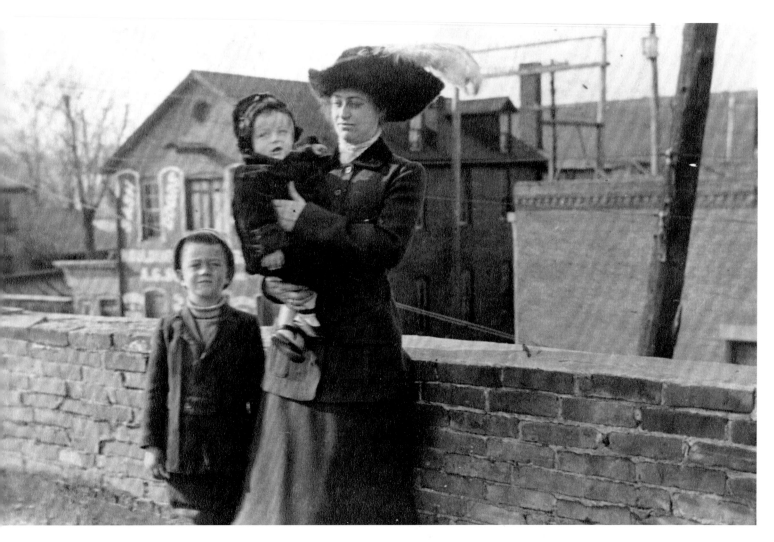

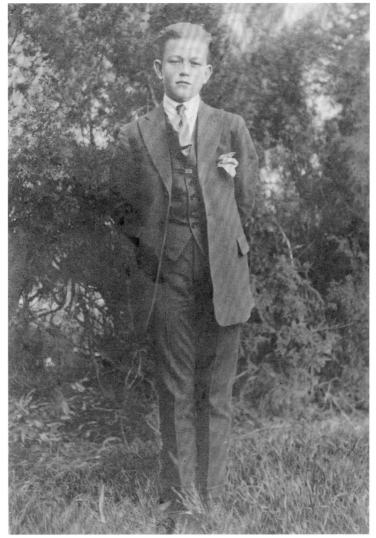

TOP Marion Morrison with his mother and younger brother, Robert.

ABOVE RIGHT Marion Morrison standing outside with his mother and younger brother, Robert.

LEFT A young Marion Morrison in a three-piece suit.

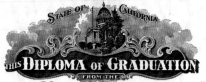

STATE OF CALIFORNIA

THIS DIPLOMA OF GRADUATION

FROM THE

Elementary School of *Glendale City District*
is awarded by the County Board of Education of *Los Angeles*
County to *Marion Mitchell Morrison*
For having successfully completed the Course of Study prescribed for the
Elementary Schools of the County

Mark Keppel
SECRETARY BOARD OF EDUCATION

Jenny Tucker Cohn
PRESIDENT BOARD OF EDUCATION

Jan. 25 1921.

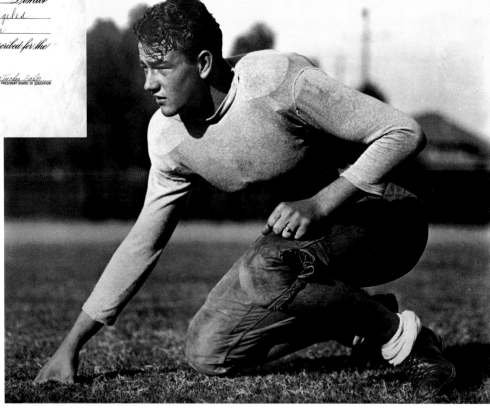

SENIOR DANCE

Marion Morrison
Chairman

Program and Decoration Committee

Miss Grace Rensch, Faculty Chairman
Henry Grace, Student Chairman
Ruth Clausen, Alice Duey, Betty Mabery, Lee Osborne, Carl Denney, Leonora Rose, Shirley Fawkes, Velma Pierce.

Refreshment Committee

Miss Jessie Hill, Faculty Chairman
Pauline Miller, Student Chairman
Elmer Muff, Archie Neel, Kathryn Nelson, Emily Torchia.

Reception Committee

George U. Moyse, Faculty Chairman
Marion Morrison, Student Chairman
Robert Hatch, Kathryn Nelson, Velma Pierce, Mary Jo Phillips, Bonnie Jean Lockwood.

Floor Committee

Miss Mabel Murphy, Faculty Chairman
Leslie Lavelle, Student Chairman
Roland Hodder, Jack Alvord, Carolyn Ayars, Carlton Walker, Robert Eastman.

Music Committee

Miss Grace Rensch, Faculty Chairman

Checking Committee

Hendrik Van Rensselaer, Richard Ryan

MARION MORRISON
Guard Weight 170
2 Years Varsity

LEWIS DOTSON
Tackle Weight 170
2 Years Varsity

BILL BRADBURY
Tackle Weight 165
1 Year Varsity

ELLSWORTH DE PARCQ
End Weight 150
1 Year Varsity

CECIL ZAUN
Center Weight 175
2 Years Varsity

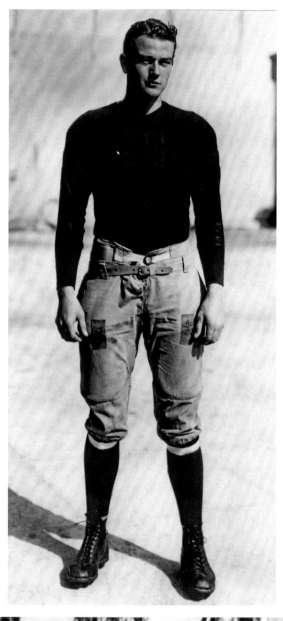

"A man's got to have a code, a creed to live by."

John Wayne

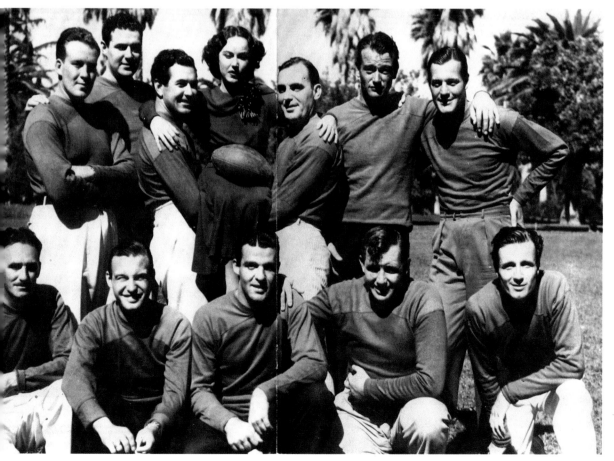

"Don't pick a fight, but if you find yourself in one I suggest you make damn sure you win."

John Wayne

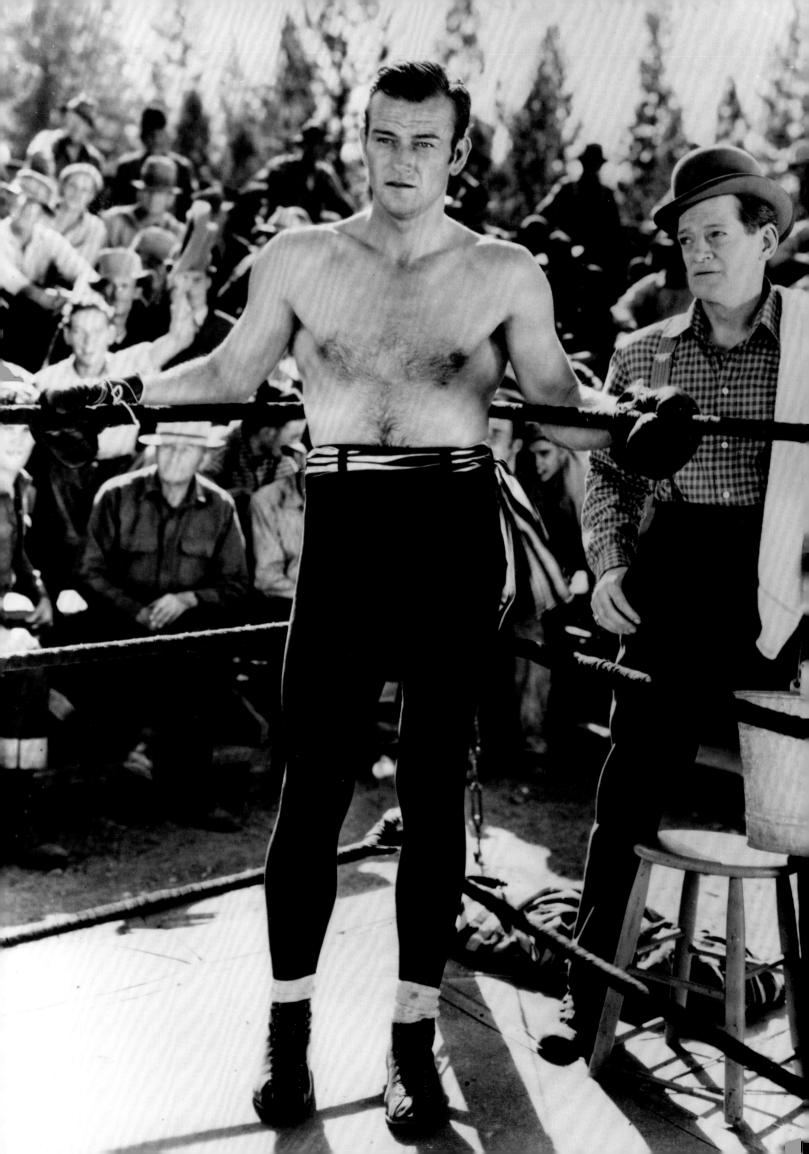

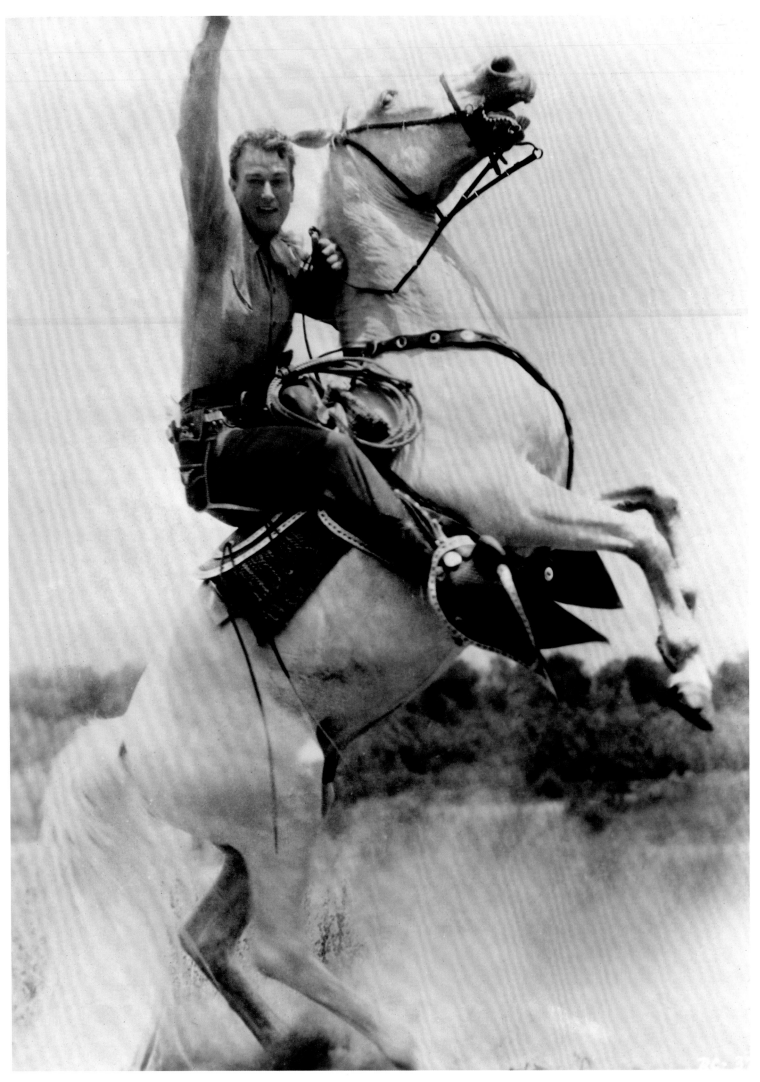

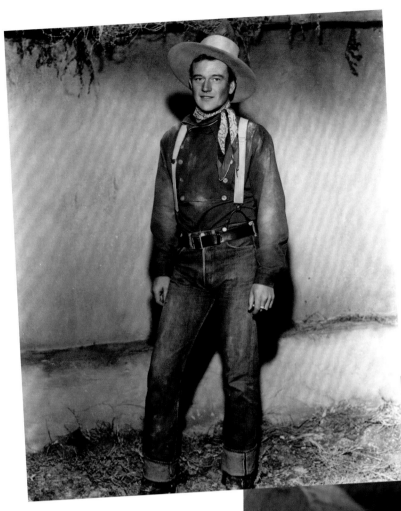

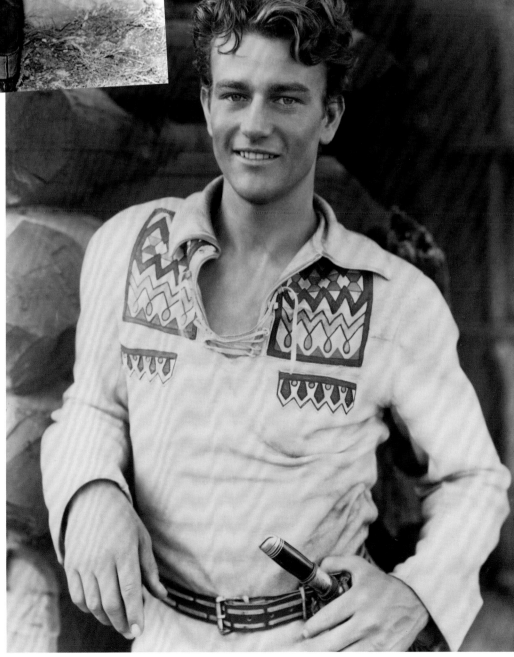

OPPOSITE PAGE This handsome white horse, Duke, received co-billing alongside John Wayne, (e.g. "Starring John Wayne and Duke, The Wonder Horse" or "Starring John Wayne with Duke, The Miracle Horse") in several of his B western films in the 1930s.

ABOVE John Wayne in western costume wearing neckerchief, bib shirt, dungarees, hat, and boots in *Stagecoach* (1939).

RIGHT John Wayne as Breck Coleman in Raoul Walsh's *The Big Trail* (1930). It was Walsh and Winfield Sheehan, head of Fox Studios, who gave Duke his screen name "John Wayne."

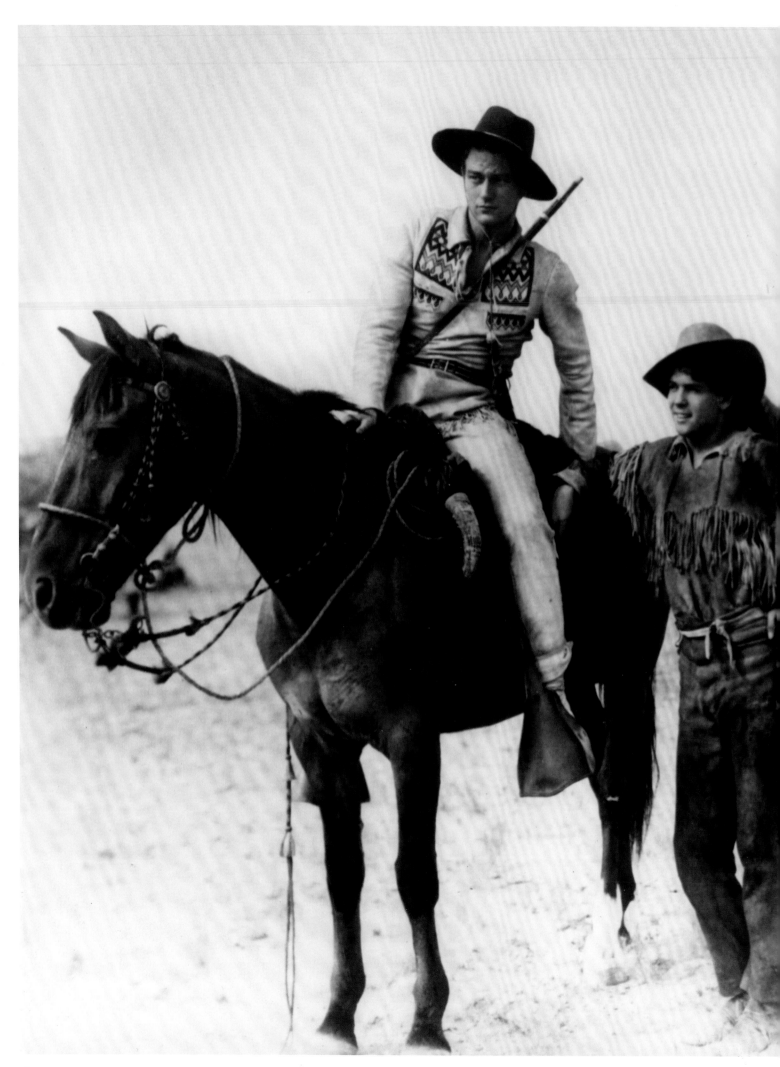

LEFT Studio still from *The Big Trail* (1930), the first film in which Duke was credited under "John Wayne." He played Breck Coleman, an Indian scout who takes on the perils and hardships of the historic Oregon Trail journey.

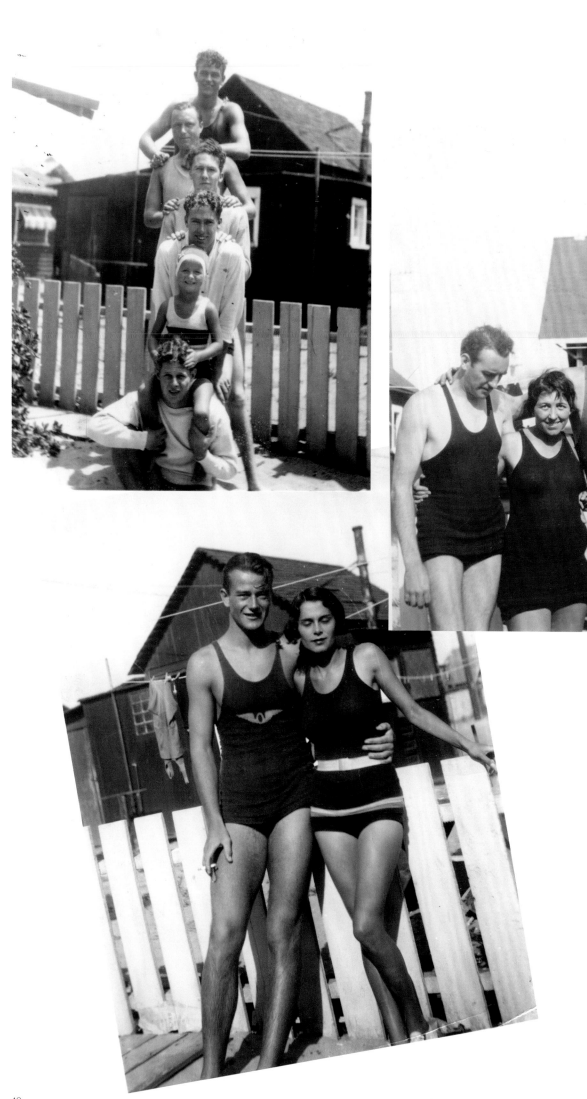

ABOVE LEFT Wayne enjoyed spending time on California's beaches with friends and family.

ABOVE Duke, third from left, with first wife Josephine "Josie" Saenz, far right, at a Southern California beach. Josephine was the daughter of Dr. Jose Saenz, the consul for several Caribbean and Latin American countries.

LEFT Duke with Josephine at a Southern California beach. Duke and Josie courted for many years before marrying in 1933 and eventually having four children together.

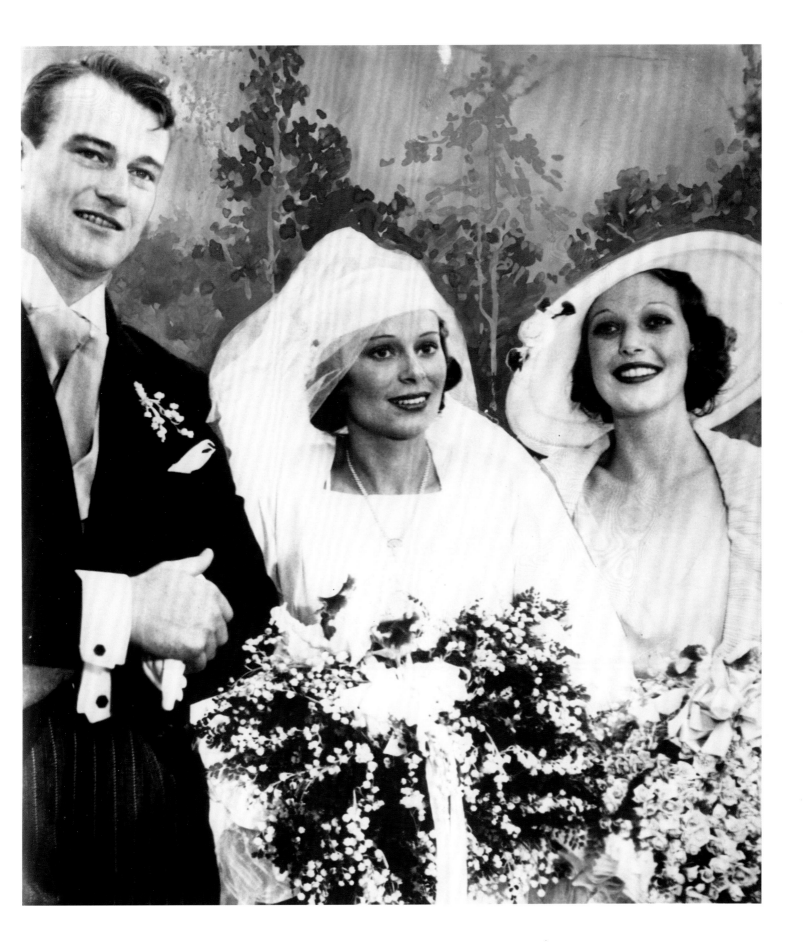

ABOVE Pictured on their wedding day June 24, 1933, groom John Wayne and bride Josephine Saenz together with their bridesmaid Loretta Young. The ceremony was held in the gardens of the Bel-Air home of Loretta Young's family. John Wayne's wedding party consisted of his best man, Louis Gerpheide and eight Sigma Chi fraternity brothers.

OPPOSITE PAGE John Wayne and
Josephine Saenz's first child
Michael Anthony was born
November 23, 1934.

ABOVE Wayne with Patrick John,
their third child, born July 15, 1939.

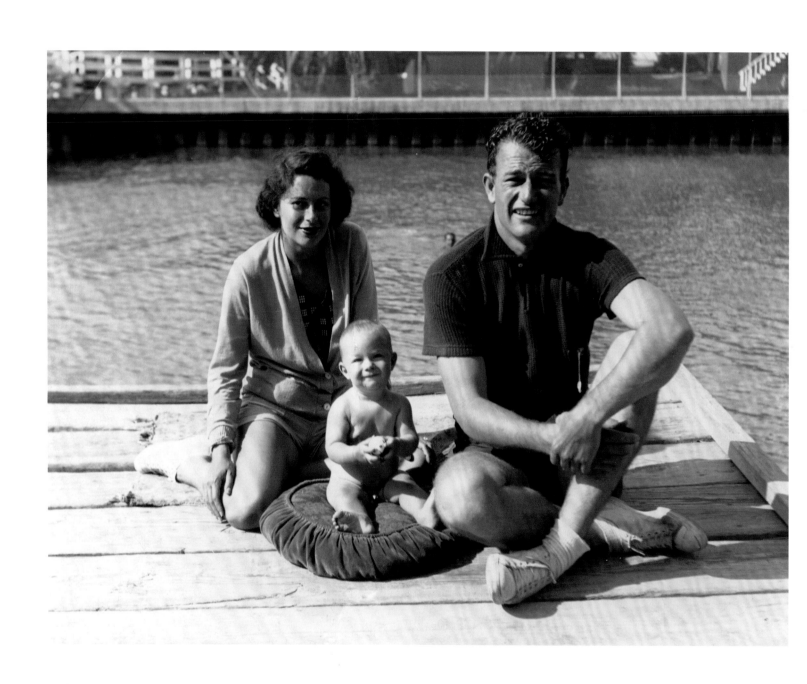

ABOVE Josephine and John
Wayne by the water with son
Michael Wayne.

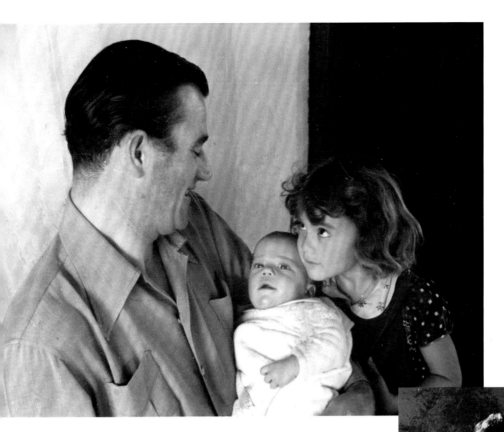

TOP John Wayne with son Patrick and second child, daughter Antonia "Toni" Wayne.

ABOVE Wayne with Michael and fourth child, daughter Melinda.

ABOVE RIGHT Wayne children with their father.

RIGHT Wayne children (left to right) Michael, Antonia, Patrick, and Melinda.

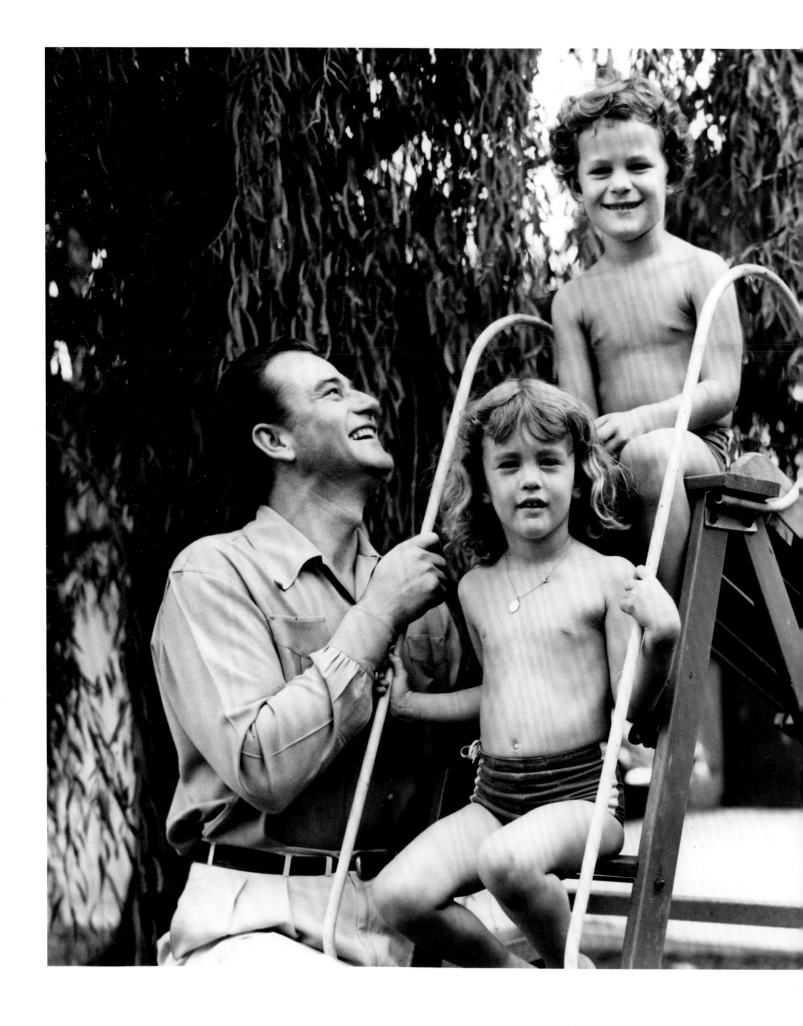

ABOVE John Wayne with his children Michael and Antonia.

NEXT SPREAD John Wayne on Republic Studios lot with Michael, Antonia, Patrick, and Melinda.

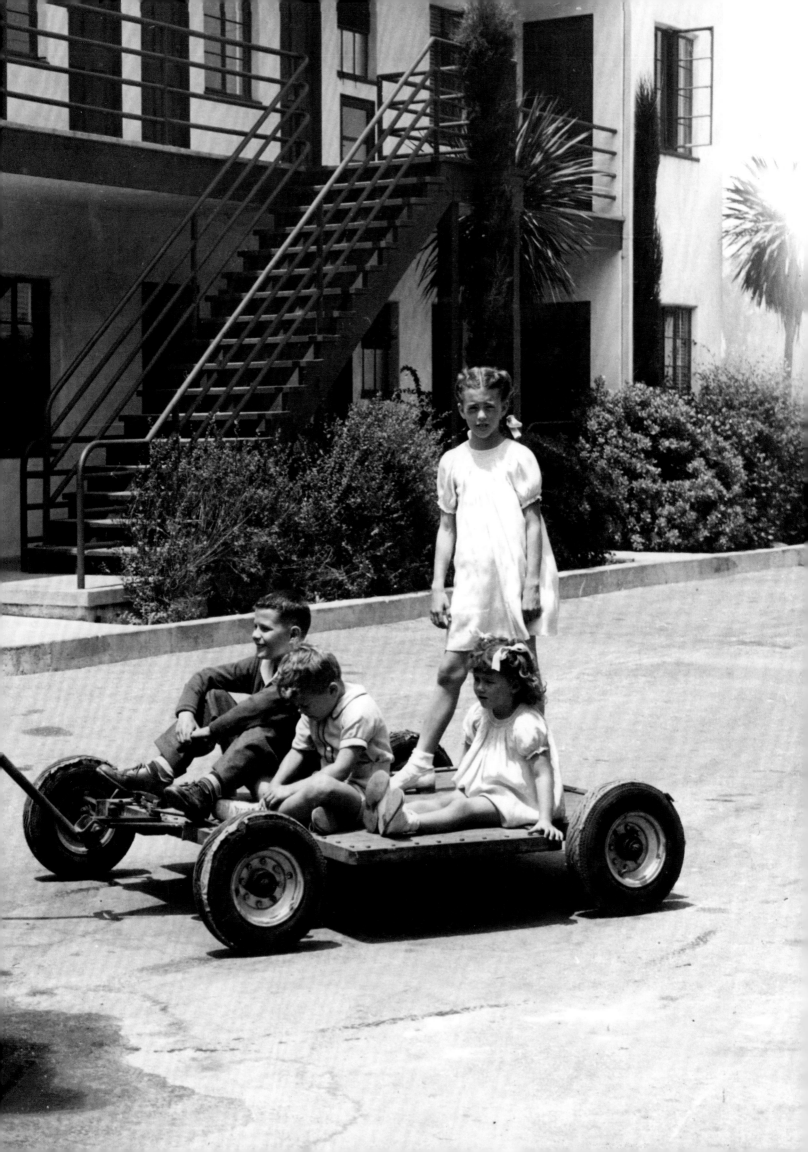

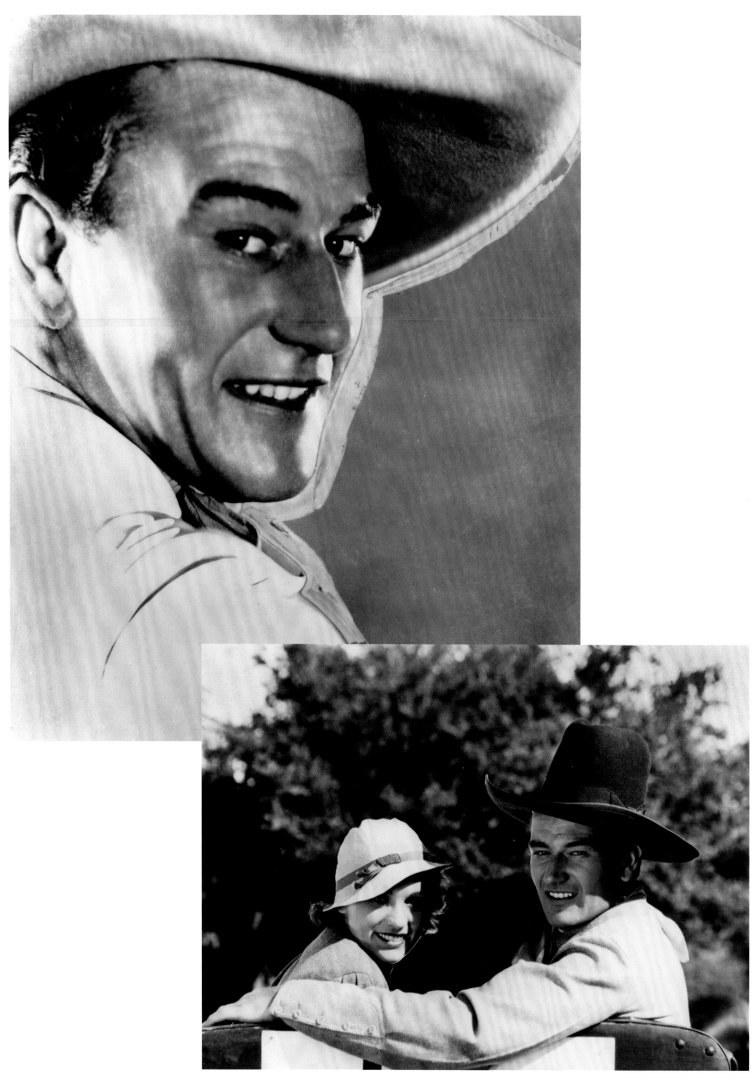

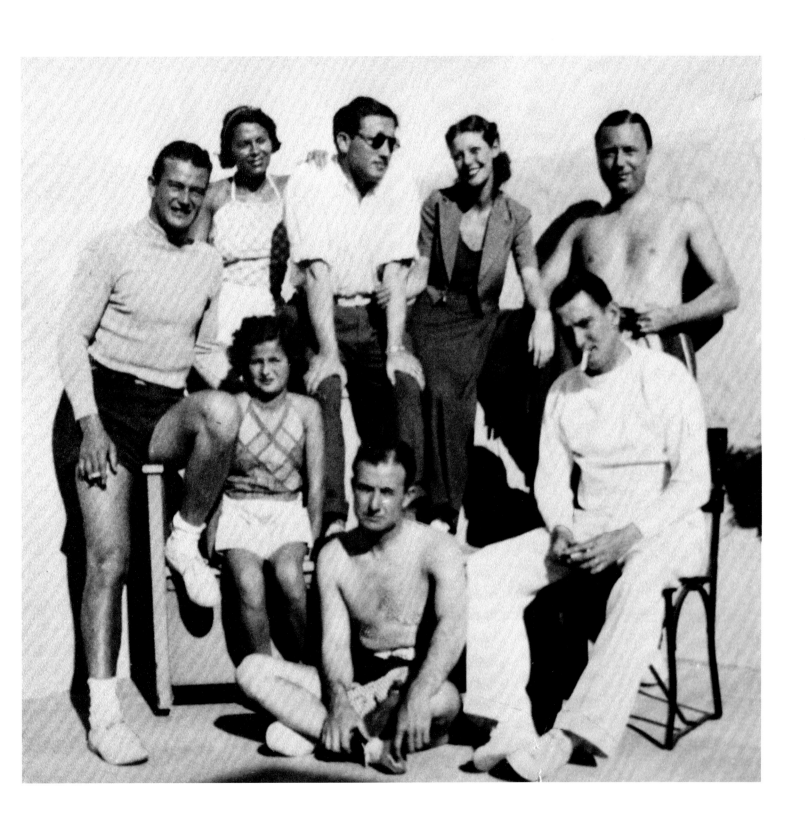

ABOVE John Wayne brawling in *The Hurricane Express* (1932).

OPPOSITE PAGE, ABOVE Gambling scene with John Wayne rolling the dice in *A Lady Takes a Chance* (1943).

OPPOSITE PAGE, BELOW A production still from *Adventure's End* (1937). Original image caption: "Duke Slade (John Wayne) half-owner of the whaling vessel *Mary Drew* has just been captured by the mutinous crew who know that somewhere on the vessel he has concealed a fortune in pink pearls. Slade is wearing a striped shirt. The old pirate with the pistol and knife is Blackie (Maurice Black) who has just told Slade: 'Either you kick through with the poils or we'll shoot you full of holes.' Pleasant People!"

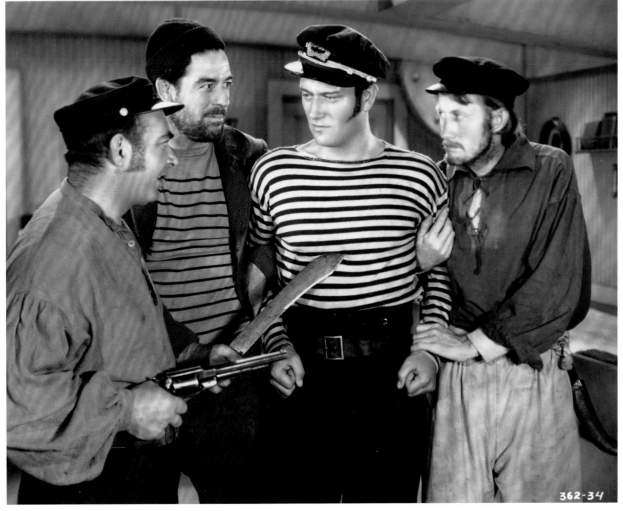

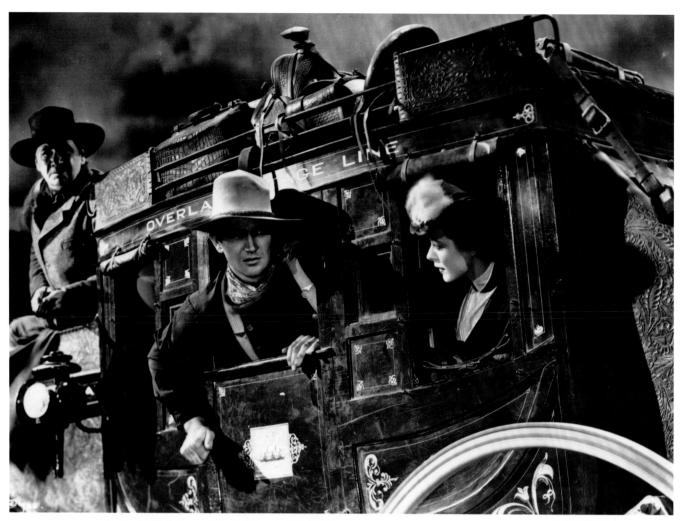

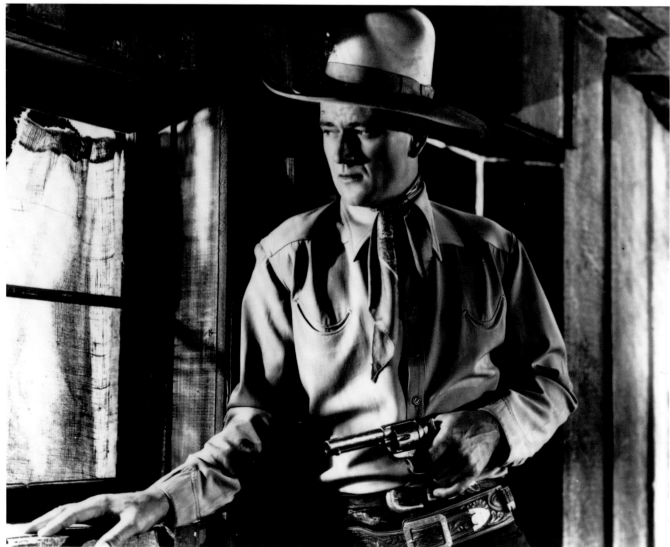

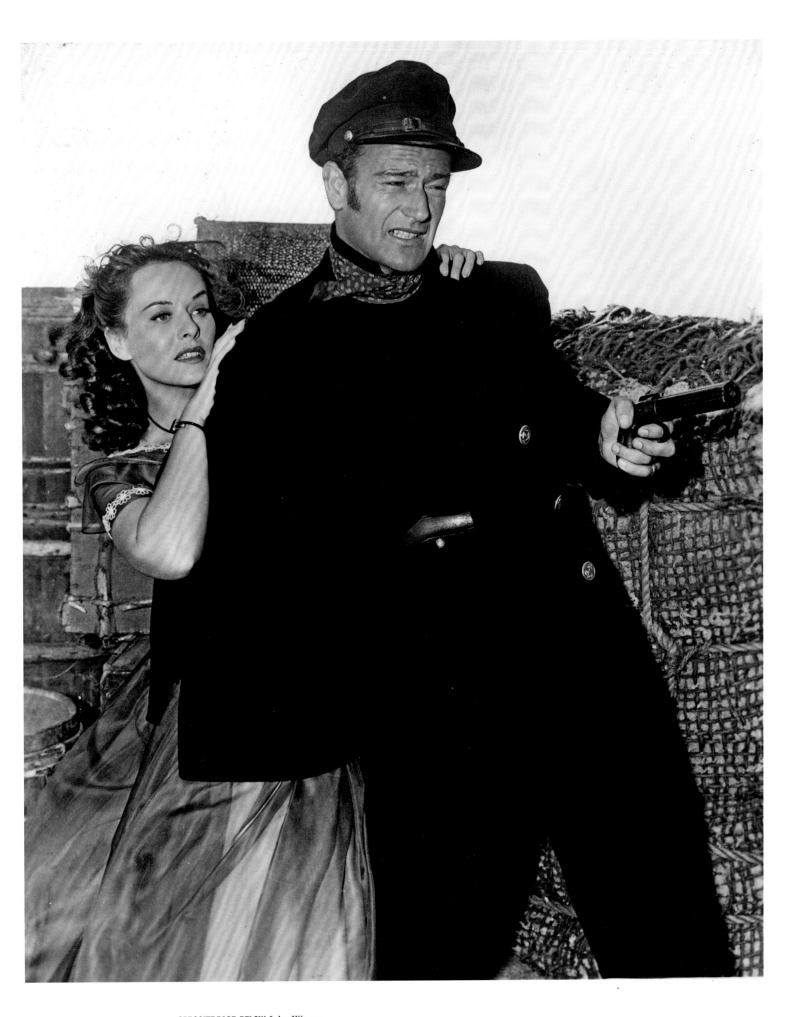

OPPOSITE PAGE, ABOVE
George Bancroft, John
Wayne, and Louise Platt in
Stagecoach (1939).

OPPOSITE PAGE, BELOW John Wayne
as Stony Brooke in *Pals of the Saddle*
(1938). *Pals of the Saddle* is the first
of eight *Three Mesquiteer* westerns
John Wayne made for Republic
Studios from 1938 to 1939.

ABOVE John Wayne and Paulette
Goddard in Cecil B. DeMille's
Reap The Wild Wind (1942).

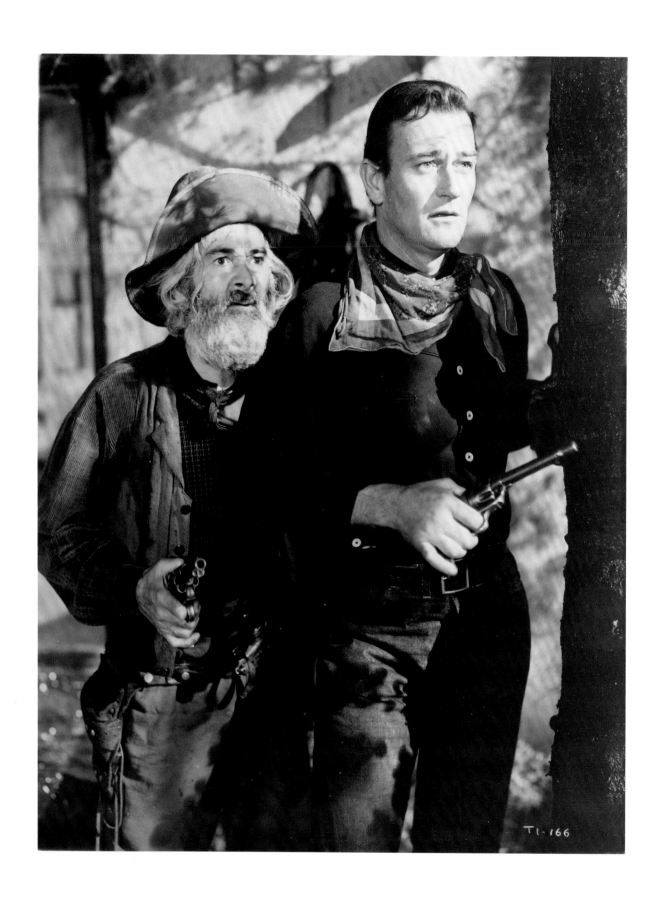

TI-166

ABOVE John Wayne and legendary character actor George "Gabby" Hayes in *Tall in the Saddle* (1944).

OPPOSITE PAGE John Wayne as Quirt Evans in *Angel and the Badman* (1947).

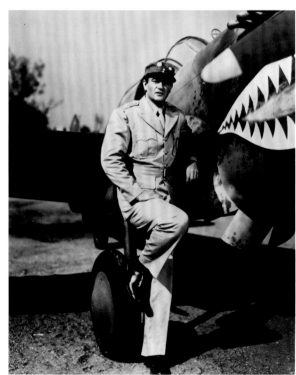

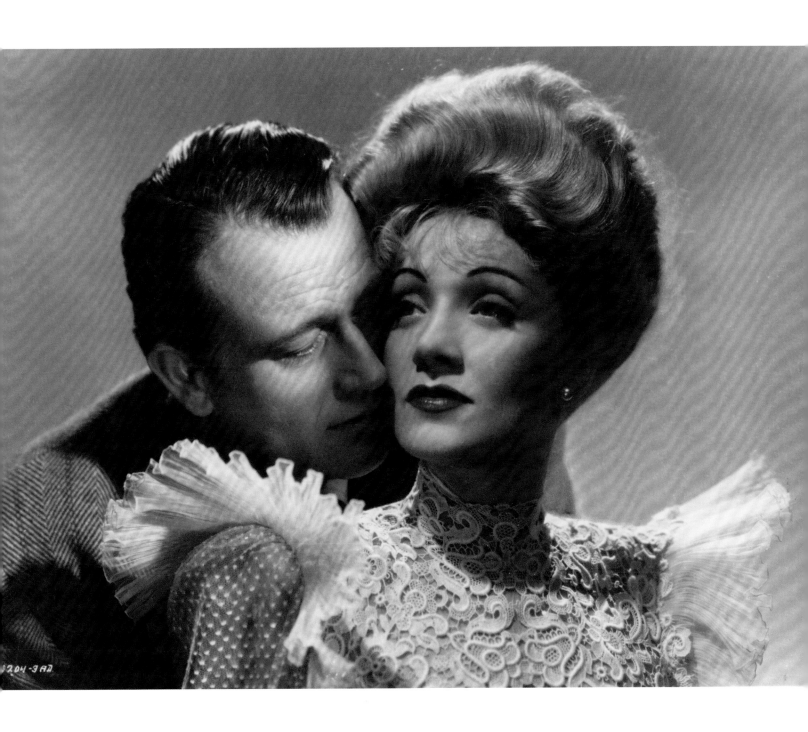

OPPOSITE PAGE John Wayne in his first WWII film, *Flying Tigers* (1942), starring as a mercenary fighter pilot in a rogue unit battling the Japanese prior to U.S. entry into the war.

ABOVE John Wayne and Marlene Dietrich were paired in three Universal films, *Seven Sinners* (1940), *Pittsburgh* (1942), and *The Spoilers* (1942).

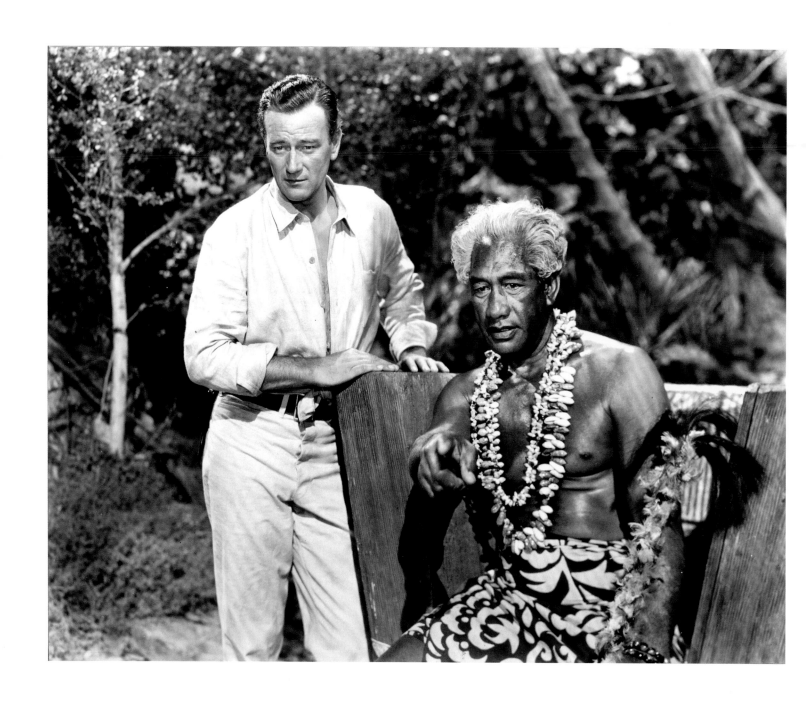

ABOVE John Wayne and Duke Kahanamoku in *Wake of the Red Witch* (1948). Duke Kahanamoku, considered the father of surfing and five-time Olympic medalist in swimming, and John Wayne were also friends off-screen and shared a common love of the ocean.

OPPOSITE PAGE John Wayne on the set of *Flying Tigers* (1942).

"Courage is being scared to death but saddling up anyway."

John Wayne

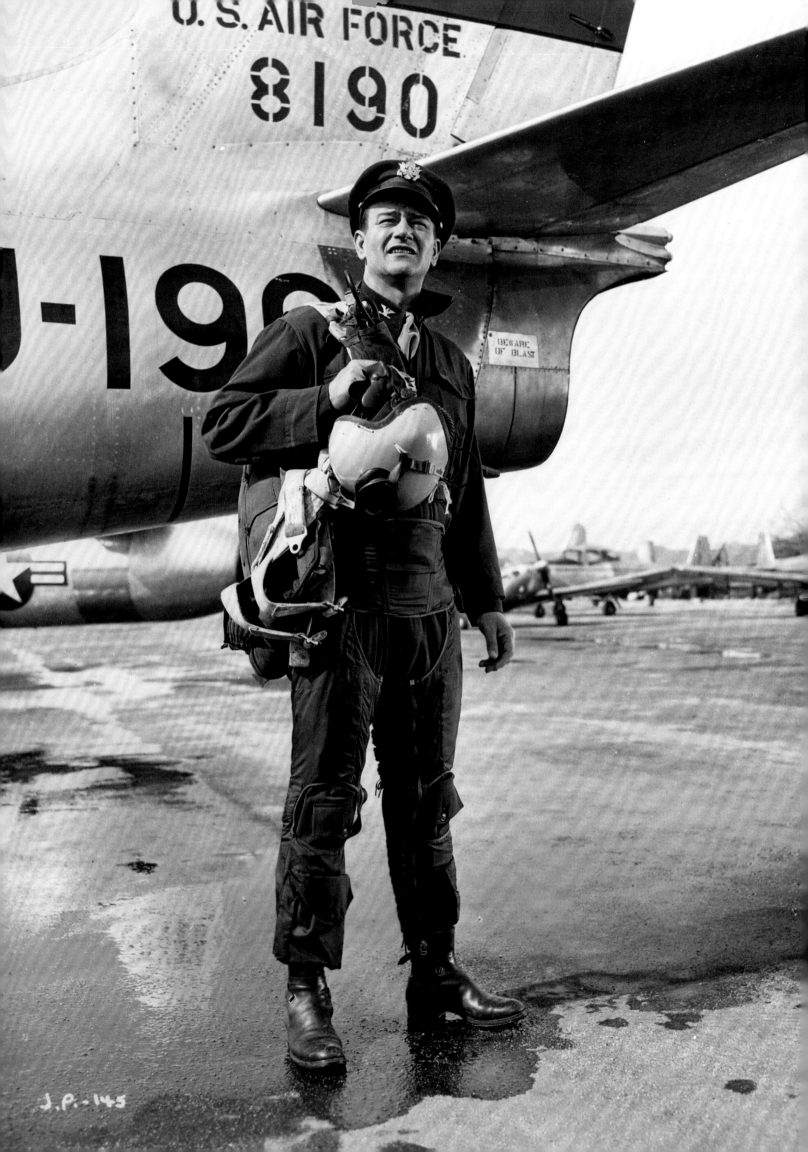

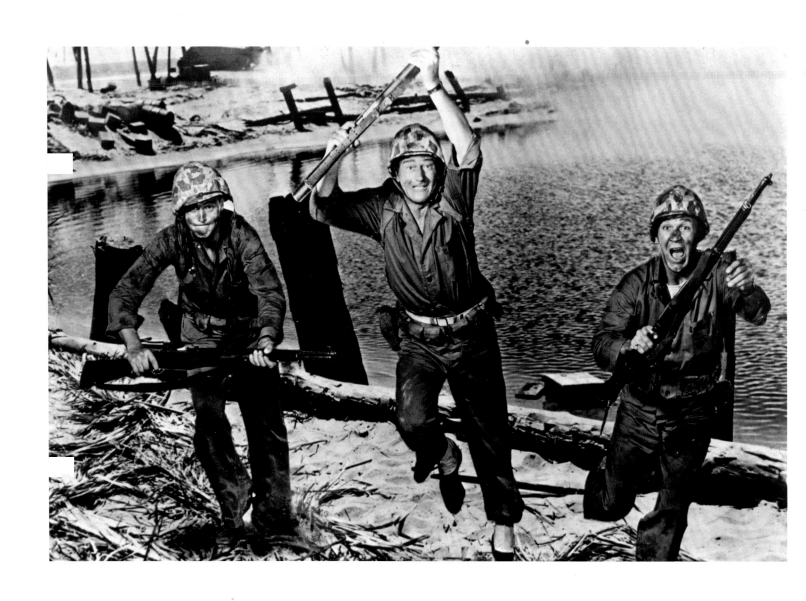

ABOVE AND OPPOSITE PAGE
John Wayne's portrayal of
Sergeant John M. Stryker in
the Marine combat film *Sands
of Iwo Jima* (1949) earned him
his first nomination from the
Academy for Best Actor in a
Leading Role.

64

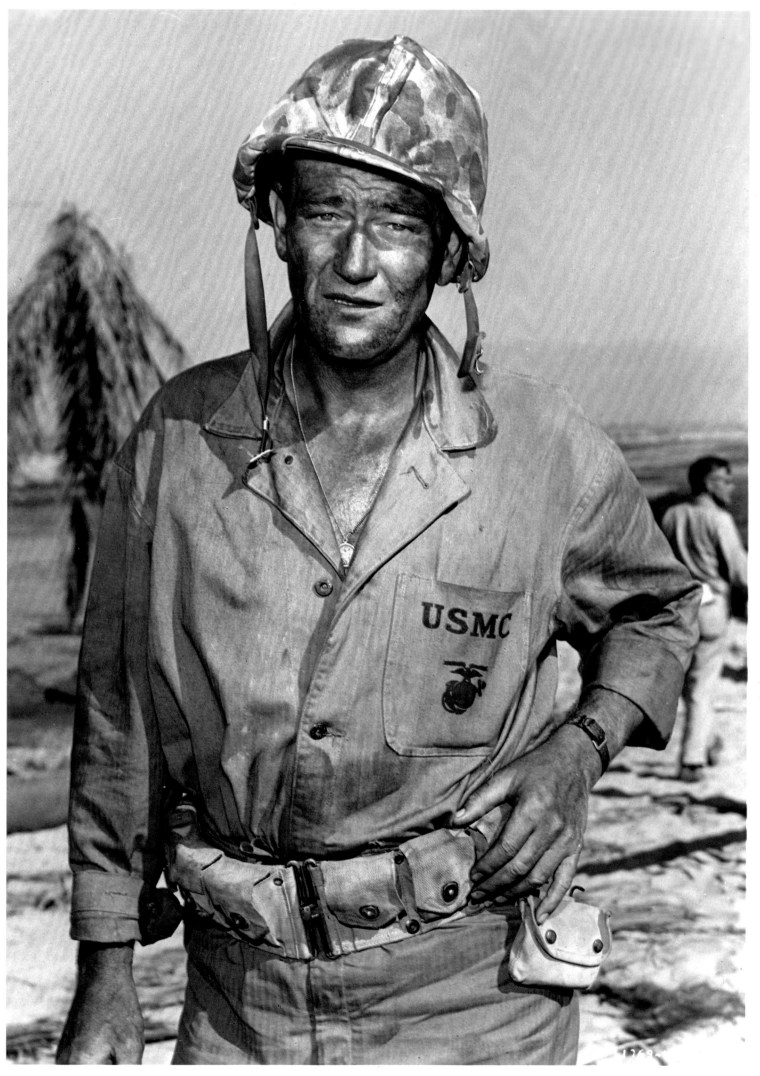

65

He talks rough, he

acts tough, but he plays

croquet as good as poker.

Wayne's the kind of guy

you'd walk a mile for.

by TOM CARLILE

Esperanza (he calls her Chata) and John rewind some film he shot in Mexico. He's producing a bullfight picture there for Republic, and is currently in MGM's *Jet Pilot*.

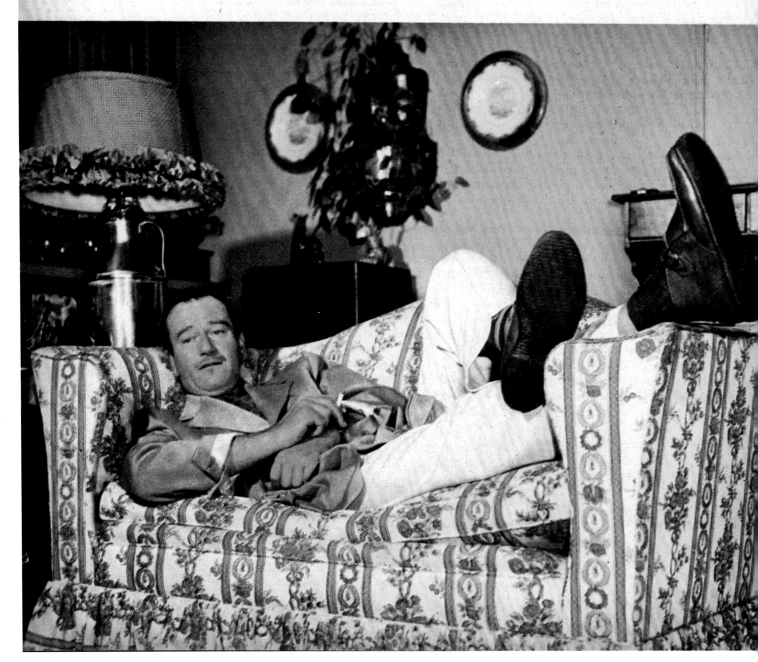

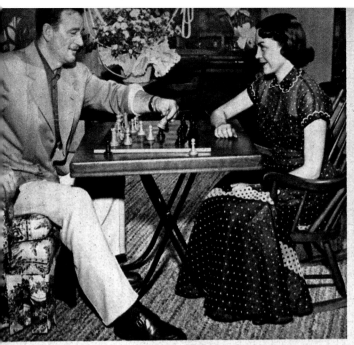

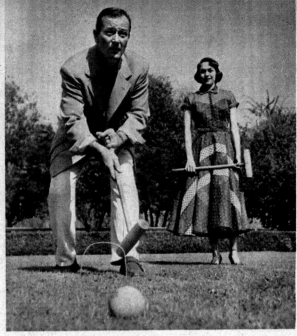

Since their marriage in 1945, Duke's become a home guy, leads a quiet life with Chata in their San Fernando home. (He's expert at chess.)

Duke was discovered by director John Ford in 1927. He's now at work on his 145th role and signed for the next three years.

wonderful lug

■ When John Wayne, otherwise known as Duke, came to Hollywood, there were few who would call him polished, and fewer still who would call him an actor. He sat a horse well, he looked good in leather pants, but he delivered lines like a Western Union messenger.

People thought of him as a slam-bang roughneck who liked to fight, use colorful language and sit up all night playing poker. He did—all three. But at heart, he was a gentleman, and this is what people never knew.

Duke took a lot of ragging in those early days. Once, when he'd begun to get leading man roles, he was assigned to play a suave, young society lawyer. This wasn't exactly up his alley, but it was headed straight for his wallet, so he made the best of it.

The first day, he forced himself into a tuxedo and patent leather pumps and tried looking nonchalant. Every time he stepped out of camera range he'd tug at his collar and make faces.

The director who went with the movie wasn't very democratic. He'd obviously been born with a black tie in his mouth and scorned those who weren't as fortunate. "Too (Continued on page 71)

He likes to deep-sea fish, used to go deer hunting. Lately he enjoys milder pleasures—like all-night poker, croquet with Chata.

31

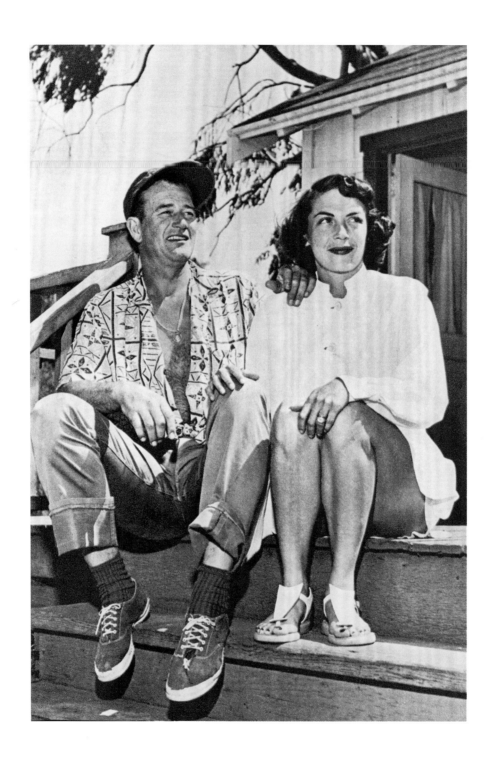

PREVIOUS SPREAD John Wayne
and second wife, Esperanza
"Chata" Baur (née Diaz
Ceballos) in a pop magazine
article from the 40s.

ABOVE John Wayne with
his second wife Esperanza
"Chata" Bauer; they married
in 1946 and divorced in 1954.

ABOVE John Wayne
relaxing at home in the San
Fernando Valley.

69

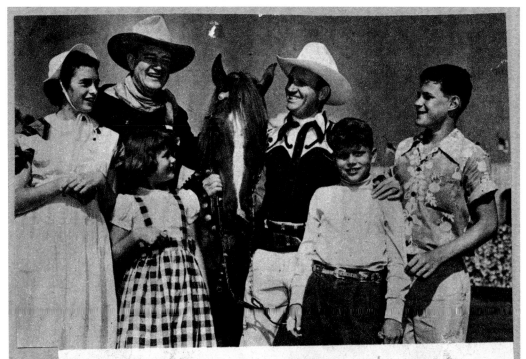

His Children . . . Duke adores the four youngsters of his first marriage—Toni, Melinda, Patrick and Michael—and the feeling's mutual! He loves to have them visit on-set, give 'em thrill of introduction to stars like Autry. Kids made movie debut in bit parts in *The Quiet Man*. Duke curbs tendency to be over-indulgent, believes children should learn to be independent, lets 'em earn money for extras by doing chores. Mike's saving money for first car by washing windows in hotel Dad owns!

LEFT Newspaper photo of Duke's children Toni, Melinda, Patrick, and Michael turning out to watch their father act as Grand Marshal for Gene Autry's Rodeo in the L.A. Coliseum.

BELOW AND BOTTOM LEFT Newspaper photographs of John Wayne and actor son Patrick in Utah filming *Rio Grande* (1950).

OPPOSITE PAGE John Wayne and son Patrick on location in Utah for *Rio Grande* (1950). Patrick had a bit part in the third installment of John Ford's "cavalry trilogy."

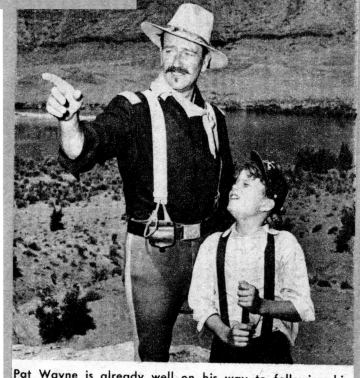

Pat Wayne is already well on his way to following his father's example with a movie career of his own. Above: Pat visited dad in 1950, wore costume for fun.

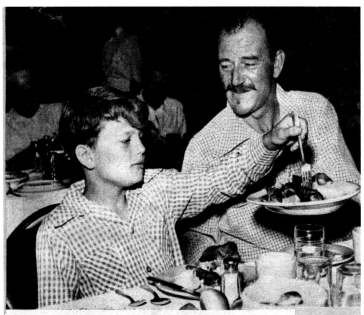

Son Pat gets a taste of his dad's wild screen life—he has a bit part in "Rio Grande," filmed in Utah

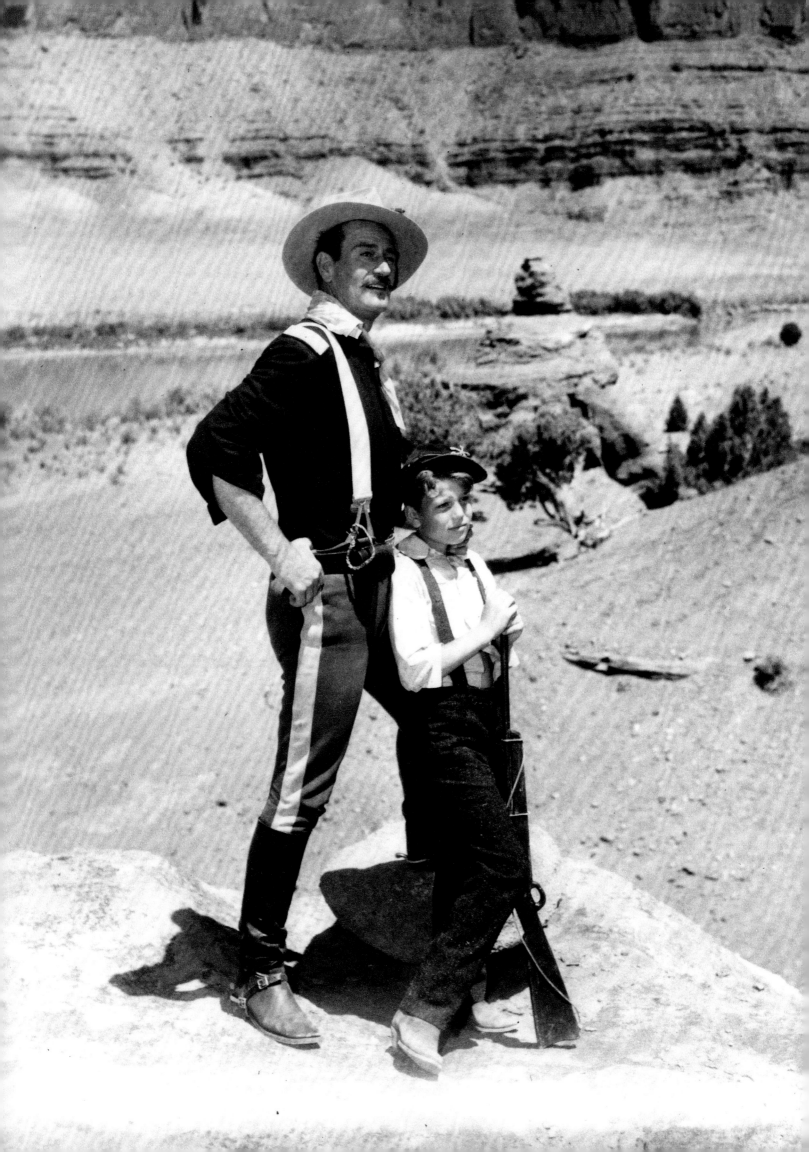

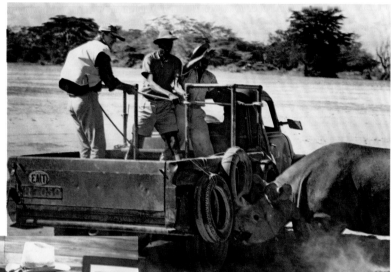
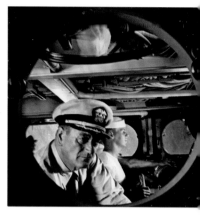

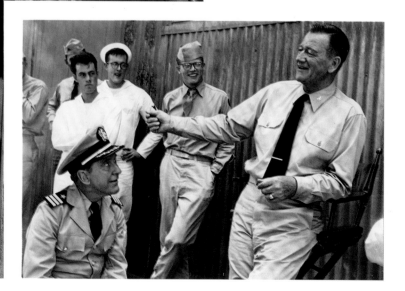

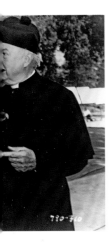

RIGHT John Wayne, with co-star Nancy Olson, on the set of *Big Jim McLain* (1952) filmed in Hawaii.

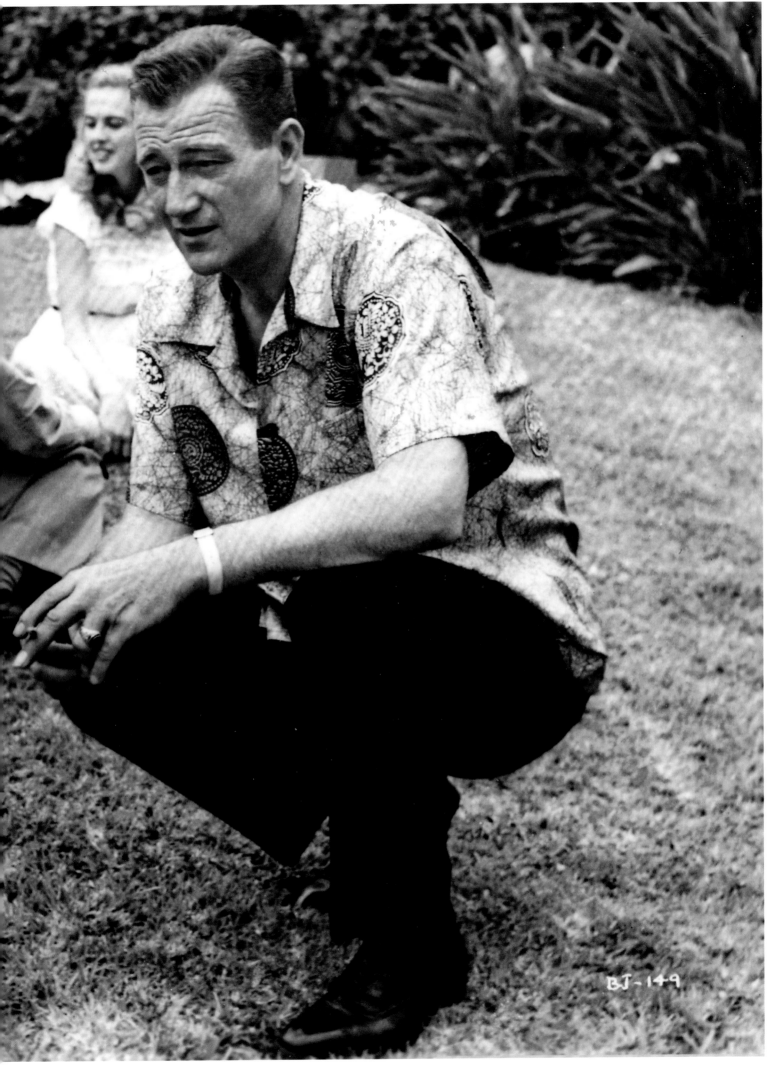

BJ-149

February 1954

TELEGRAM 11:00 A.M.

MR. JOHN FORD
U.S. THAYER HOTEL
WEST POINT, N. Y.

DEAR COACH:

THIS IS AN IMPORTANT DATE IN MY LIFE BECAUSE I'M MORE
OF A MAN FOR KNOWING A FELLOW WHO WAS BORN ON IT.
HAPPY BIRTHDAY,

DUKE

DELIVERY OF ABOVE WIRE VERIFIED AS OF 3:00 P.M. EST

ABOVE John Wayne's lifelong friendship with director John Ford is well known and widely documented; he often called Ford "Coach" or "Pappy."

OPPOSITE PAGE John Wayne between dressing room doors while filming with director John Ford.

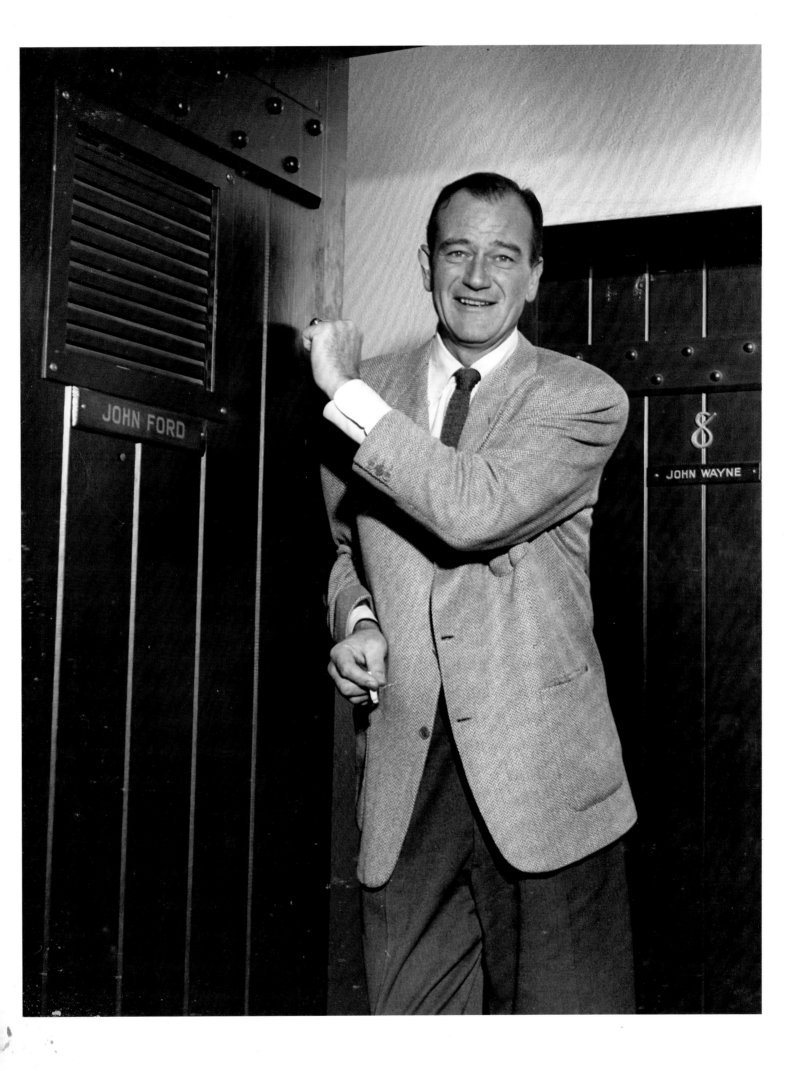

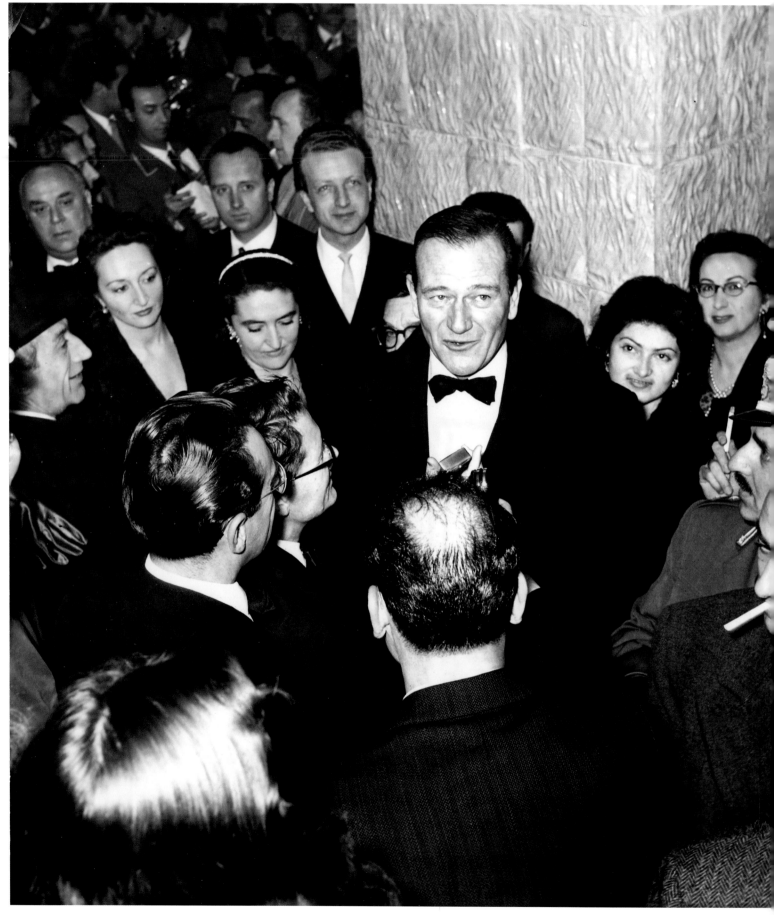

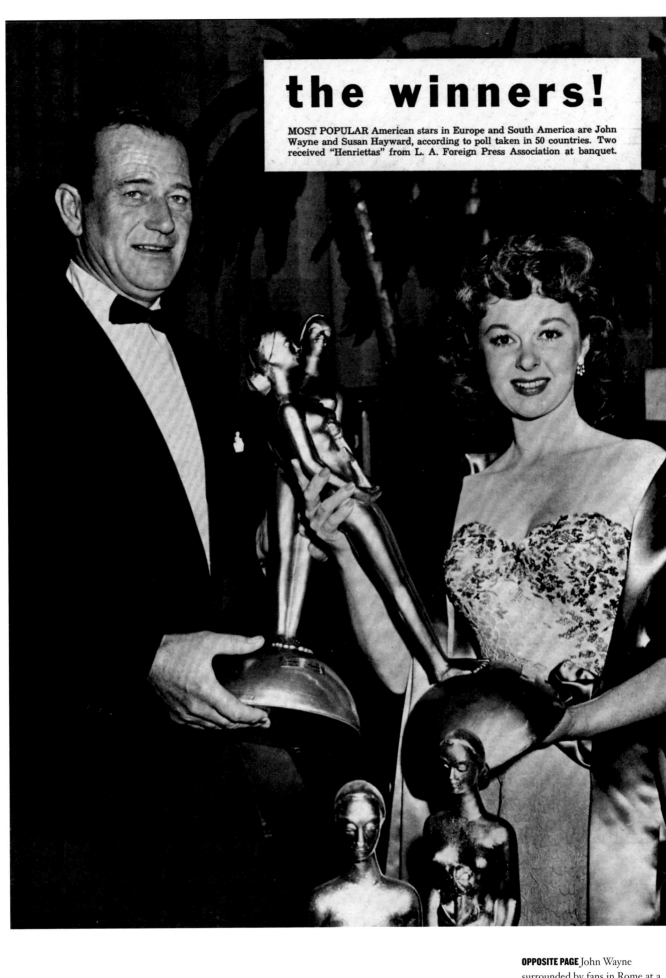

the winners!

MOST POPULAR American stars in Europe and South America are John Wayne and Susan Hayward, according to poll taken in 50 countries. Two received "Henriettas" from L. A. Foreign Press Association at banquet.

OPPOSITE PAGE John Wayne surrounded by fans in Rome at a Gala at the Sistina Theatre.

ABOVE John Wayne and Susan Hayward posing with their awards from the L.A. Foreign Press Association, in 1952, precursor to today's Golden Globes.

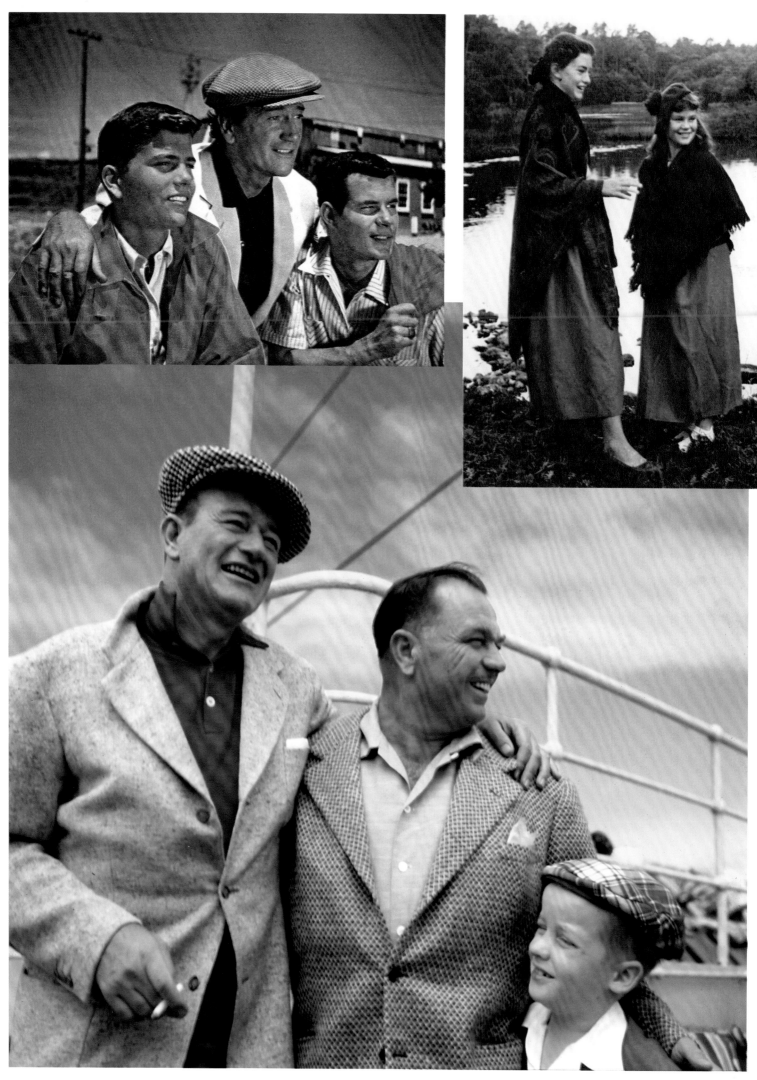

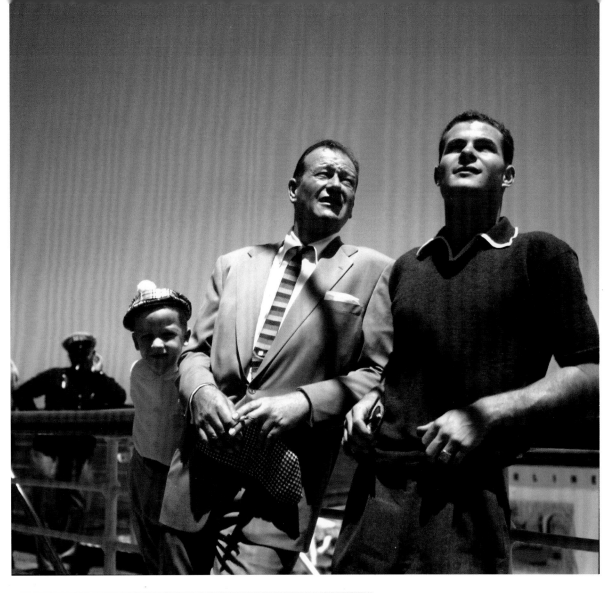

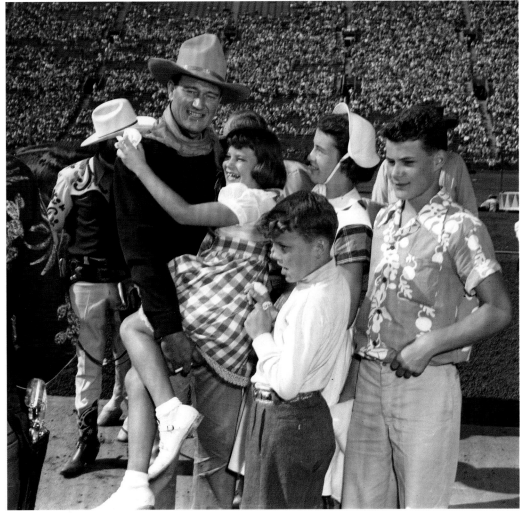

OPPOSITE PAGE, ABOVE LEFT Duke with sons Patrick and Michael.

OPPOSITE PAGE, ABOVE RIGHT Toni and Melinda Wayne as extras on location in Ireland filming *The Quiet Man* (1952).

OPPOSITE PAGE, BELOW John Wayne on a passenger cruise ship with his business manager, Bo Roos and his son Bo Roos, Jr.

ABOVE Wayne with his oldest son Michael and Bo Roos, Jr.

LEFT Wayne with his kids (Melinda, Patrick, Toni, and Michael) at Gene Autry's Rodeo at the L.A. Coliseum.

"I want to play a real man in all my films,
and I define manhood simply: men should
be tough, fair, and courageous; never petty,
never looking for a fight, but never backing
down from one either."

John Wayne

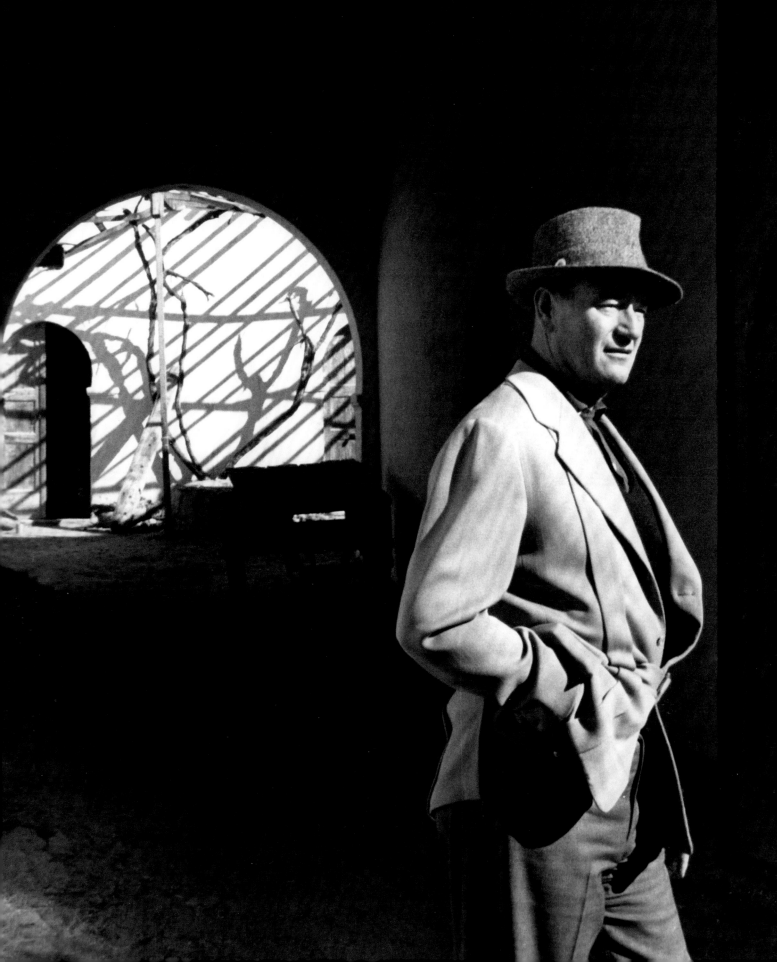

"Goddamn, I'm the stuff men are made of!"

John Wayne

OPPOSITE PAGE
John Wayne in *Hondo* (1953).

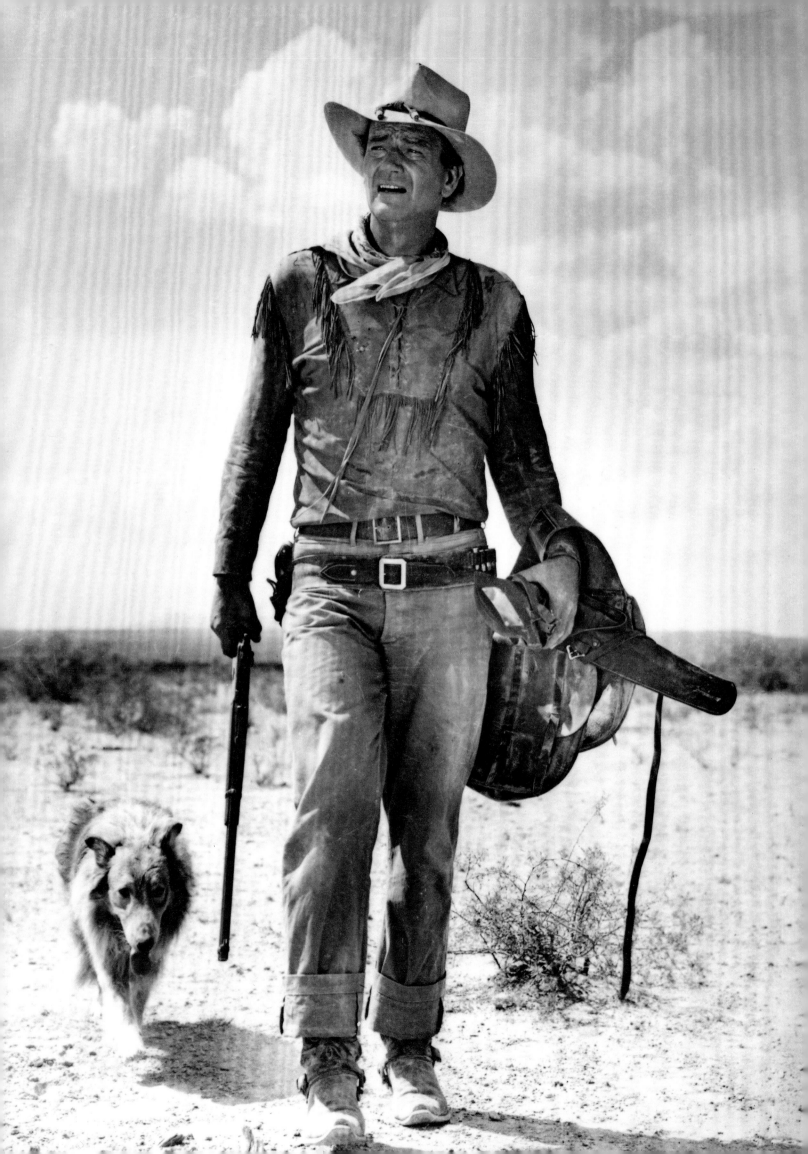

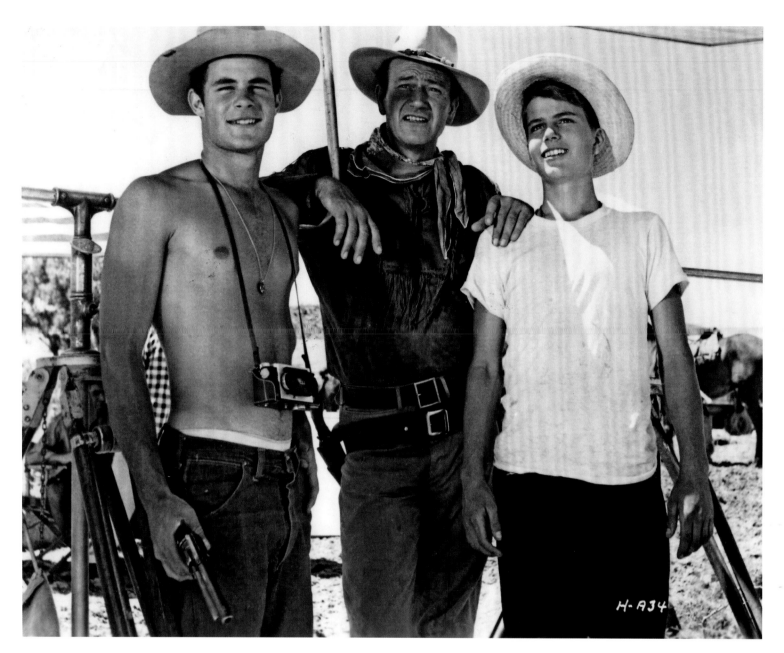

ABOVE John Wayne's sons Michael and Patrick with their father on the set of *Hondo* (1953).

LEFT John Wayne and Mexican character actor Rodolfo Acosta in *Hondo* (1953).

OPPOSITE PAGE John Wayne as Ethan Edwards in *The Searchers* (1956).

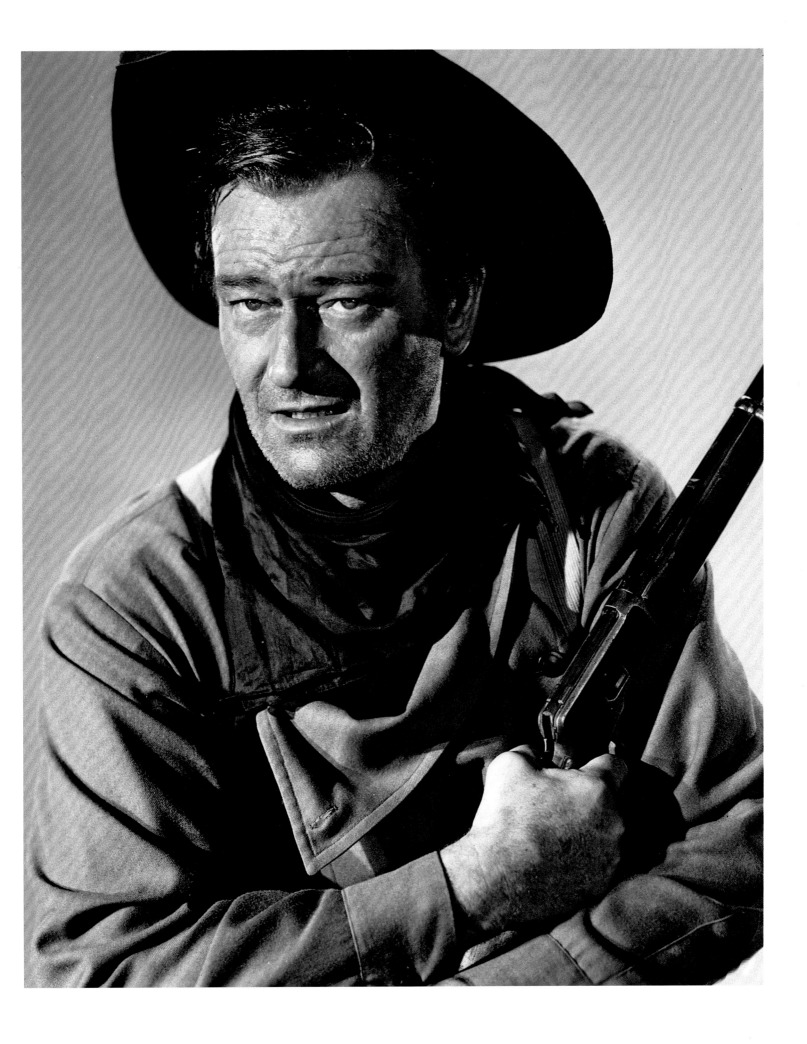

"When I was starting out, I did a lot of quickie westerns and serials. You learn so much: how to handle yourself before the camera, how to ride, do stunts. Plus you'll get a tremendous audience of people who will know who you are."

John Wayne to James Arness
on auditioning for the role of Matt Dillon in Gunsmoke

OPPOSITE PAGE Magazine interview with James Arness on working with John Wayne on the set of *Hondo* (1953).

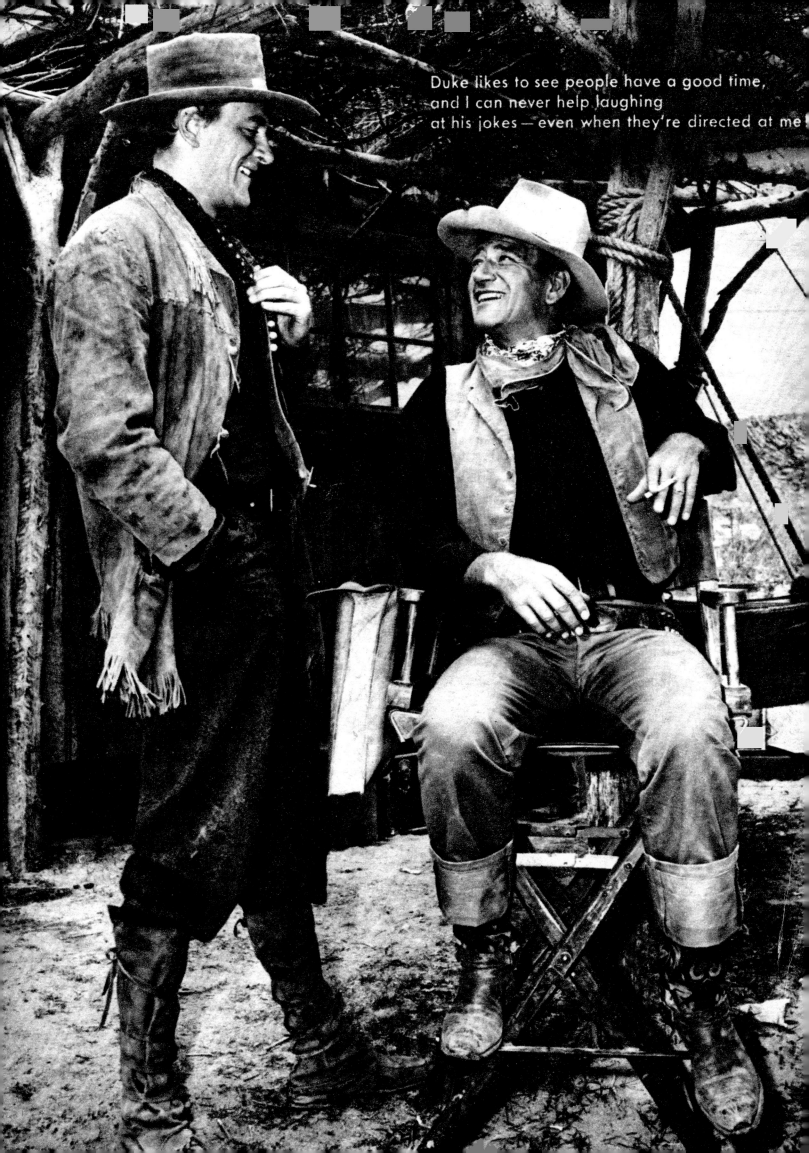

Duke likes to see people have a good time, and I can never help laughing at his jokes — even when they're directed at me!

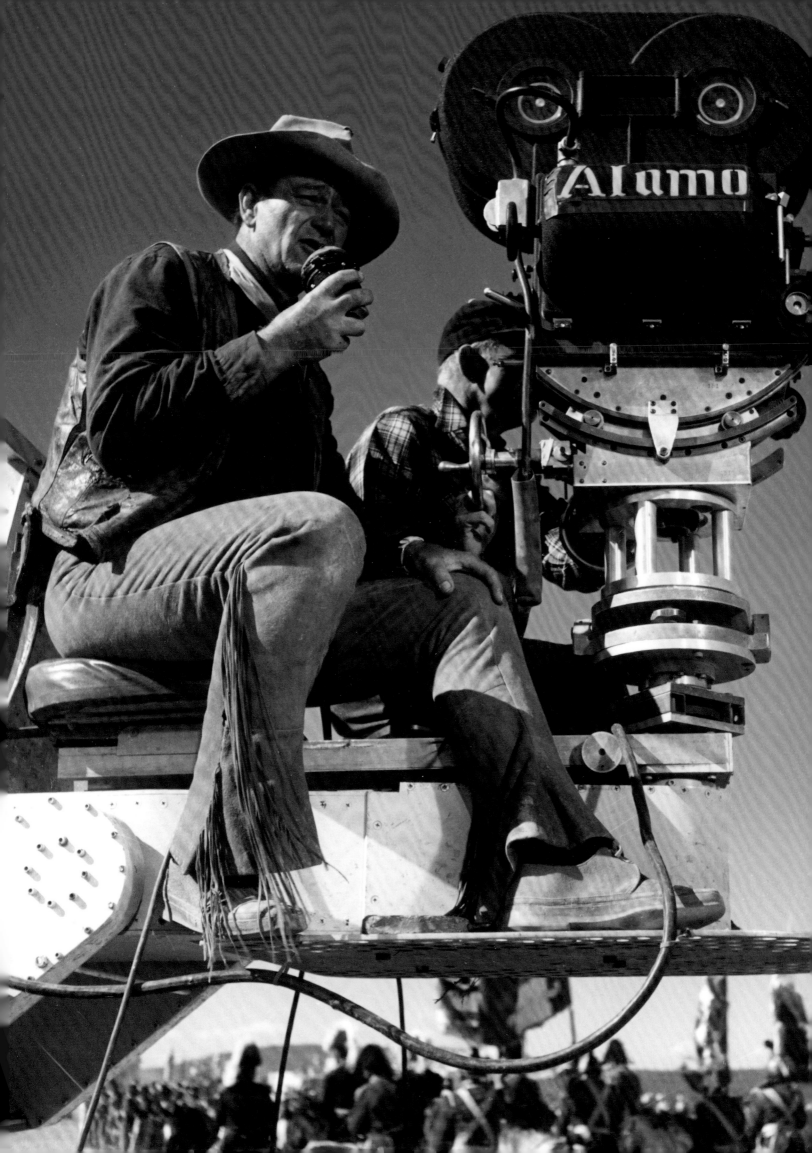

LEFT Wayne directed, produced, and starred in his lifelong dream project *The Alamo* (1960). The film's production cost exceeded ten million dollars, then the most expensive film ever made in the United States.

RIGHT *The Alamo* (1960) was
nominated for seven Academy
Awards including Best
Picture. It won one Oscar,
for Best Sound.

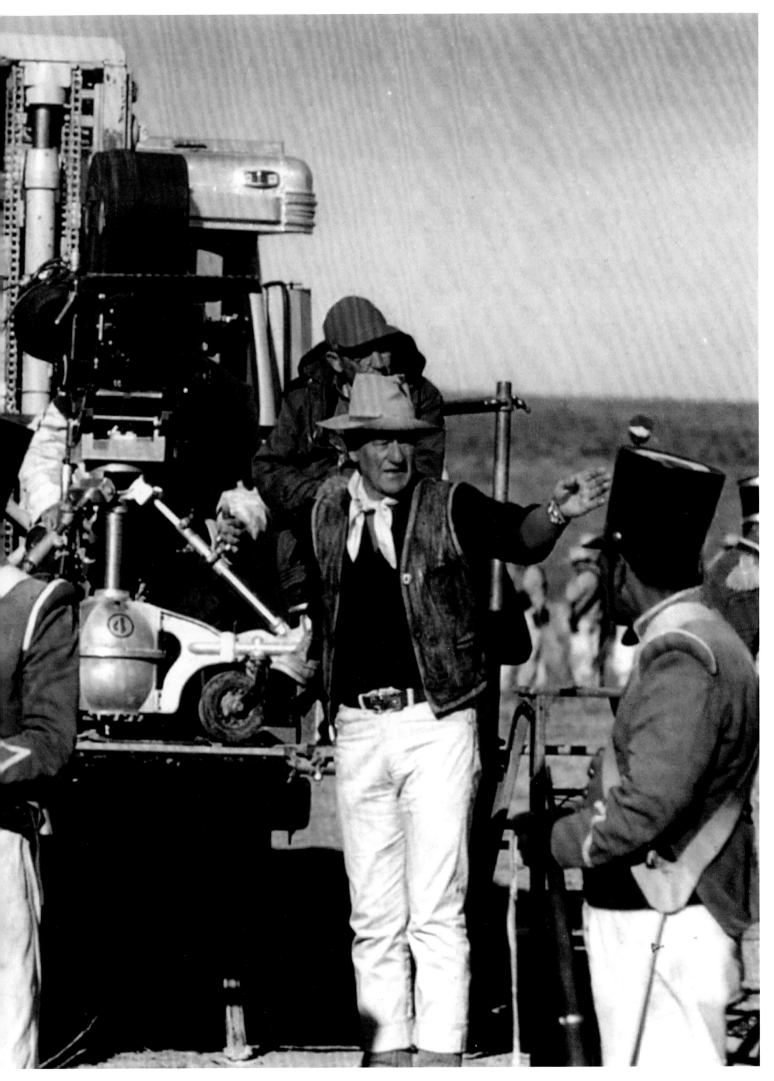

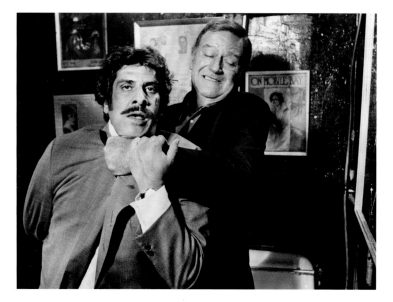

JOHN WAYNE
&
THE COWBOYS "A"
A MARK RYDELL FILM
JOHN WAYNE in A Mark Rydell Film "THE COWBOYS"
Panavision · · Technicolor ·
From Warner Bros. A Warner Communications Company

JOHN WAYNE
&
THE COWBOYS "A"
A MARK RYDELL FILM
JOHN WAYNE in A Mark Rydell Film "THE COWBOYS"
Panavision · · Technicolor ·
From Warner Bros. A Warner Communications Company

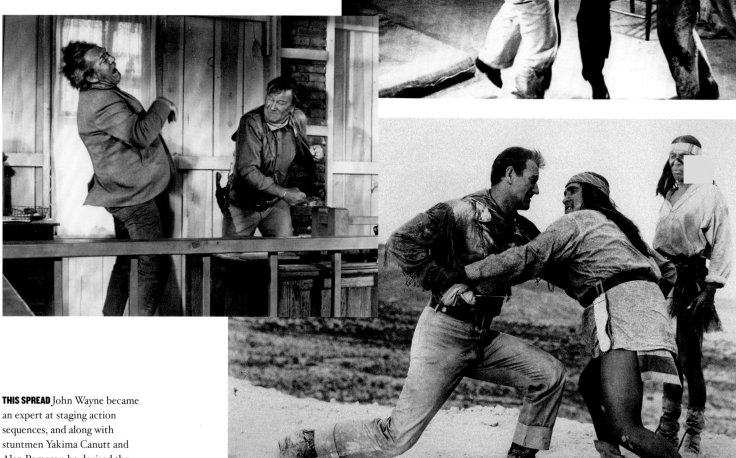

THIS SPREAD John Wayne became
an expert at staging action
sequences, and along with
stuntmen Yakima Canutt and
Alan Pomeroy, he devised the
"pass-blow" system of staging
film fights.

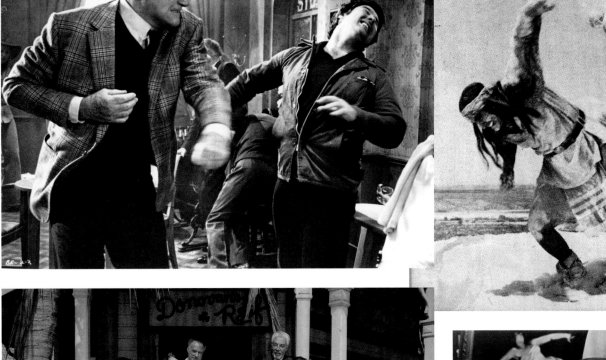

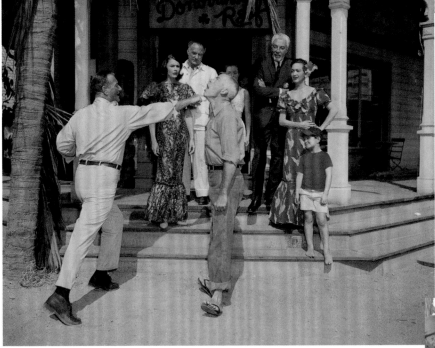

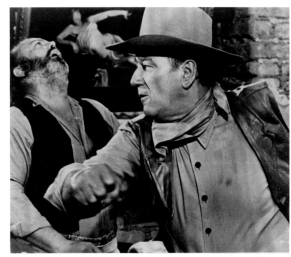

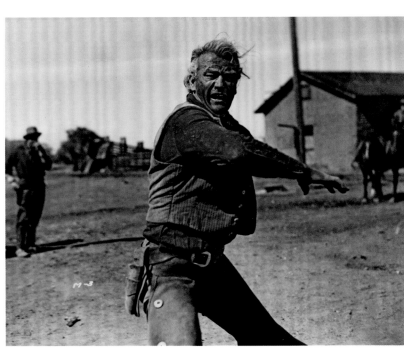

When a man is tall and . . .

handsome and wealthy . . .

he's bound to be popular.

The girl with Waikiki in her eyes!

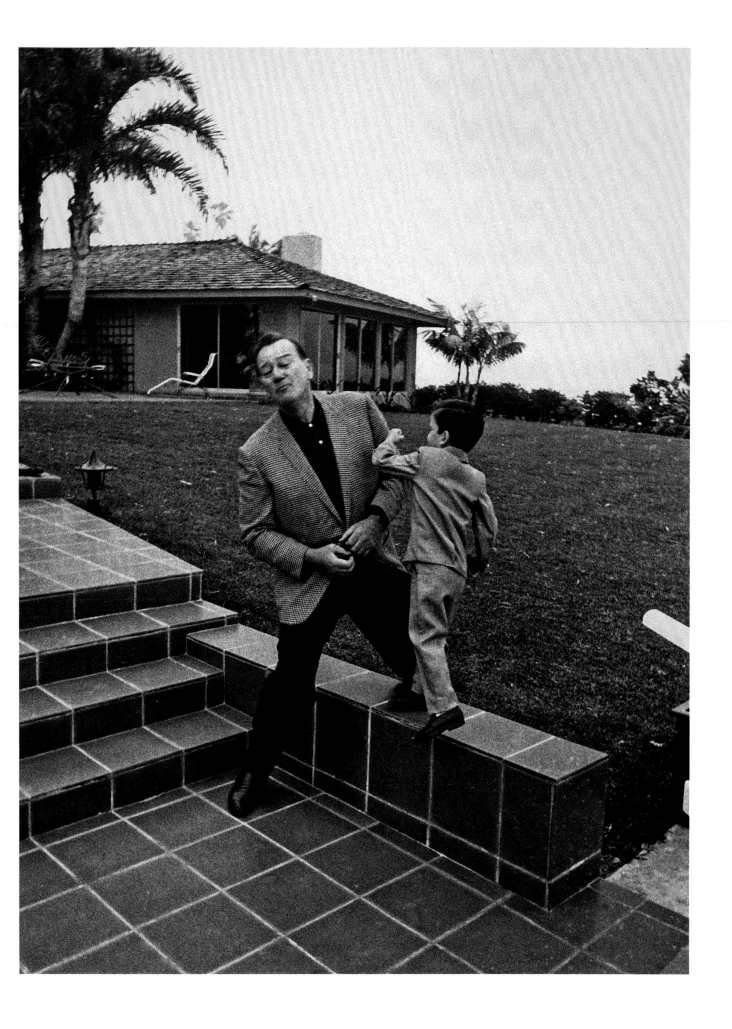

OPPOSITE PAGE A fan scrapbook page containing clippings with Wayne in action, mostly from *Big Jim McLain* (1952).

ABOVE John Wayne and his youngest son Ethan horsing around on the lawn of their bayfront Newport Beach home.

97

RIGHT Candid shot of John
Wayne with adoring fans.

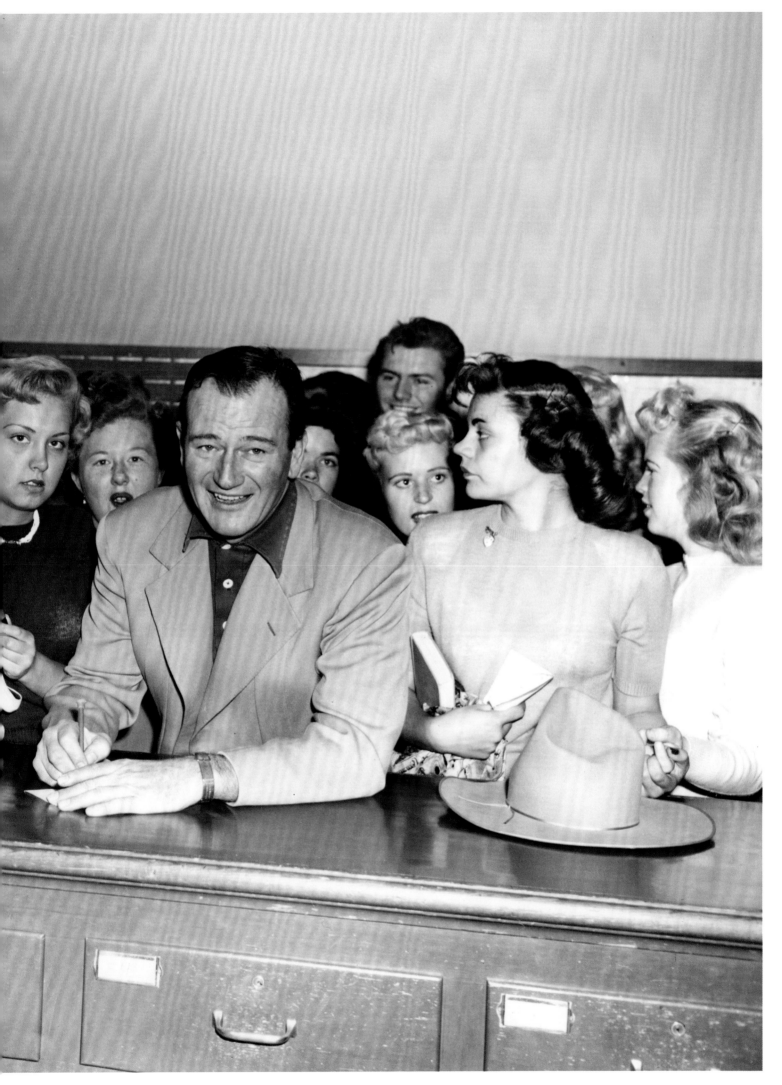

JP-PUB A27

LEFT John Wayne on the set of *Jet Pilot* (1957) with his makeup man, Webb Overlander.

ABOVE John Wayne and legendary surfer Duke Kahanamoku hula in Hawaii.

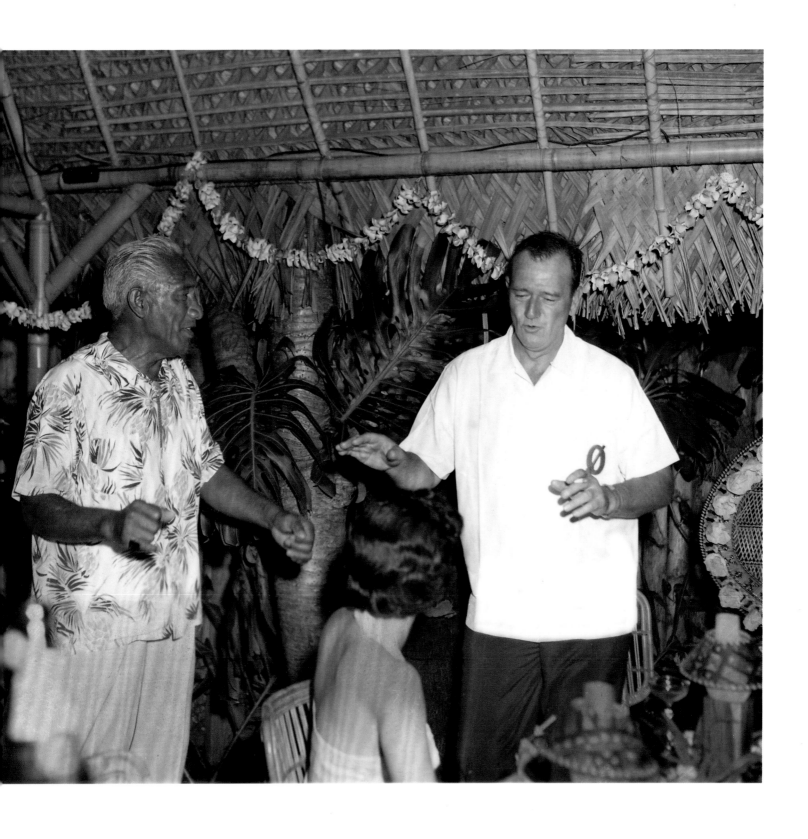

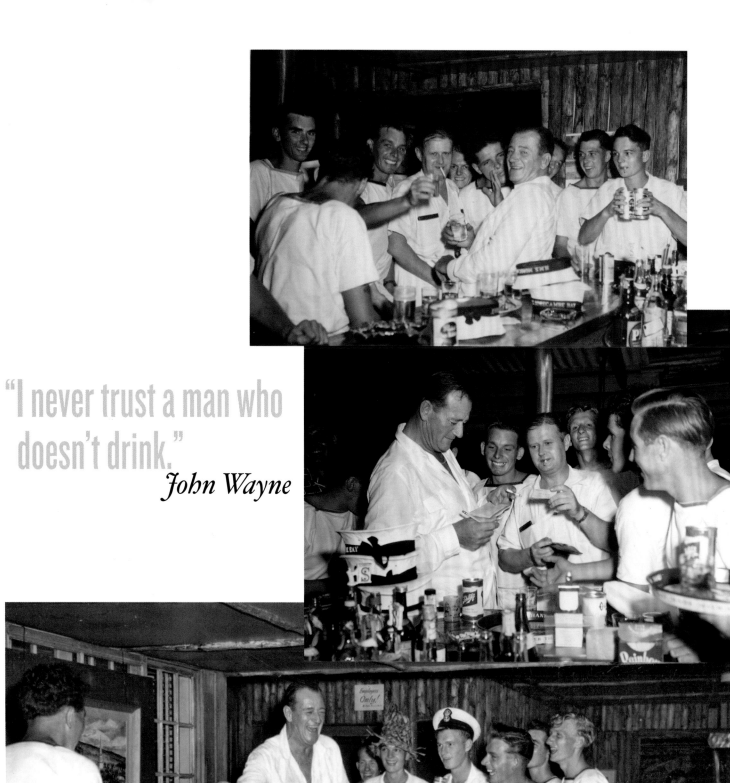

"I never trust a man who doesn't drink."

John Wayne

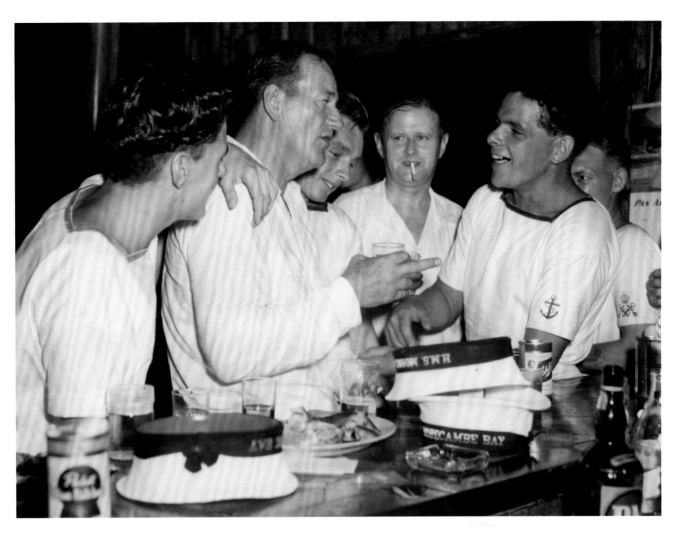

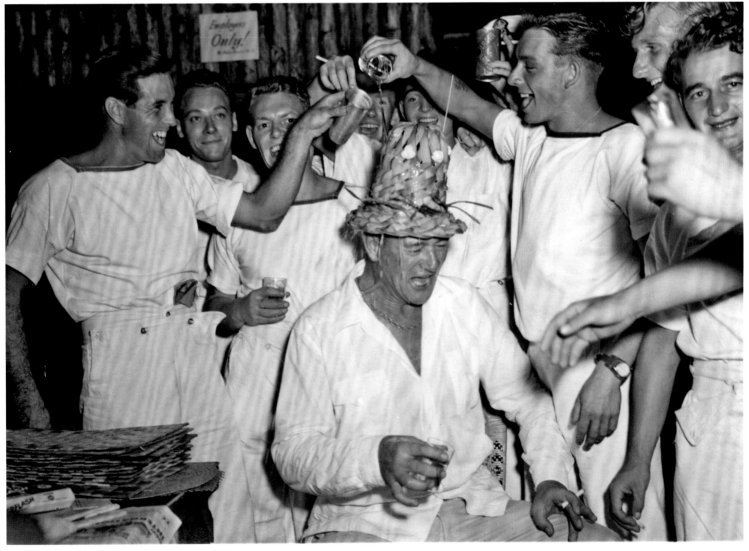

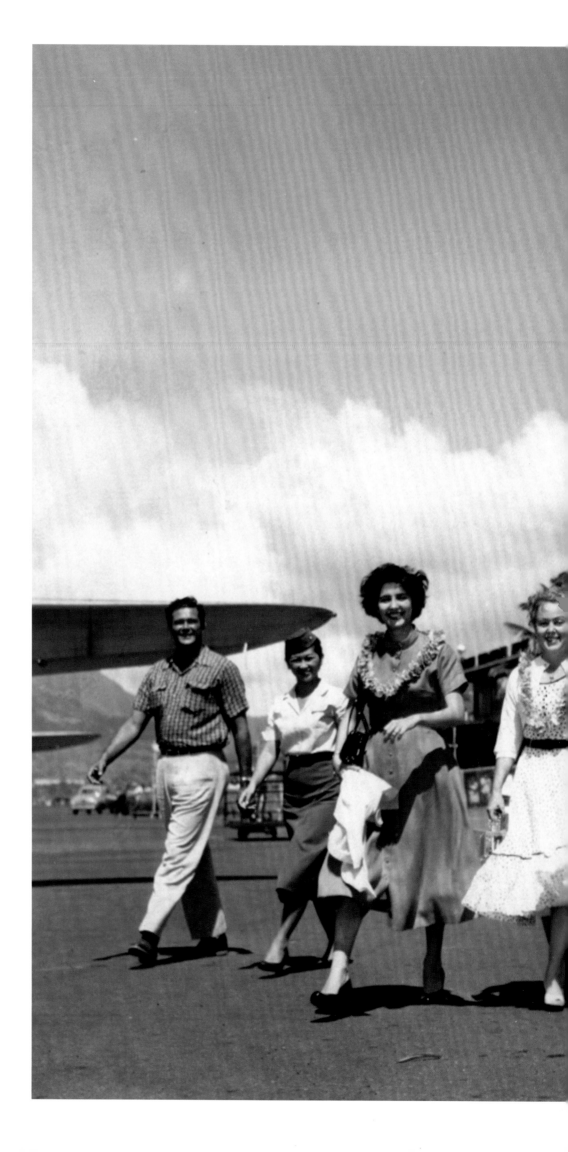

PREVIOUS SPREAD John Wayne partying with a group of young servicemen, on shore leave in Hawaii.

RIGHT John Wayne with family and friends in Hawaii, 1954.

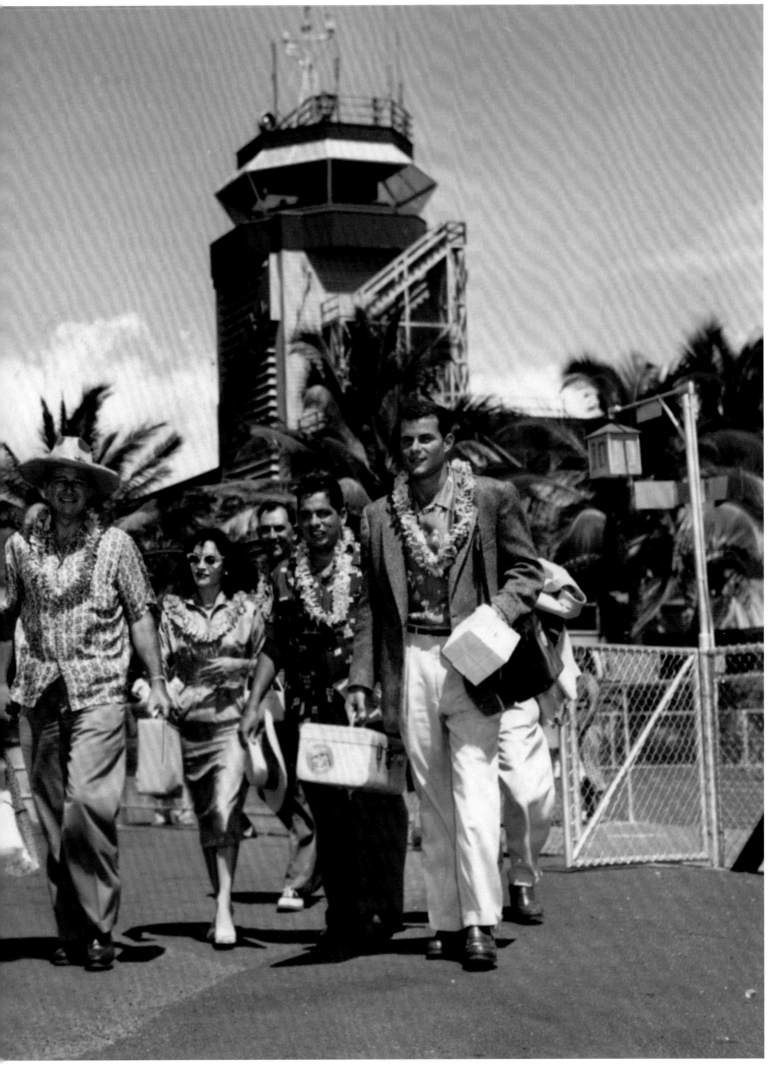

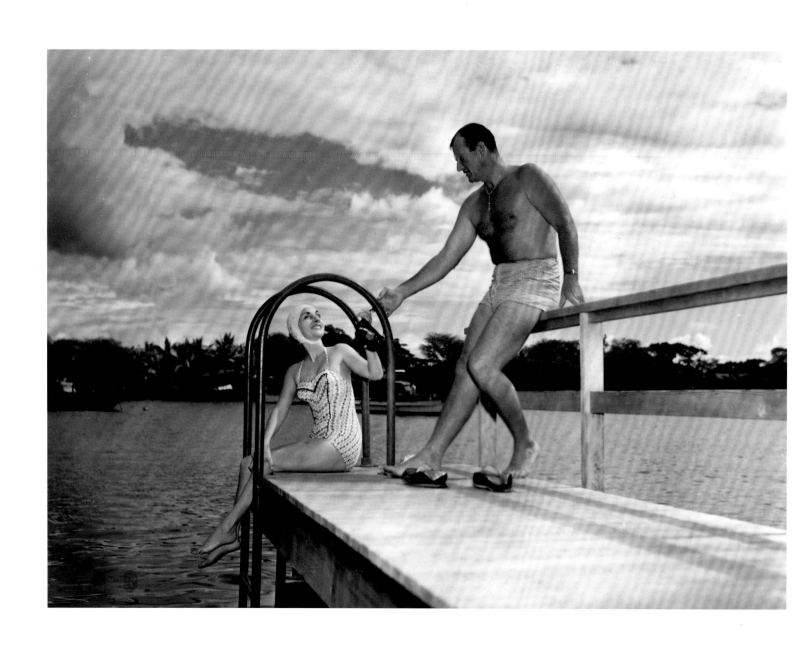

ABOVE Pilar Wayne and Duke in
Hawaii, 1954.

OPPOSITE PAGE Michael Wayne
and Duke in Hawaii, 1954.

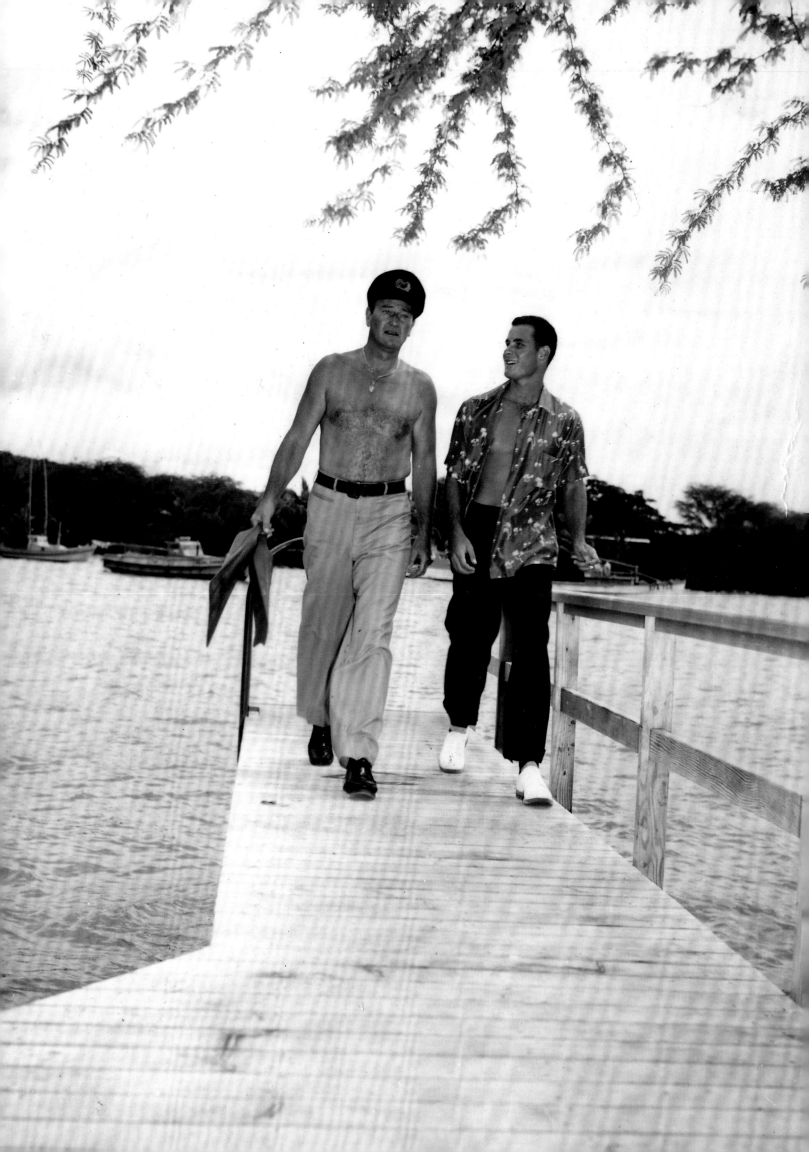

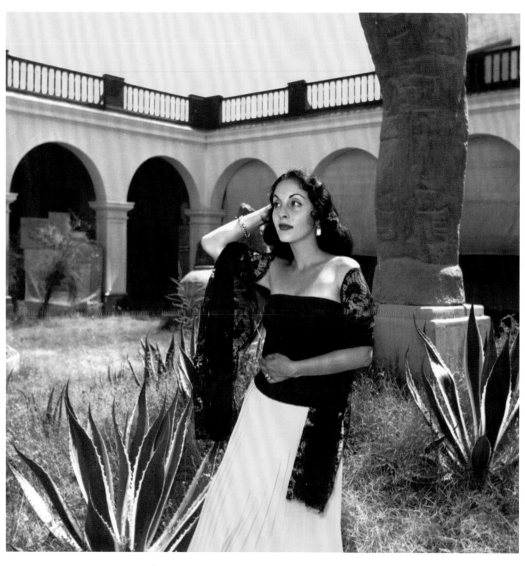

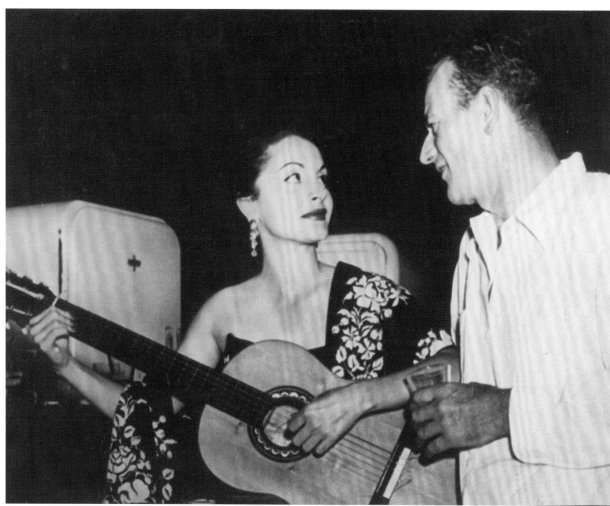

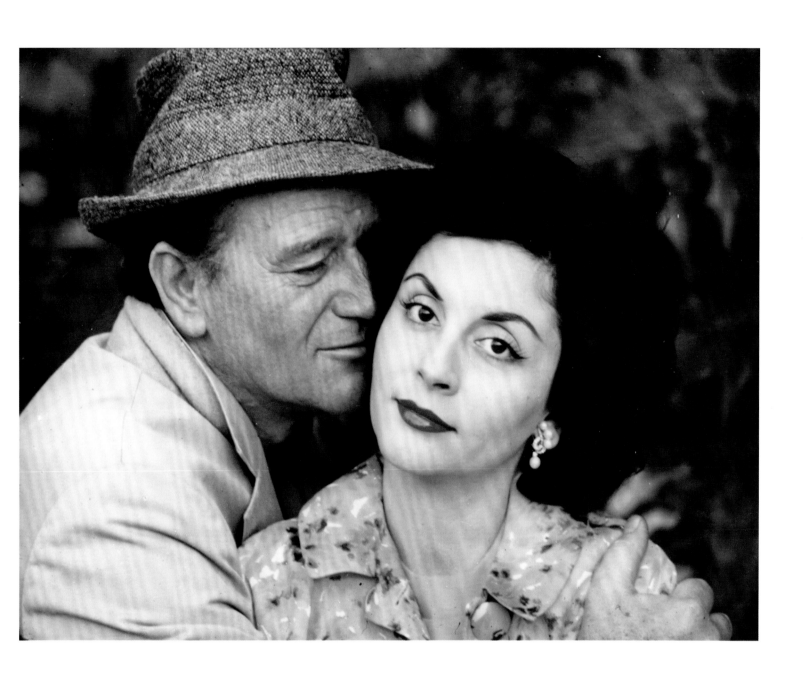

OPPOSITE PAGE, ABOVE Pilar Pallete, the beautiful young Peruvian movie actress, became John Wayne's third wife in 1954.

OPPOSITE PAGE, BELOW John Wayne first met Pilar in 1952 on her film set when Duke made a trip to Tingo Maria, Peru. This photograph was taken the first day they met. When Pilar, an accomplished guitar player, came to California to pursue her career, John Wayne gave her a Martin guitar on their first date.

ABOVE Pilar as Mrs. John Wayne.

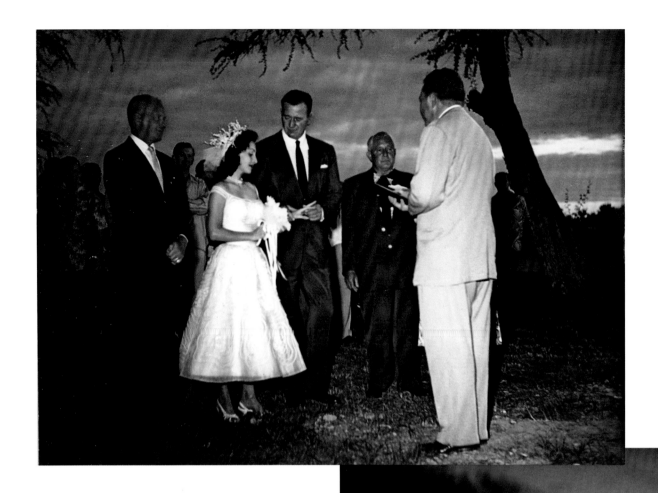

ABOVE AND RIGHT John and Pilar Wayne's wedding in Hawaii on November 1, 1954, at the summer home of Territorial Senator William H. Hill—once home of Hawaiian King Kamehameha III—on Hawaii's Kona Coast, where John Wayne had been living while filming *The Sea Chase* (1955).

OPPOSITE PAGE Pilar and Duke arriving in Los Angeles after their wedding in Hawaii.

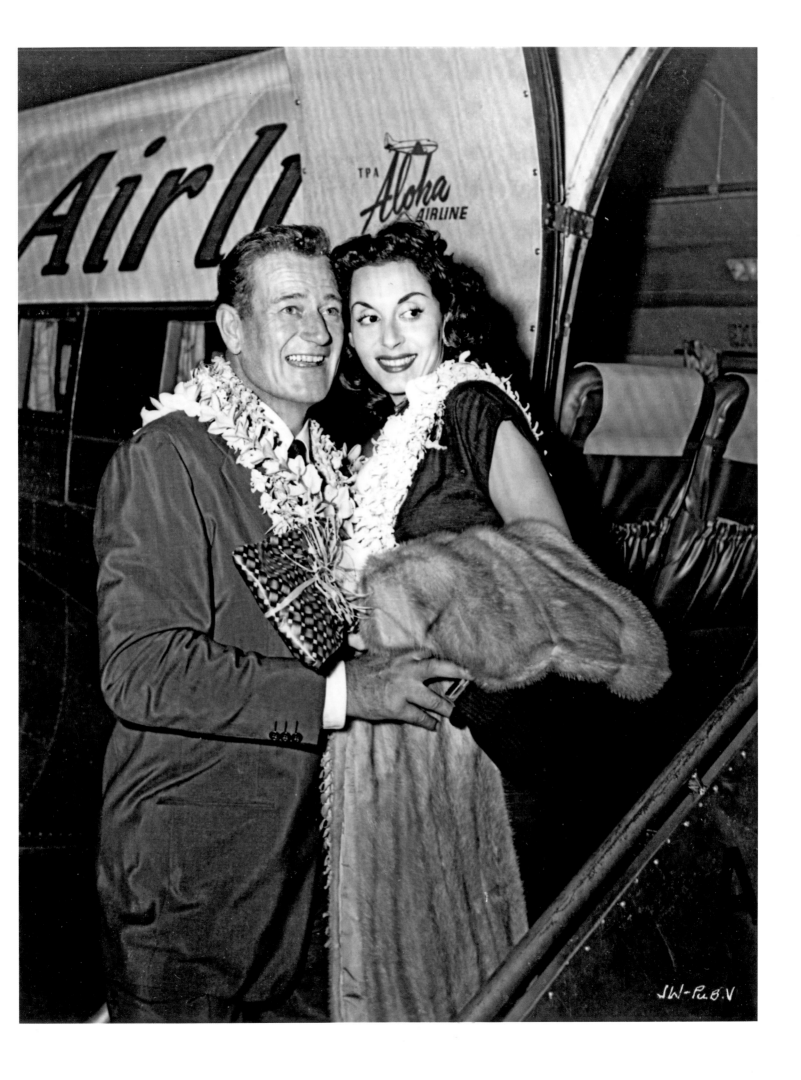

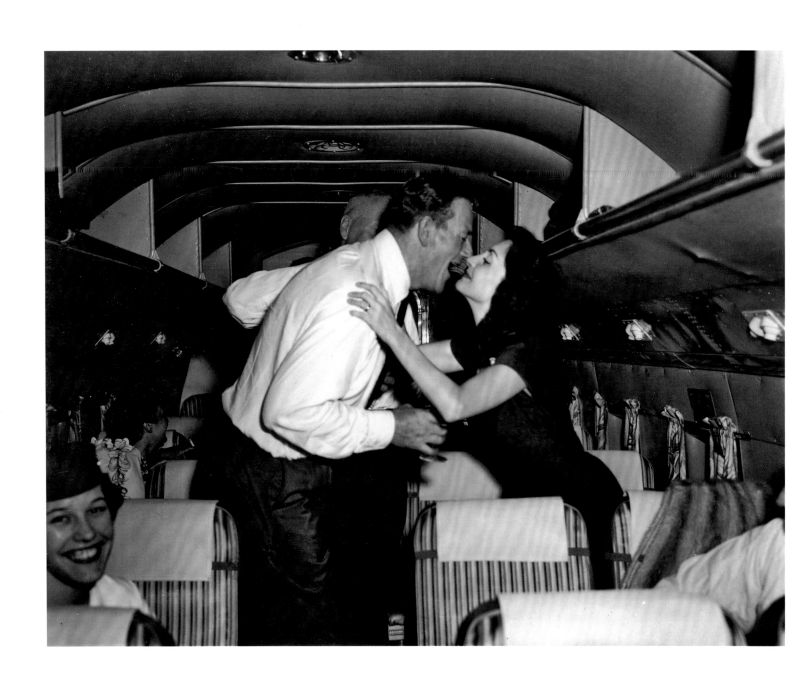

ABOVE Duke ordered ten cases of Champagne for the twenty-minute flight to the Big Island.

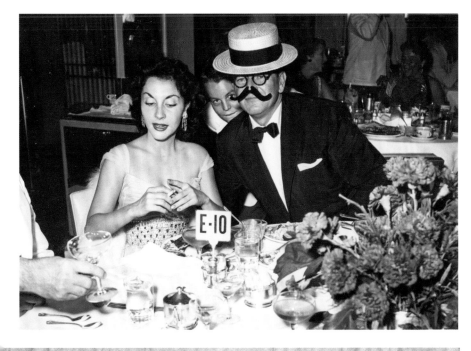

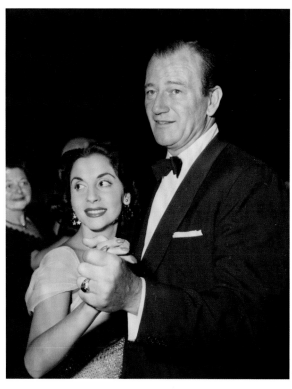

LEFT Pilar and Duke aboard a passenger ship on their way to Hawaii.

BELOW LEFT Pilar and John Wayne in St. George, Utah during the filming of *The Conqueror* (1956).

BELOW RIGHT Pilar and Duke at a Hollywood function.

BOTTOM Pilar and John Wayne on one of their first dates.

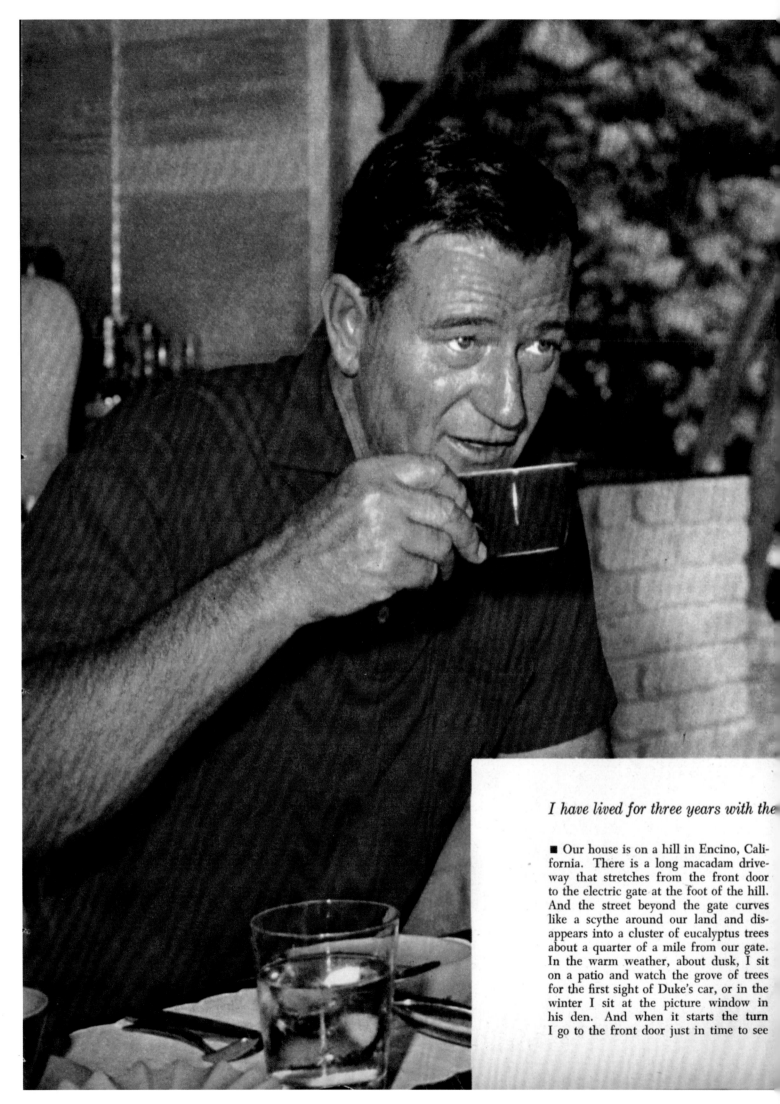

I have lived for three years with the

■ Our house is on a hill in Encino, California. There is a long macadam driveway that stretches from the front door to the electric gate at the foot of the hill. And the street beyond the gate curves like a scythe around our land and disappears into a cluster of eucalyptus trees about a quarter of a mile from our gate. In the warm weather, about dusk, I sit on a patio and watch the grove of trees for the first sight of Duke's car, or in the winter I sit at the picture window in his den. And when it starts the turn I go to the front door just in time to see

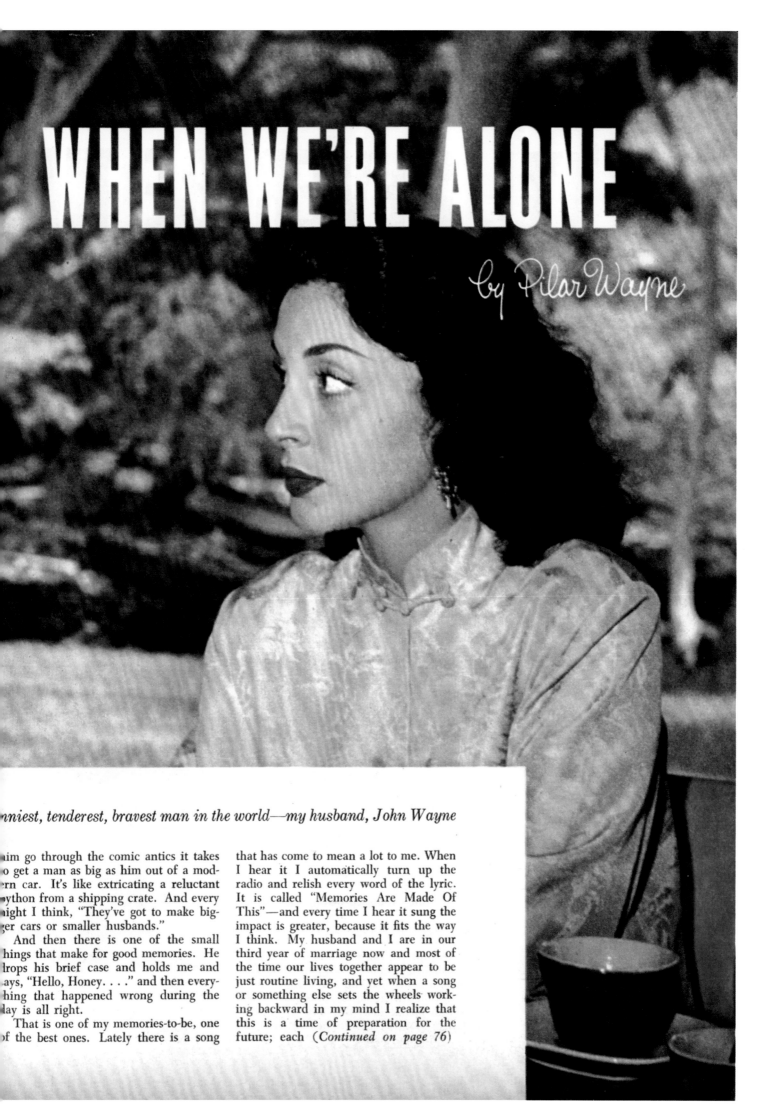

WHEN WE'RE ALONE

by Pilar Wayne

...nniest, tenderest, bravest man in the world—my husband, John Wayne

...im go through the comic antics it takes ...o get a man as big as him out of a mod-...rn car. It's like extricating a reluctant ...ython from a shipping crate. And every ...ight I think, "They've got to make big-...er cars or smaller husbands."

And then there is one of the small ...hings that make for good memories. He ...rops his brief case and holds me and ...ays, "Hello, Honey. . . ." and then every-...hing that happened wrong during the ...ay is all right.

That is one of my memories-to-be, one ...f the best ones. Lately there is a song

that has come to mean a lot to me. When I hear it I automatically turn up the radio and relish every word of the lyric. It is called "Memories Are Made Of This"—and every time I hear it sung the impact is greater, because it fits the way I think. My husband and I are in our third year of marriage now and most of the time our lives together appear to be just routine living, and yet when a song or something else sets the wheels working backward in my mind I realize that this is a time of preparation for the future; each (*Continued on page 76*)

Like the song says, "Where can I go without you?" Like John Wayne says, "Not even to Hawaii." So, like a good girl, Pilar went, too—and married him!

BY JACK WADE

It took fast talking from John to persuade Pilar to leave her house decoration chores and make the three-thousand-mile, fun-filled trip. Later, when John became sick and needed nursing, she was doubly glad she had come along.

John's Hawaiian home was more modern than native.

THE DUKE GOES WEST

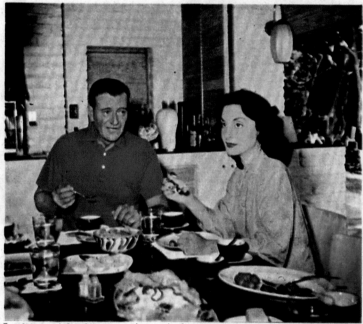

Evenings and Sundays were their only free time together. John and Pilar ate exotic foods, swam, skin-dived, fished and indulged in a favorite island custom— the *siesta*—when unusually rough location shooting wearied even the big Duke.

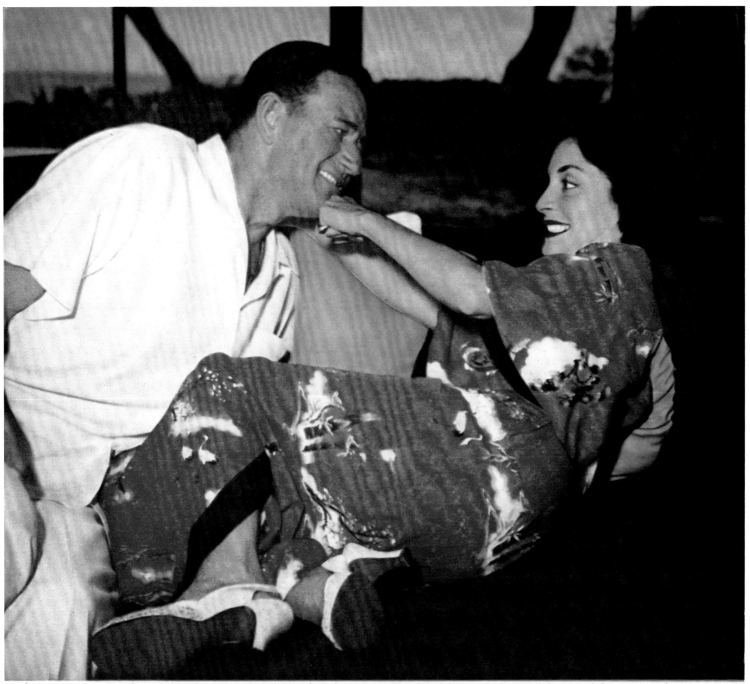

Thought of by their friends as the most lady-like of all John's loves, Pilar made sure that she was well-chaperoned during the entire trip.

PREVIOUS SPREAD A pictorial essay on life with Duke by Pilar Wayne.

THIS SPREAD Another magazine article on the glamorous couple.

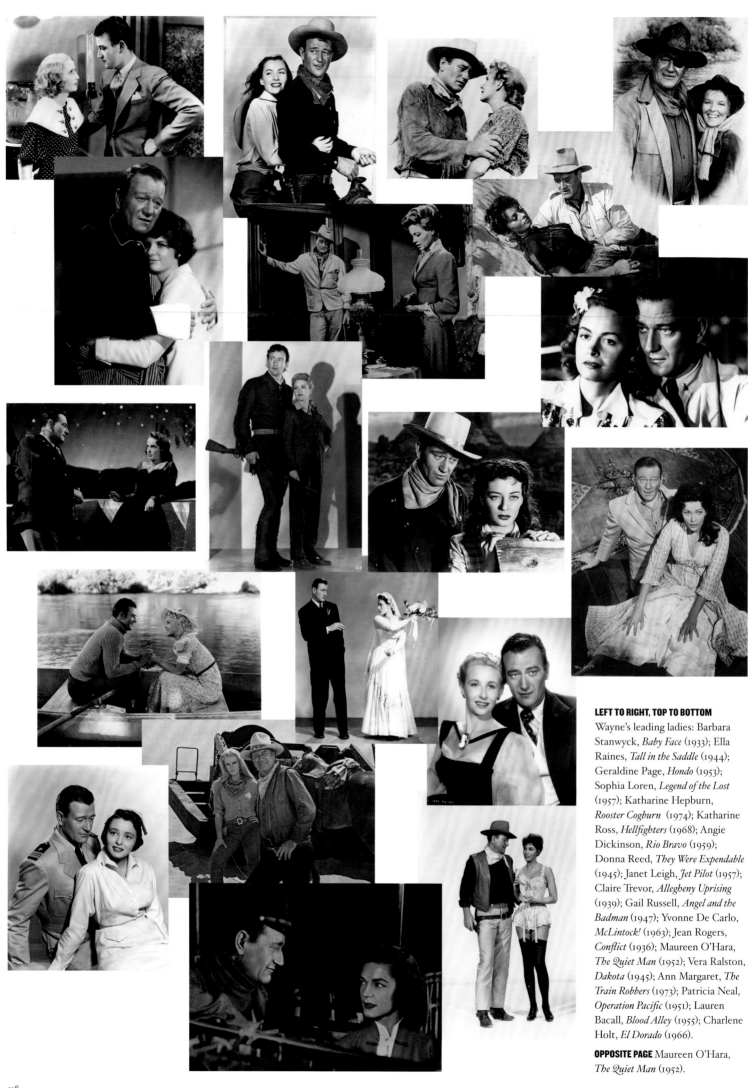

LEFT TO RIGHT, TOP TO BOTTOM

Wayne's leading ladies: Barbara Stanwyck, *Baby Face* (1933); Ella Raines, *Tall in the Saddle* (1944); Geraldine Page, *Hondo* (1953); Sophia Loren, *Legend of the Lost* (1957); Katharine Hepburn, *Rooster Cogburn* (1974); Katharine Ross, *Hellfighters* (1968); Angie Dickinson, *Rio Bravo* (1959); Donna Reed, *They Were Expendable* (1945); Janet Leigh, *Jet Pilot* (1957); Claire Trevor, *Allegheny Uprising* (1939); Gail Russell, *Angel and the Badman* (1947); Yvonne De Carlo, *McLintock!* (1963); Jean Rogers, *Conflict* (1936); Maureen O'Hara, *The Quiet Man* (1952); Vera Ralston, *Dakota* (1945); Ann Margaret, *The Train Robbers* (1973); Patricia Neal, *Operation Pacific* (1951); Lauren Bacall, *Blood Alley* (1955); Charlene Holt, *El Dorado* (1966).

OPPOSITE PAGE Maureen O'Hara, *The Quiet Man* (1952).

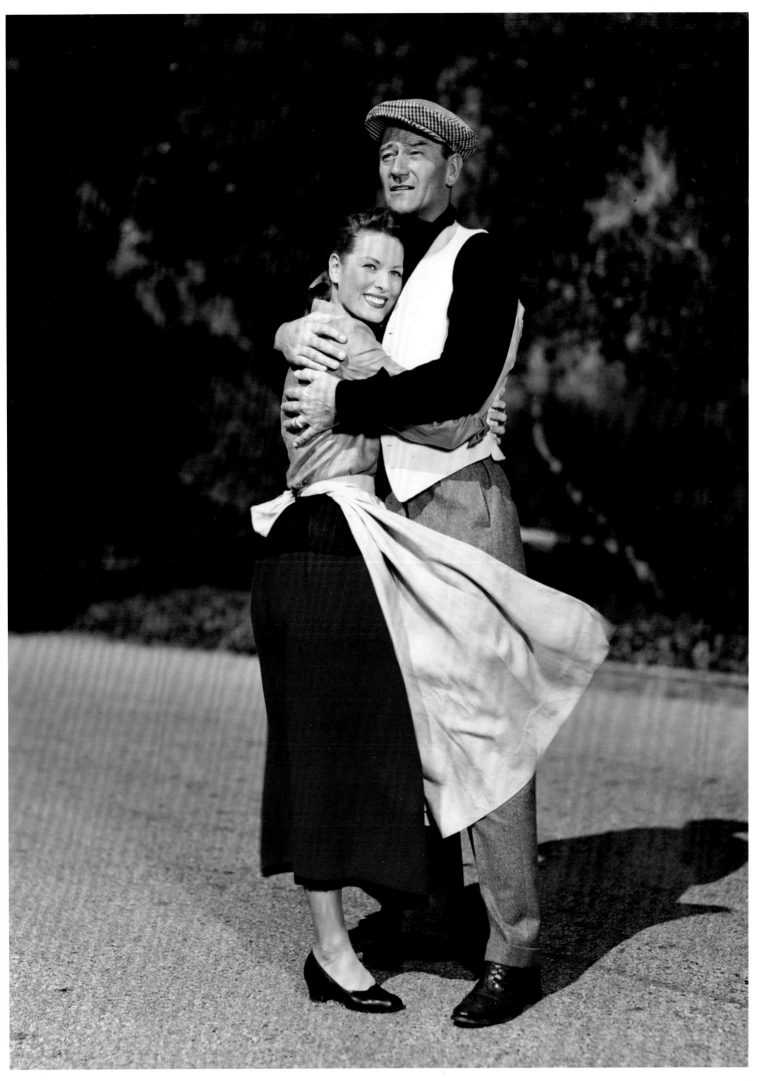

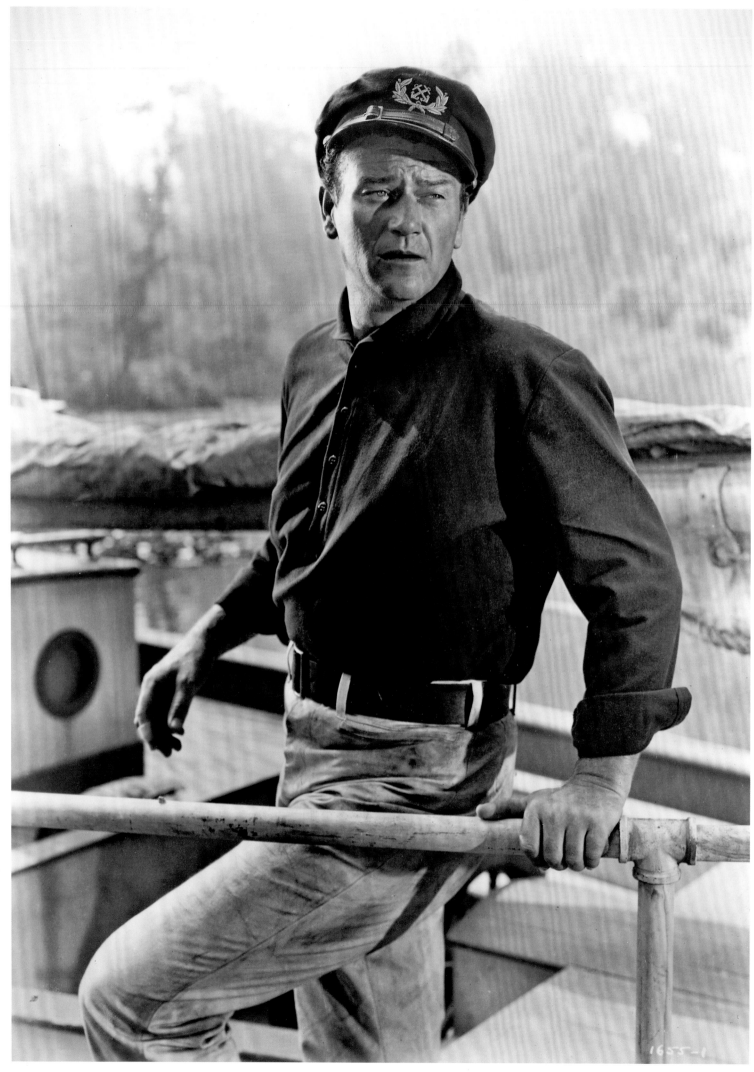

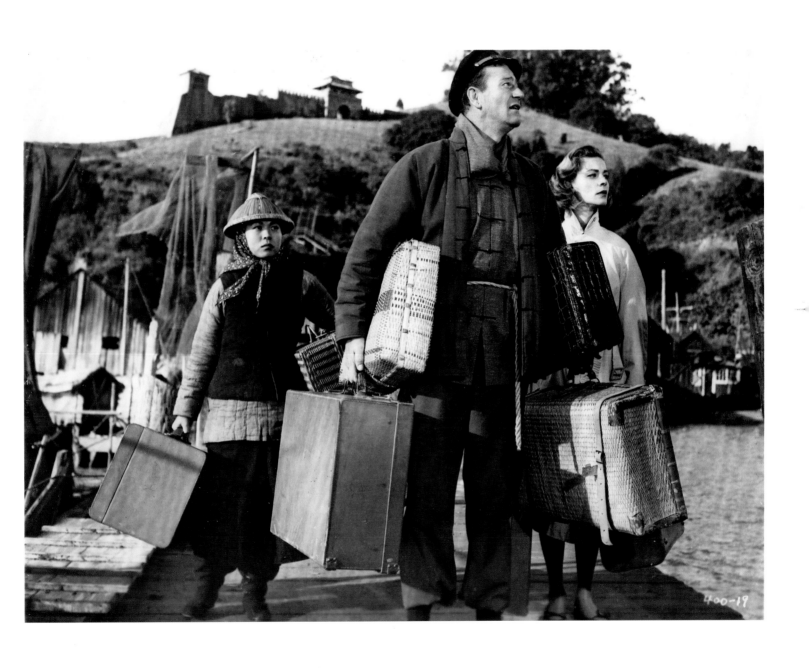

Remembrance

MAUREEN O'HARA

I met John Wayne for the first time in 1941 at John Ford's home during a dinner party. It was to be the beginning of a deep and enduring friendship. We had such respect and love for one another and that continued to build throughout the years.

Our times together were rich and I could tell a million tales. They would be serious, funny, mischievous, happy, and sad stories, and each one would touch your heart.

I made five wonderful movies with Duke. *Big Jake, The Wings of Eagles, Rio Grande, McLintock!*, and *The Quiet Man*. Once in awhile a great thing happens in the film industry. A special chemistry between an actor and actress develops and "it is magic." Ginger Rogers and Fred Astaire, Myrna Loy and William Powell, Katherine Hepburn and Spencer Tracy, Julia Roberts and Richard Gere, and of course Maureen O'Hara and John Wayne. He was an incredible person to act with, so professional, and so kind and considerate to his fellow actors. He paid me the highest compliment of my life when he said I was the greatest friend and the best guy he ever knew.

One of my fondest memories was of him begging me whenever we were together to sing a song in Irish about a little full jug (with whiskey to be sure). Here are the words in Irish and in English… I remember them with fondness for you dear friend.

Gradh mo chroi mo cruiscin slainte geal mo Mauver-neen
Love of my heart, my little jug, bright health my darling

Gradh mo chroi mo cruiscin a culleen bawn
Love of my heart, my little white jug

Gradh mo chroi mo cruiscin lan, lan, lan,
Love of my heart , my little jug, full, full, full

Ohhh gradh mo chroi mo cruiscin lan.
Love of my heart, my little full jug.

One of the saddest days of my life was when I learned that his life was coming to an end. My sun stopped shining and I only heard the sound of silence where birds used to sing. I was depressed for years over his illness and the loss of a man I felt was invincible. A man who had woven himself into the very fabric of my soul.

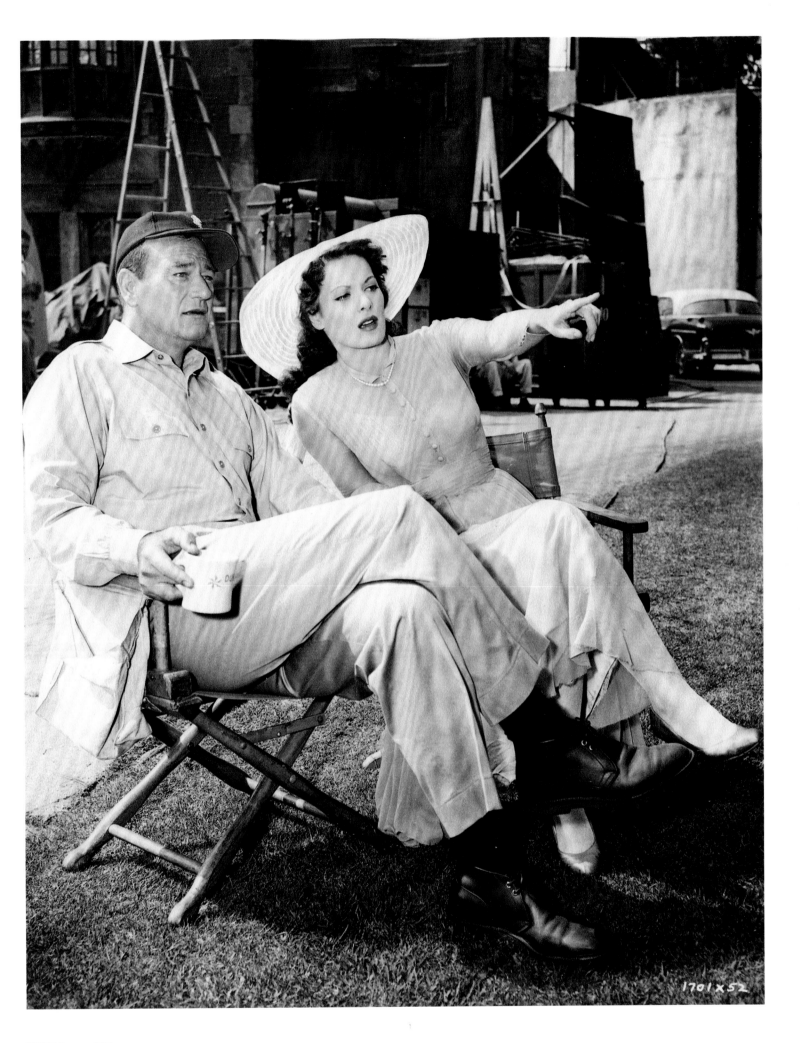

ABOVE Maureen O'Hara with John Wayne on location filming *The Wings of Eagles* (1957).

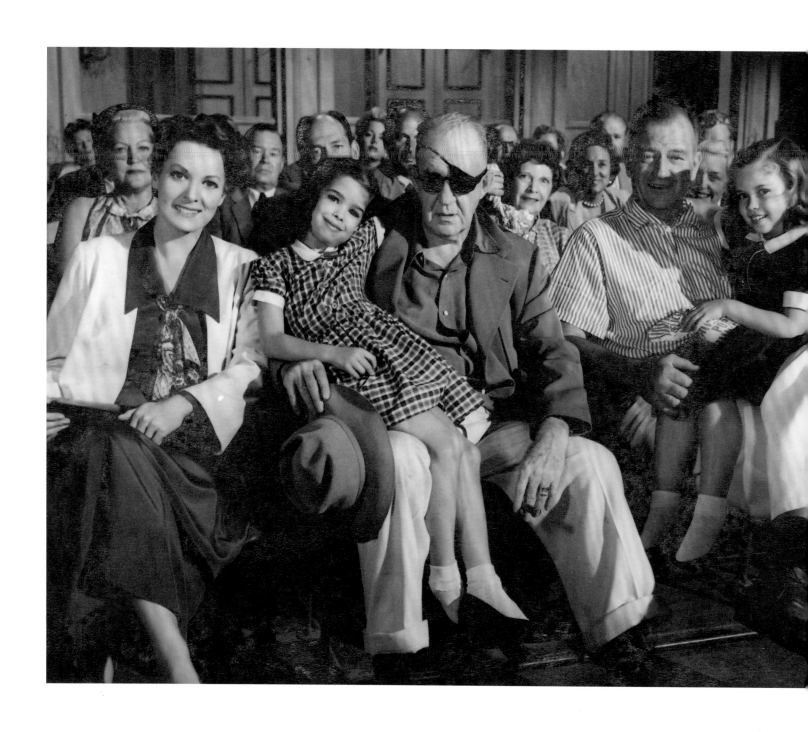

ABOVE Maureen O'Hara, John Ford, and John Wayne with Evelyn Rudie and Mimi Gibson, two popular child actresses who played Maureen and Duke's daughters in the film *The Wings of Eagles* (1957).

OPPOSITE PAGE, ABOVE Maureen O'Hara laughing on set with John Wayne while filming director John Ford's *The Wings of Eagles* (1957).

OPPOSITE PAGE, BELOW Maureen O'Hara and John Wayne film a car scene from *The Wings of Eagles* (1957).

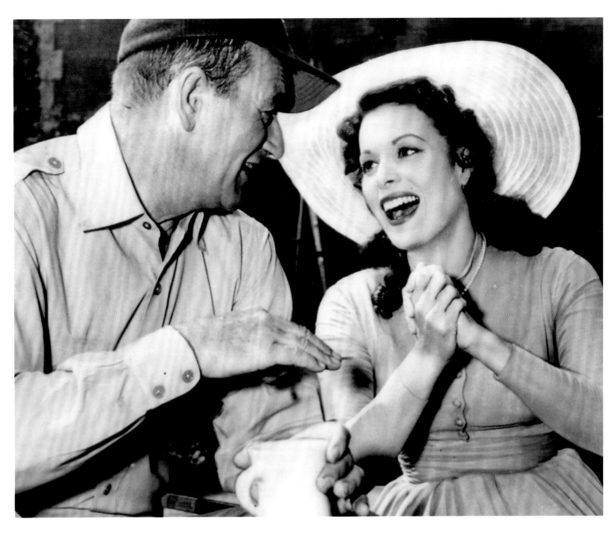

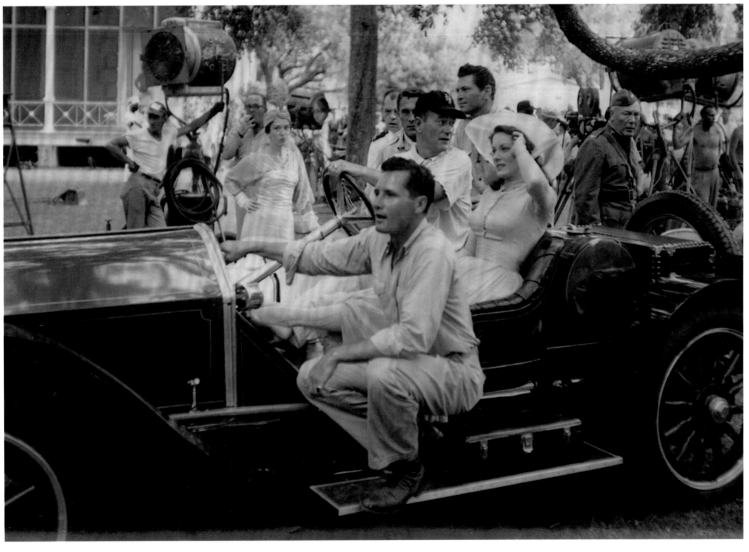

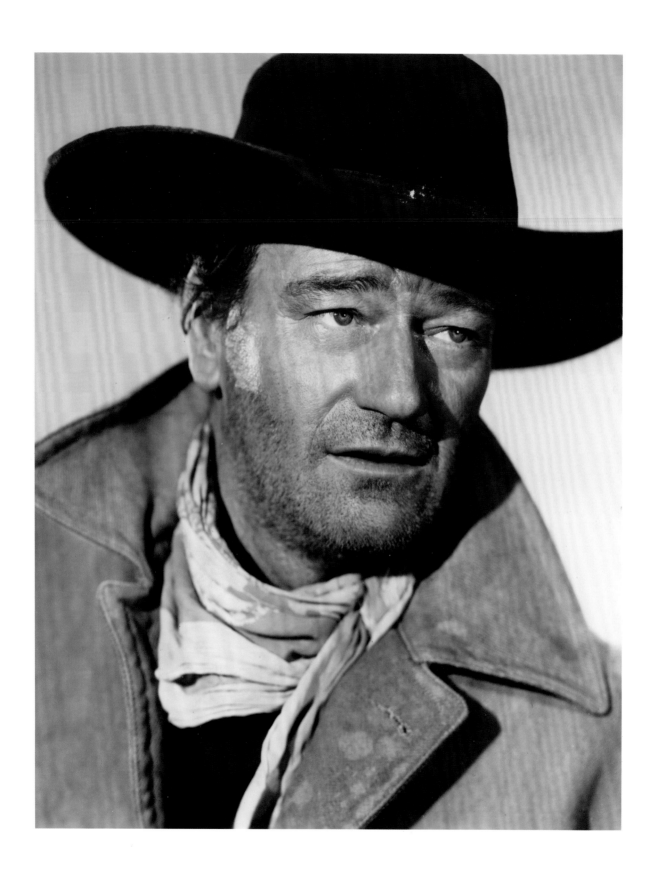

ABOVE John Wayne as Ethan
Edwards in *The Searchers*
(1956).

OPPOSITE PAGE John Wayne
in *The Comancheros* (1961).

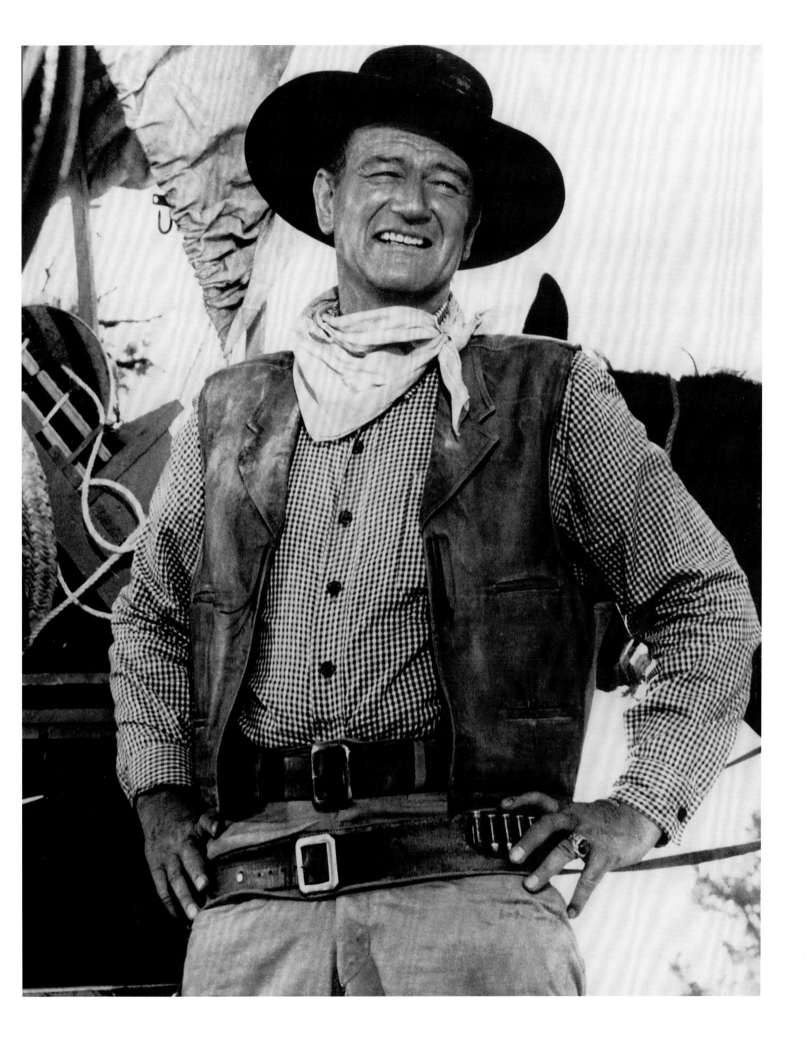

RIGHT John Wayne as Frank W. "Spig" Wead in *The Wings of Eagles* (1957).

1701-98

RIGHT Ward Bond and John Wayne in conversation on the set of *The Wings of Eagles* (1957).

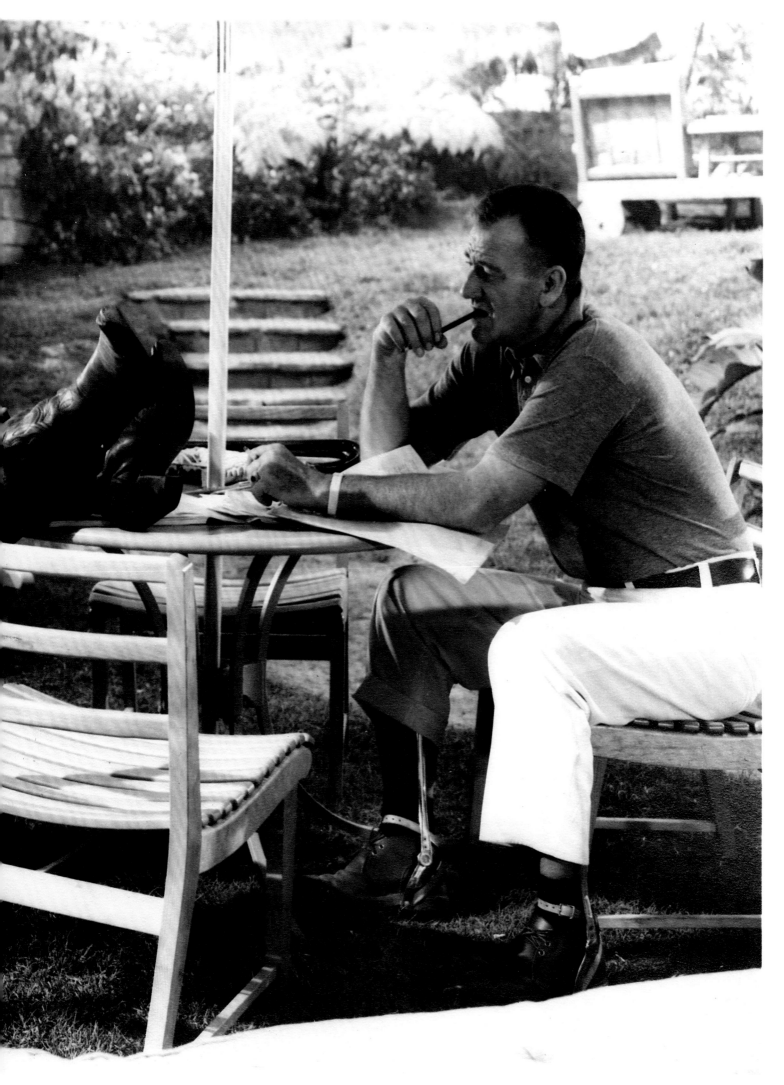

OPPOSITE PAGE John and Pilar Wayne with John Ford aboard the French ship *SS Liberté,* traveling between Southampton, U.K. and New York, for a film premiere.

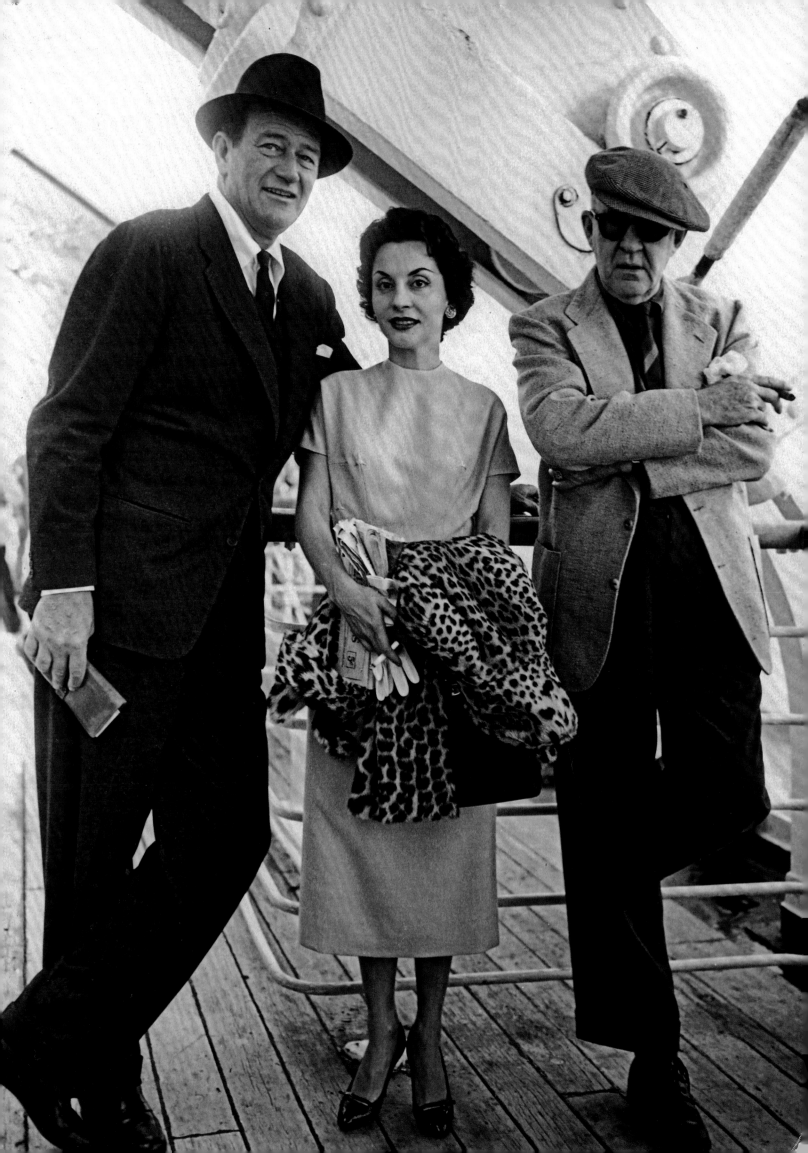

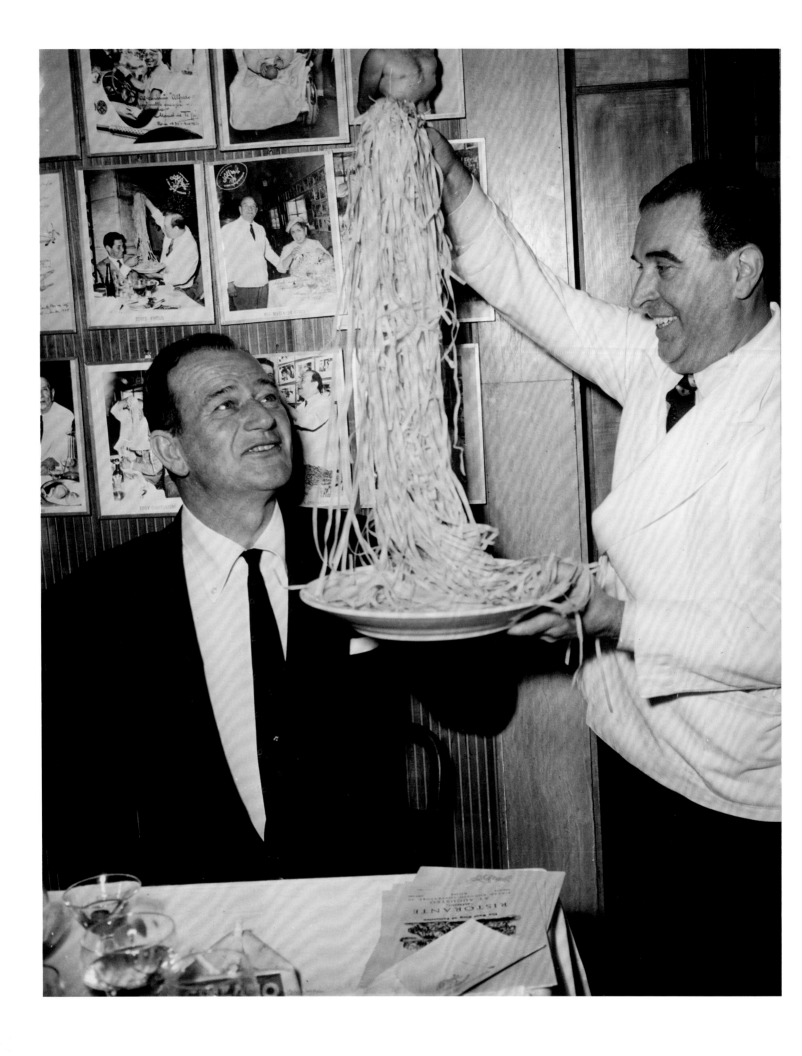

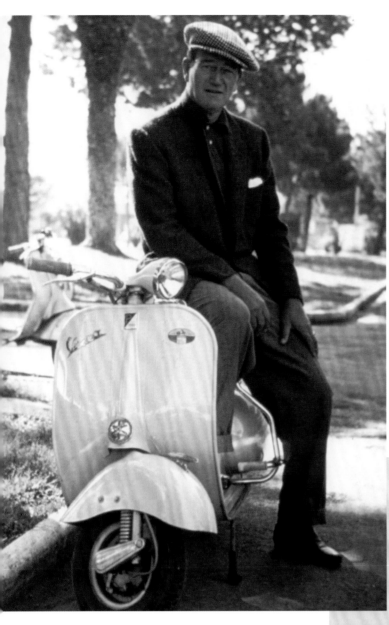

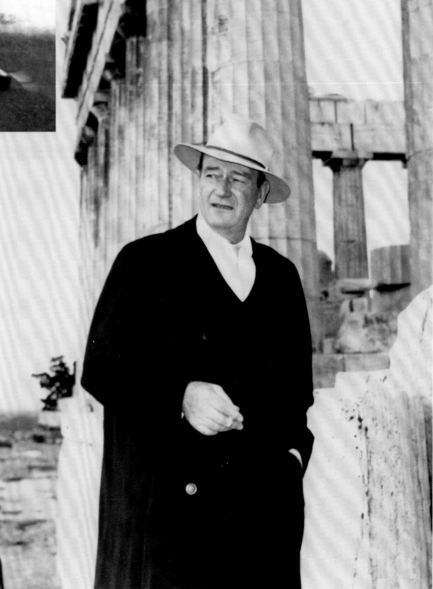

OPPOSITE PAGE John Wayne in Rome at The Alfredo Restaurant.

ABOVE John Wayne on holiday.

RIGHT John Wayne traveling in Greece.

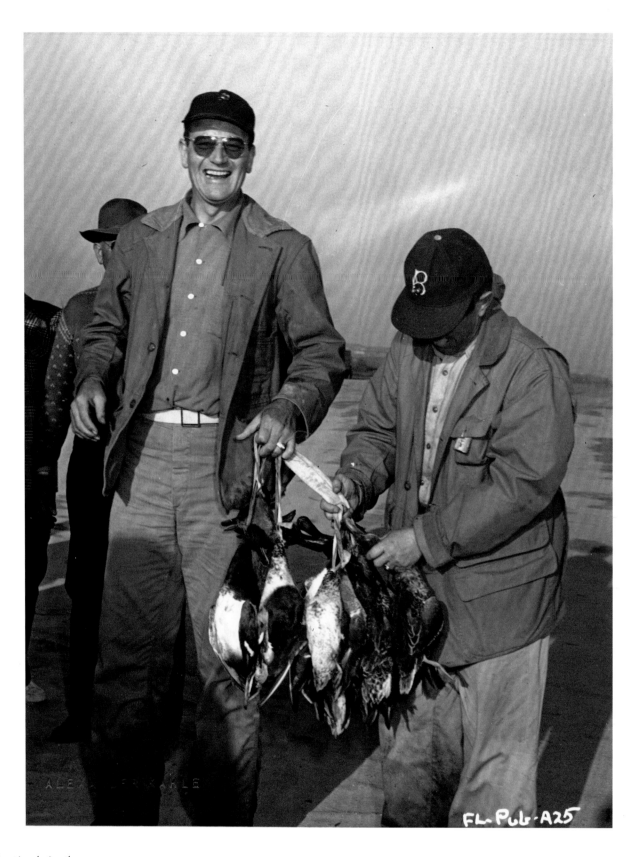

ABOVE Bird hunting during the filming of *Flying Leathernecks* (1951), in Louisiana; Duke was rarely photographed wearing sunglasses.

OPPOSITE PAGE John Wayne as sportswriter Mike Cronin, in television's *Screen Director's Playhouse*. Duke starred in the episode entitled "Rookie of the Year," directed by John Ford and with co-stars Patrick Wayne, Ward Bond, and James Gleason.

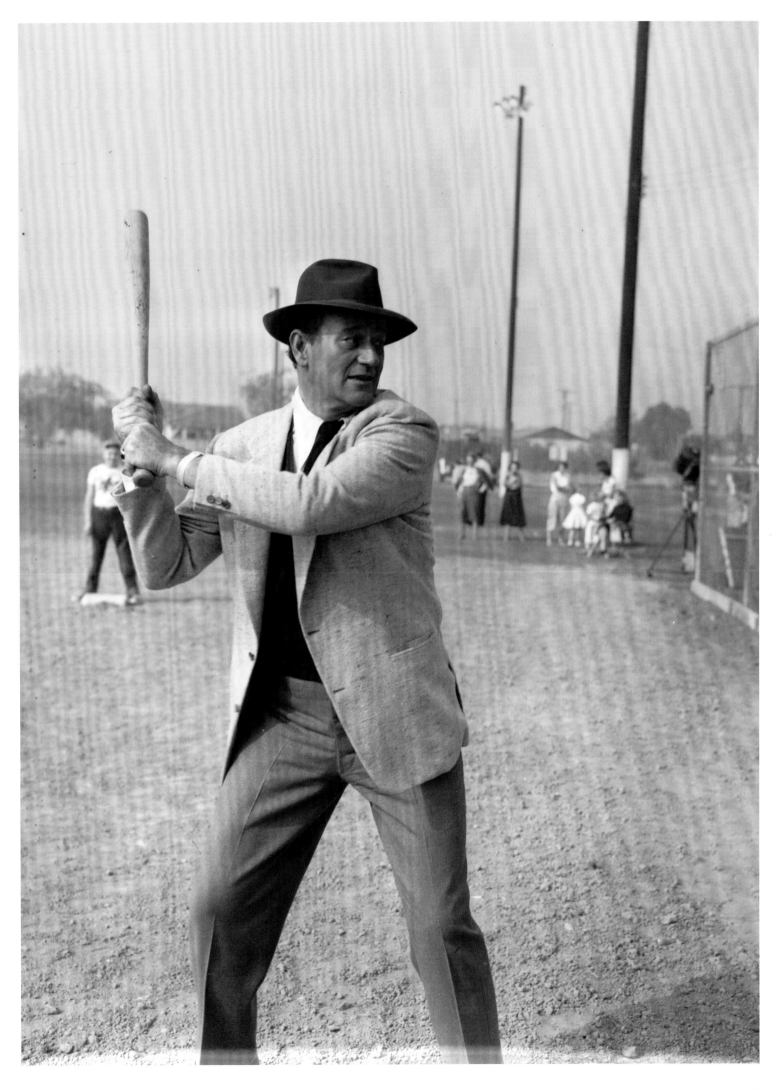

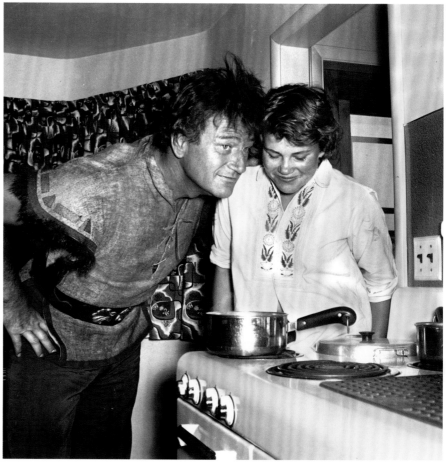

ABOVE John Wayne celebrating his birthday with director Dick Powell (far left), his daughters Toni and Melinda, and son Patrick while on the set of *The Conqueror* (1956).

RIGHT John Wayne in the kitchen with his daughter Melinda while on location in Utah filming *The Conqueror* (1956).

OPPOSITE PAGE Patrick Wayne in baseball uniform with his father in *Rookie of the Year* (1955).

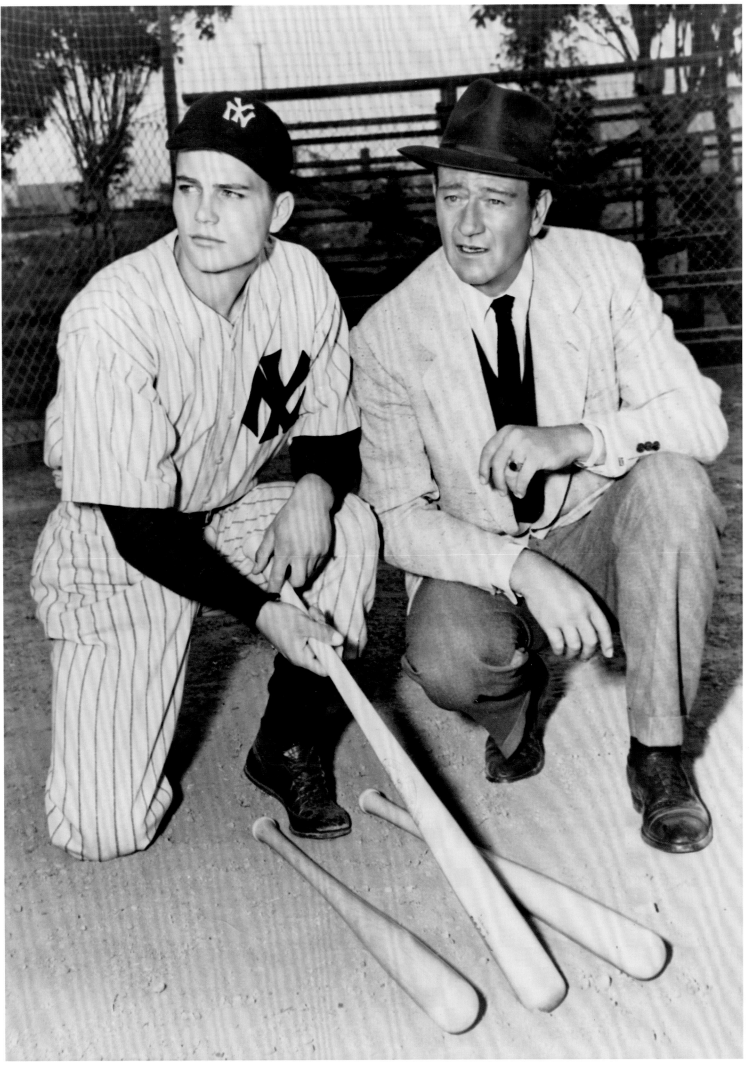

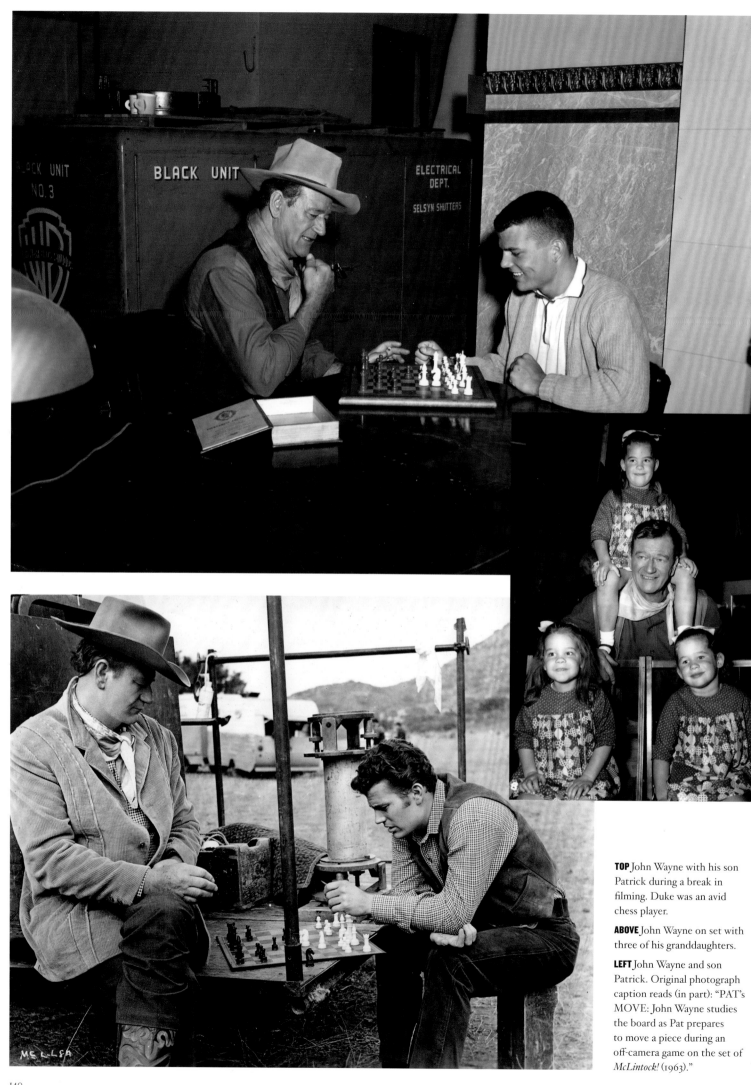

TOP John Wayne with his son Patrick during a break in filming. Duke was an avid chess player.

ABOVE John Wayne on set with three of his granddaughters.

LEFT John Wayne and son Patrick. Original photograph caption reads (in part): "PAT's MOVE: John Wayne studies the board as Pat prepares to move a piece during an off-camera game on the set of *McLintock!* (1963)."

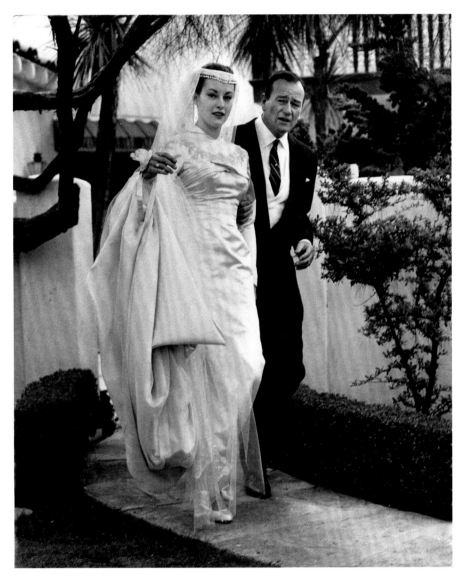

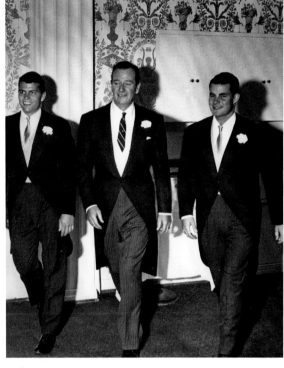

ABOVE LEFT John Wayne with his oldest daughter Toni at her wedding to Donald LaCava in May 1956.

ABOVE RIGHT Patrick, John, and Michael at Toni's wedding.

LEFT Duke with his mother Mary on his daughter Toni's wedding day.

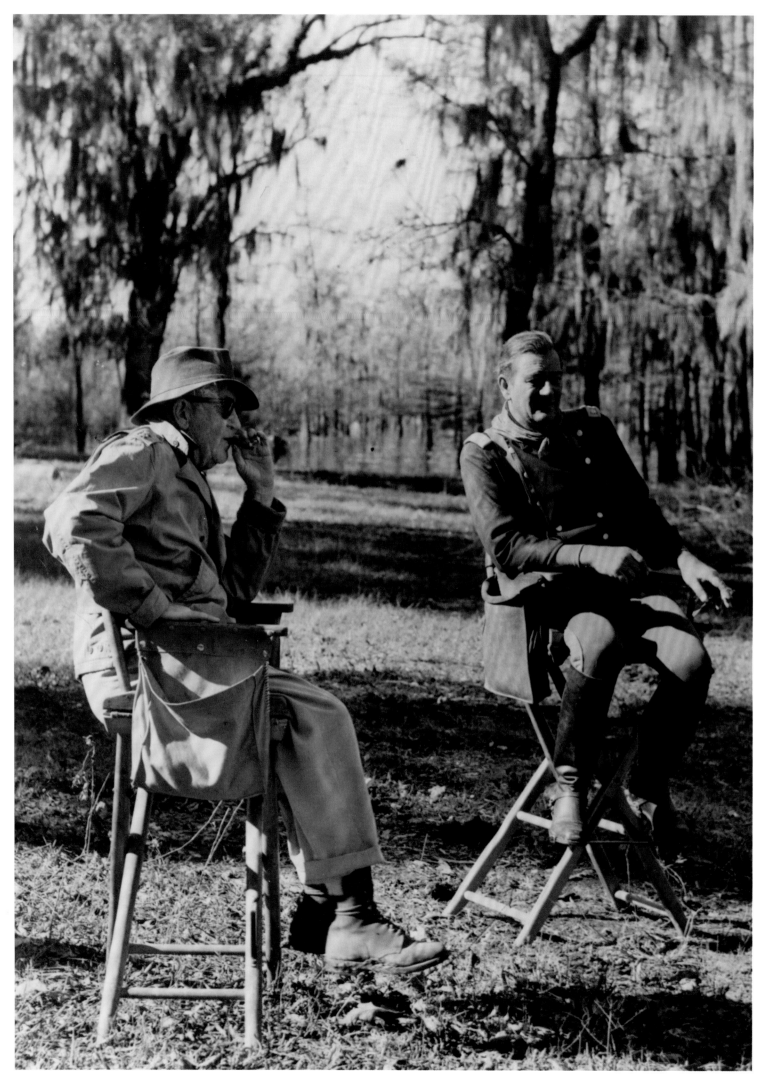

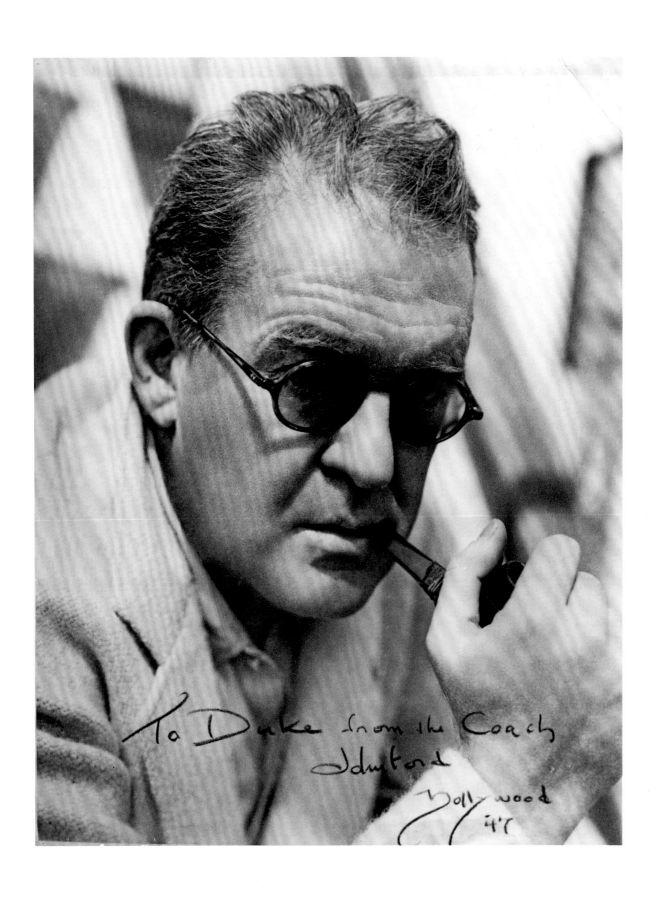

To Duke from the Coach
John Ford
Hollywood
'47

OPPOSITE PAGE Director John Ford and John Wayne filming *The Horse Soldiers* (1959).

ABOVE A publicity head shot of noted director John Ford. This photo was framed and on display in John Wayne's house.

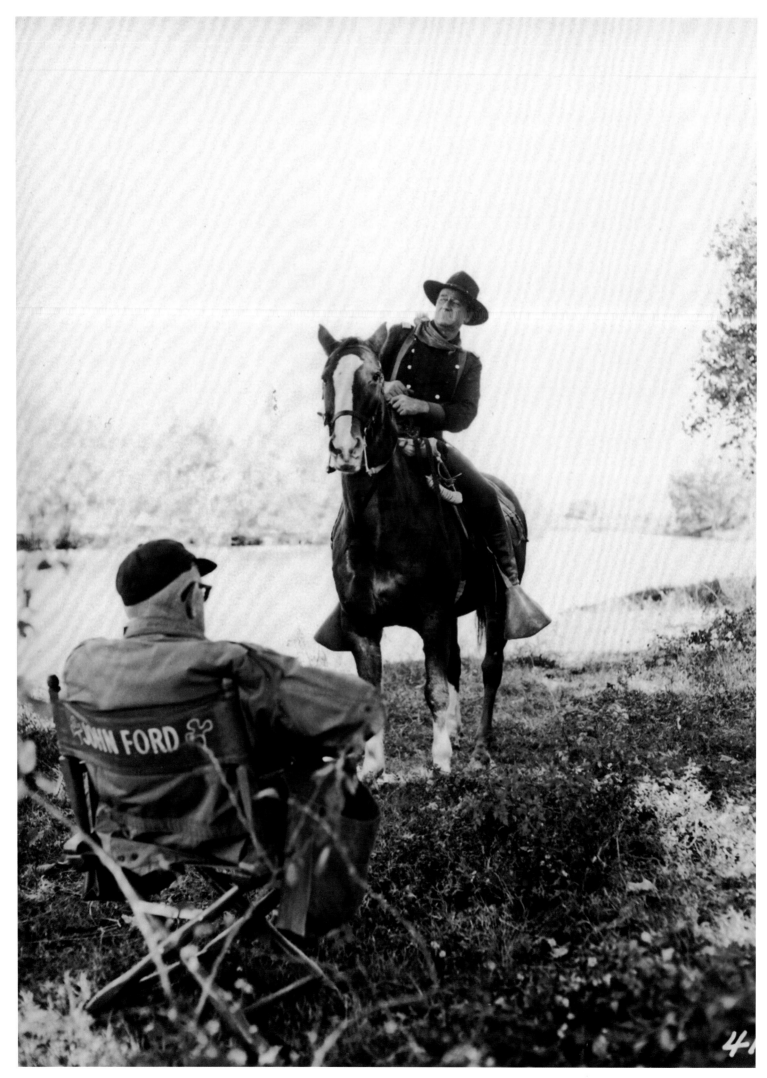

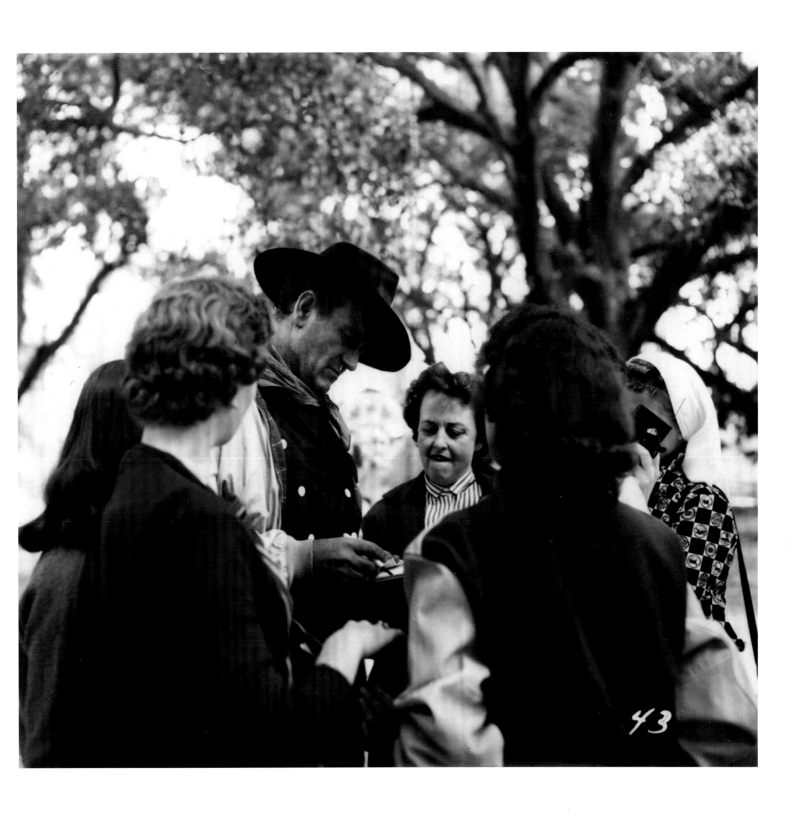

43

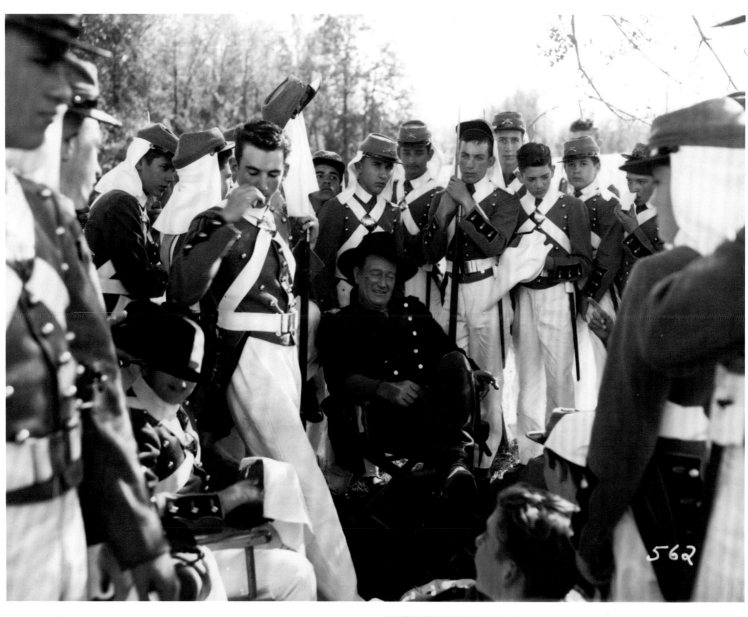

ABOVE On the set of *The Horse Soldiers* (1959).

RIGHT Inscribed on horse bucket: "To Twinkle Toes From John Wayne. For his work in *The Horse Soldiers*."

OPPOSITE PAGE, ABOVE John Wayne in action on the set of *The Horse Soldiers* (1959).

OPPOSITE PAGE, BELOW Duke between takes on the set of *The Horse Soldiers* (1959).

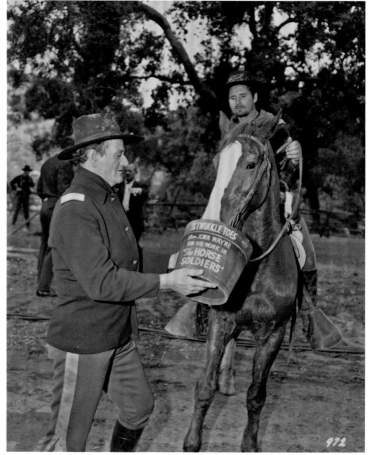

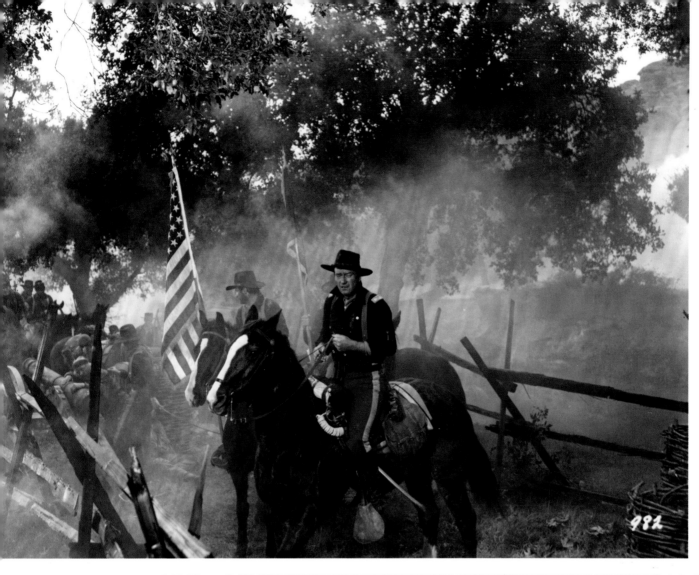

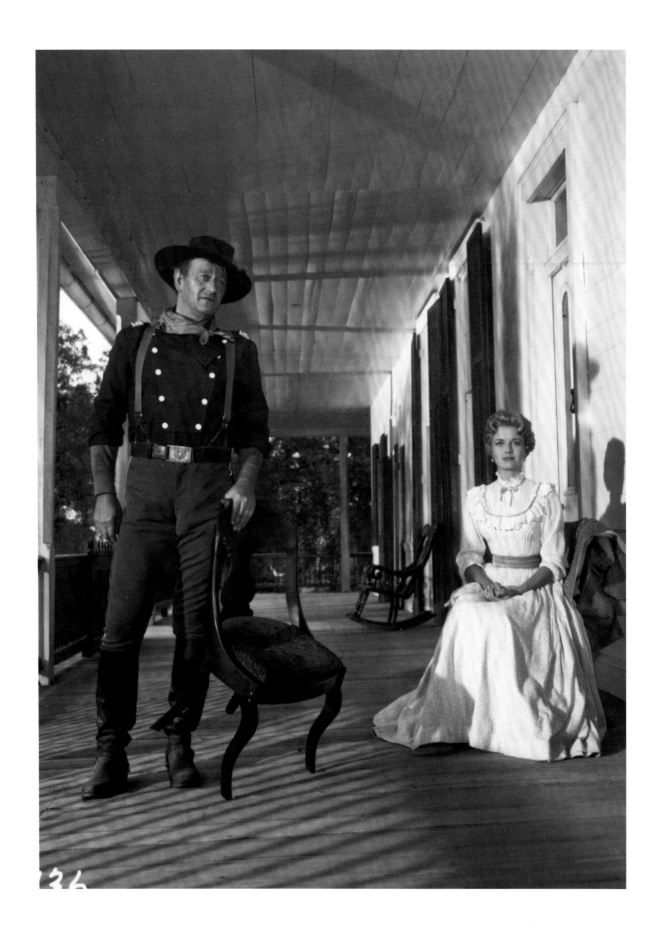

ABOVE A scene from *The Horse Soldiers* (1959).

OPPOSITE PAGE
Duke and Constance Towers
embrace in *The Horse
Soldiers* (1959).

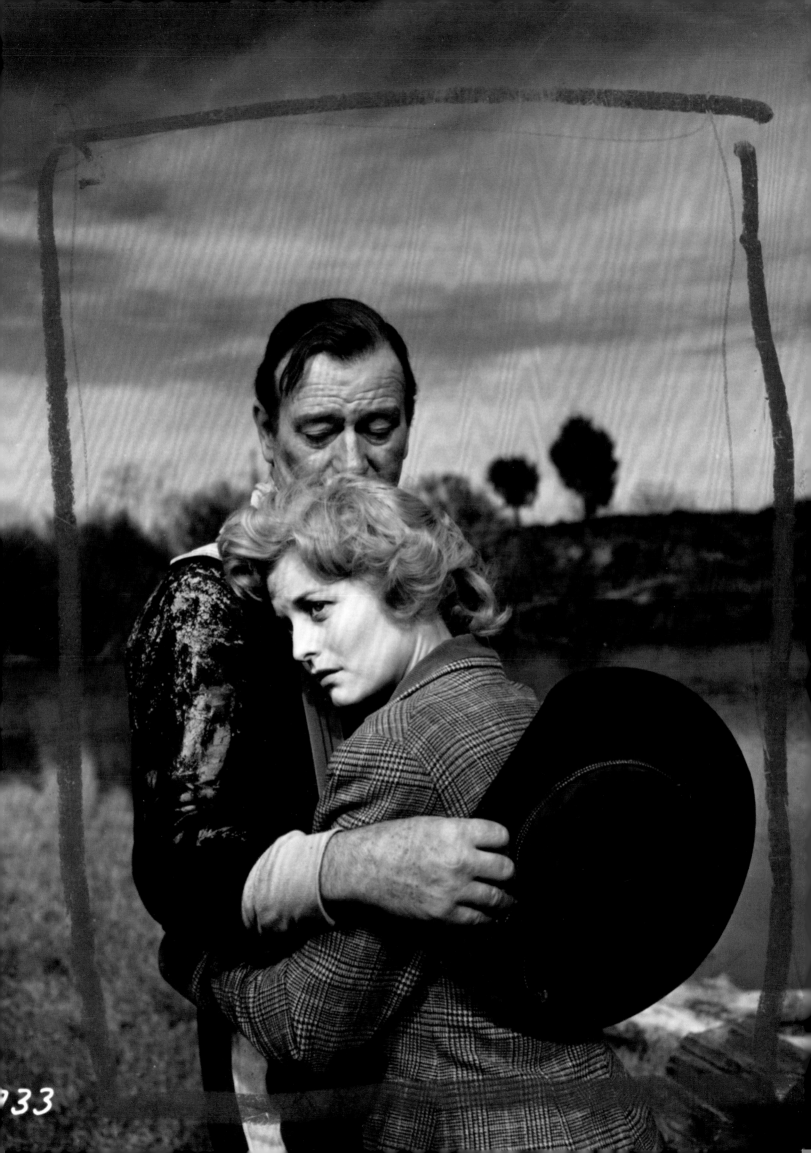

933

RIGHT John Wayne standing
outside by the pool house at
his Encino, California home.

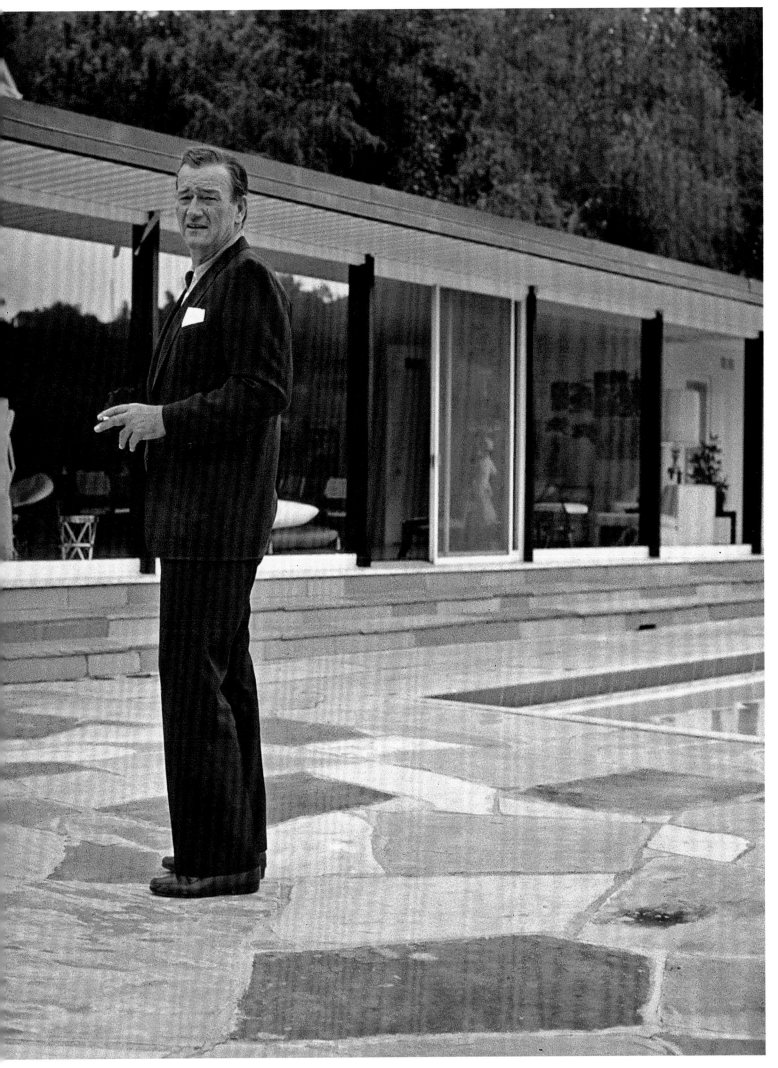

RIGHT Pilar Wayne and
daughter Aissa, admiring
an early portrait of Duke
on display in their home in
Encino, California.

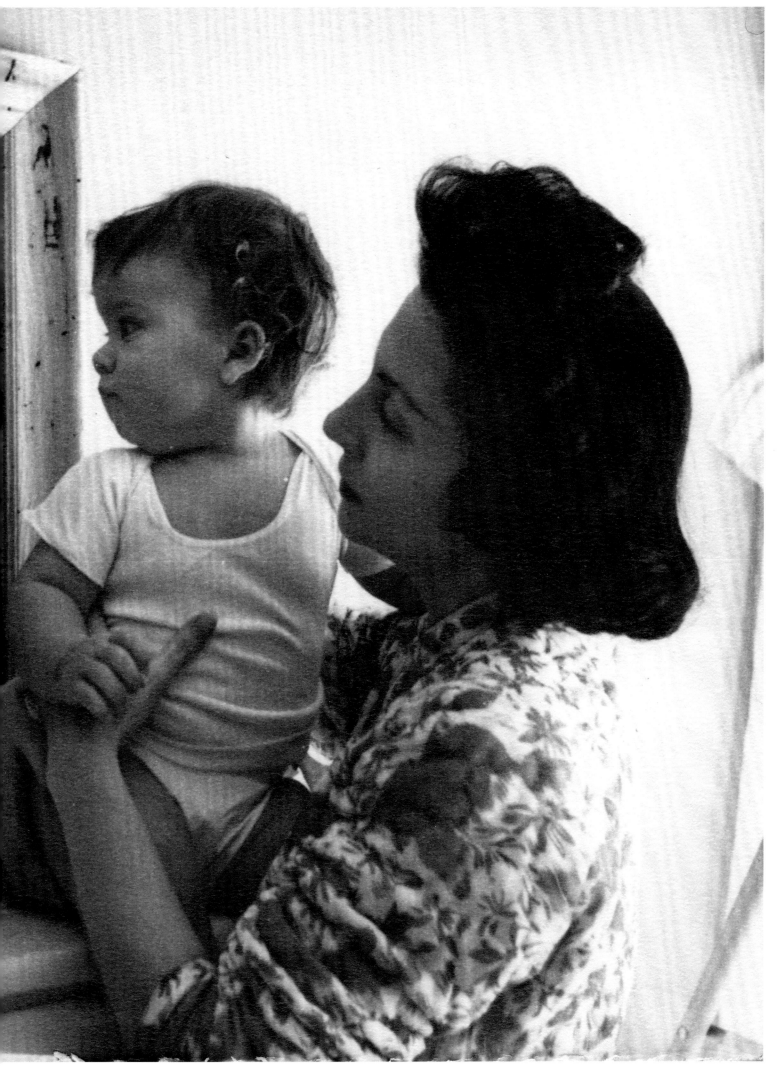

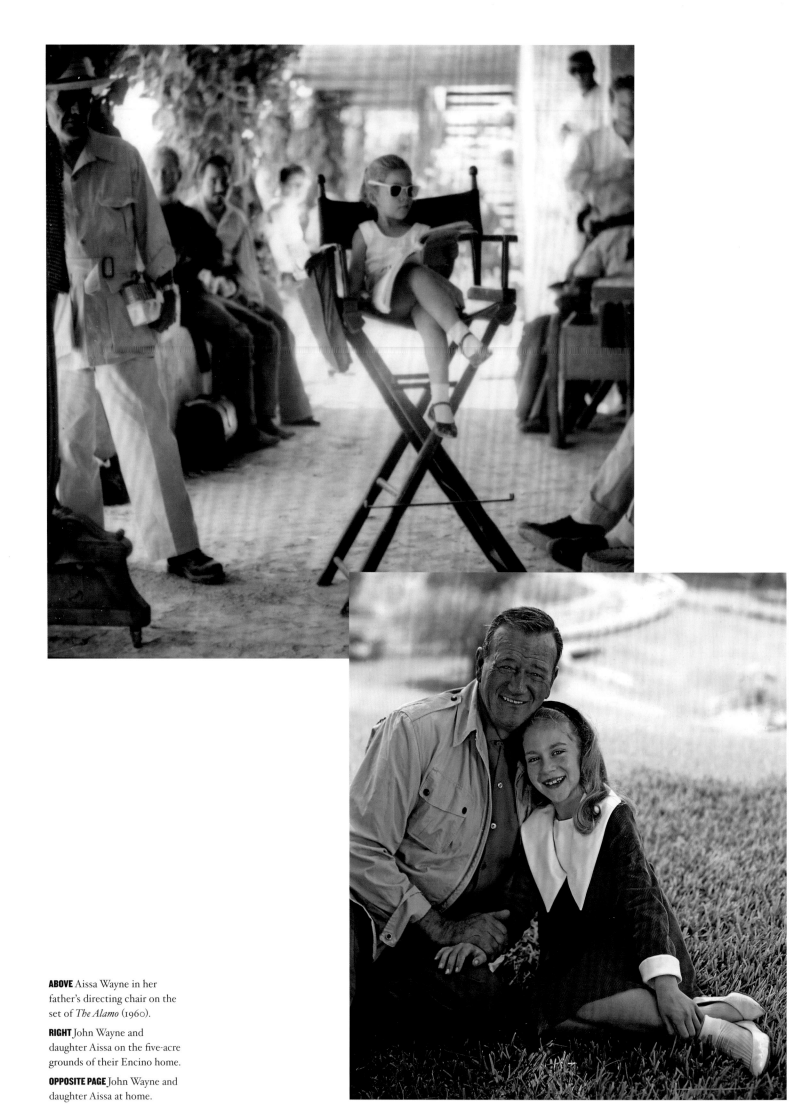

ABOVE Aissa Wayne in her father's directing chair on the set of *The Alamo* (1960).

RIGHT John Wayne and daughter Aissa on the five-acre grounds of their Encino home.

OPPOSITE PAGE John Wayne and daughter Aissa at home.

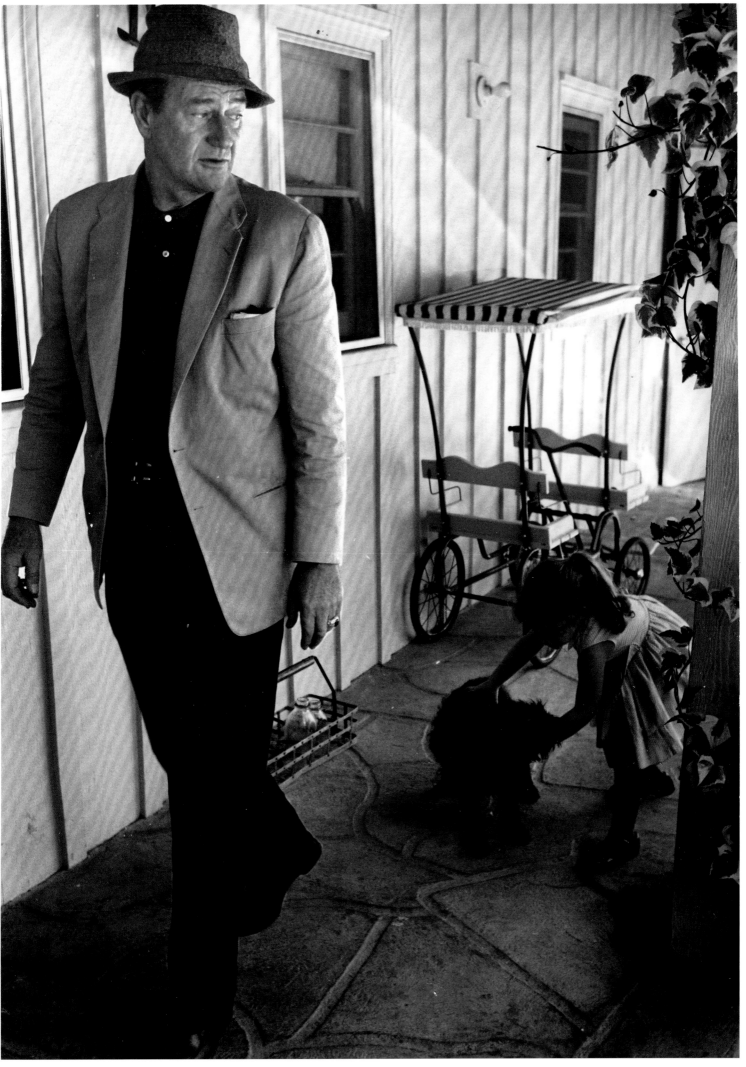

RIGHT John Wayne with Aissa and family dog Blackie in the Encino pool house. Wayne was an avid collector of Oriental art, seen in the background.

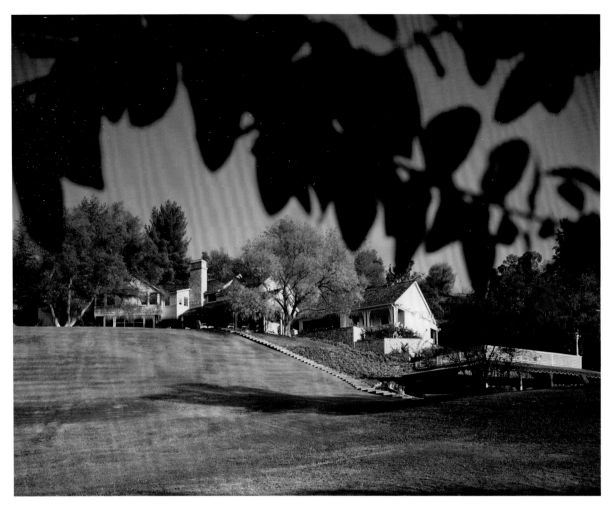

"Our house is on a hill in Encino, California. There is a long macadam driveway that stretches from the front door to the electric gate at the foot of the hill."

Pilar Wayne

ABOVE Landscape view of the Waynes' Encino ranch.

RIGHT Wayne relaxing on the patio in Encino with Blackie and friend.

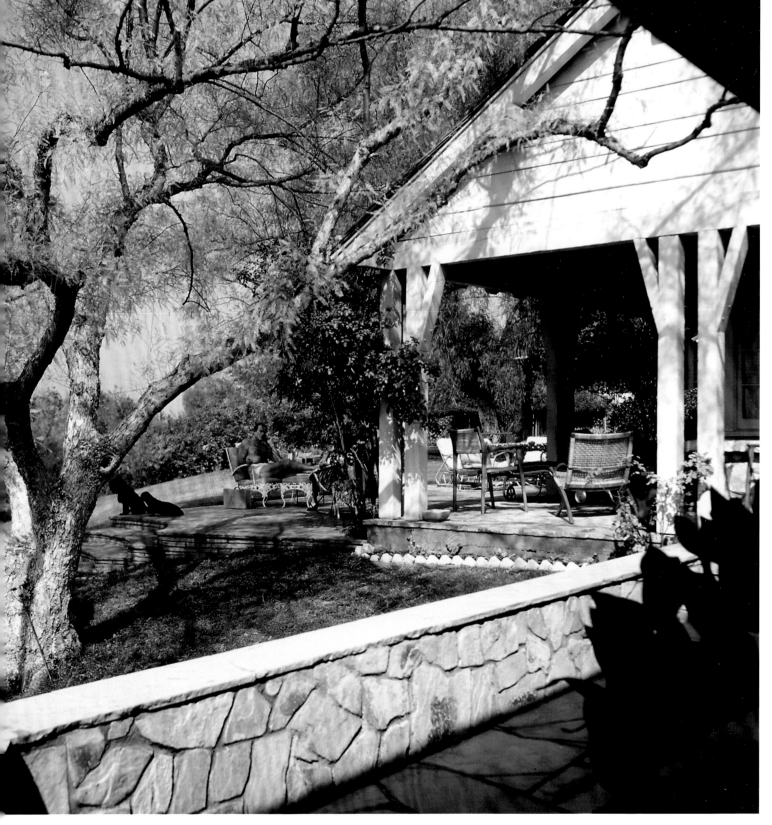

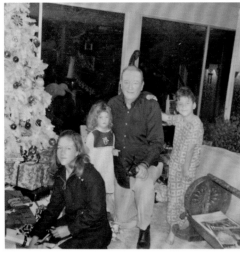

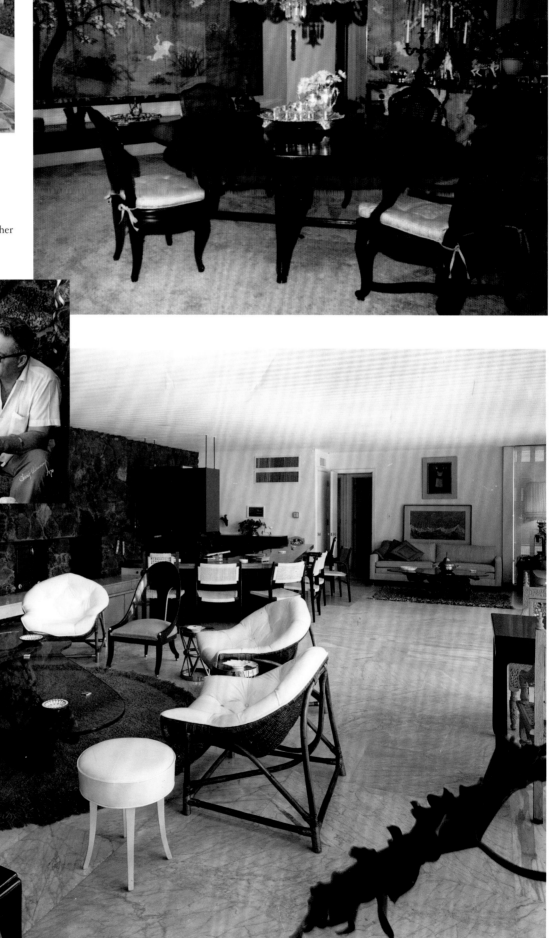

ABOVE John Wayne with Ethan, Aissa, and Marisa, on Christmas in Newport Beach.

RIGHT Newport Beach house.

BELOW Duke at home in Encino with his brother Robert Morrison.

BOTTOM Pool house—Encino home.

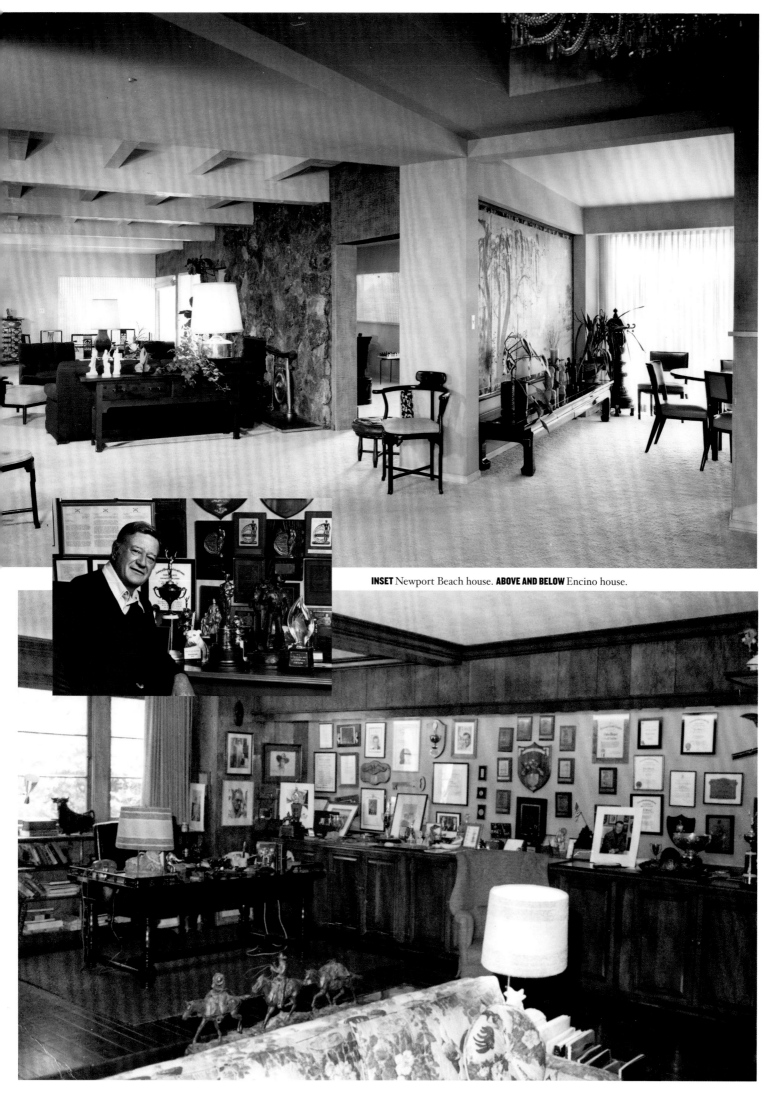

INSET Newport Beach house. **ABOVE AND BELOW** Encino house.

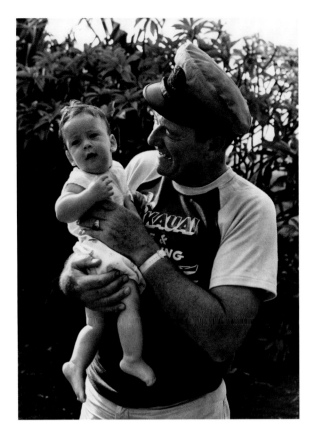

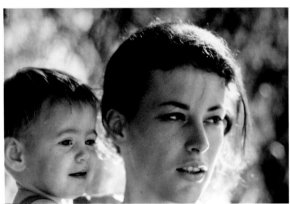

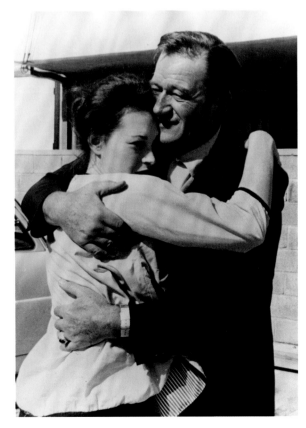

ABOVE LEFT Duke with Ethan in Hawaii.

MIDDLE LEFT Toni Wayne LaCava with her daughter, Anita, John Wayne's first grandchild.

BOTTOM LEFT Duke and Toni embracing.

ABOVE John Wayne and Aissa, his first daughter with Pilar, in the home office in Encino.

OPPOSITE John Wayne and his youngest daughter with Pilar, Marisa, at home in Newport Beach.

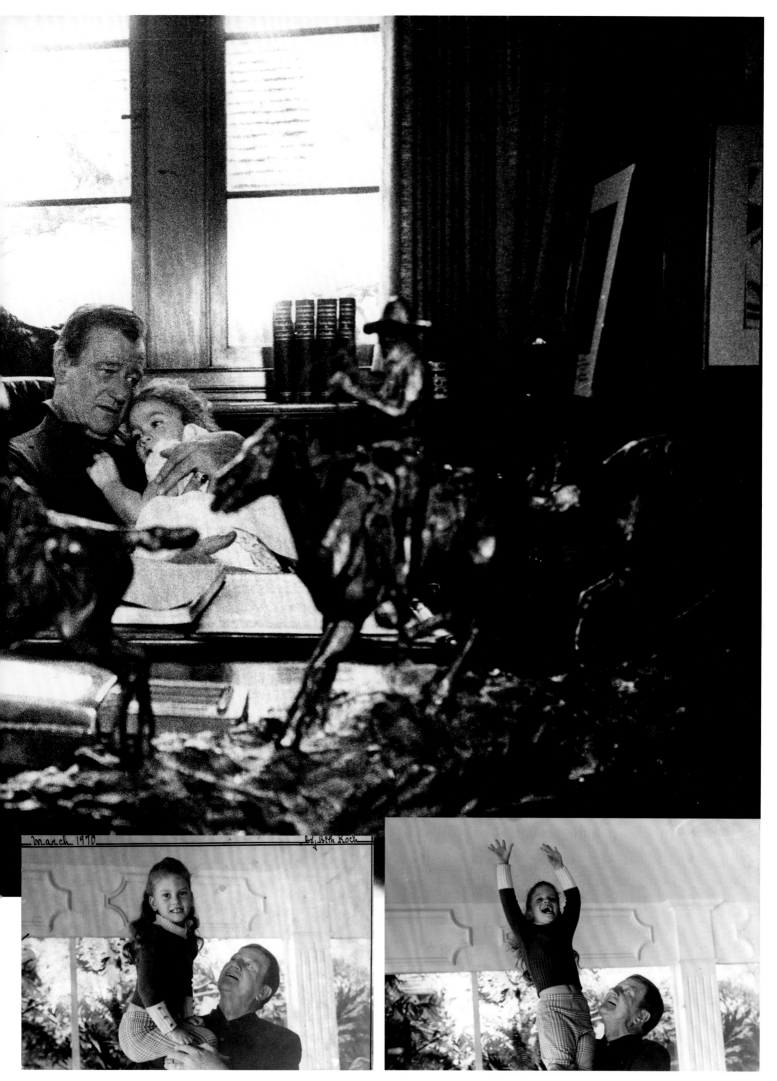

March 1970 by Beth Koch

ABOVE John Wayne with granddaughter Anita at her birthday party at the Encino home.

OPPOSITE PAGE Aissa, Pilar, and John Wayne on the grounds of their Encino home.

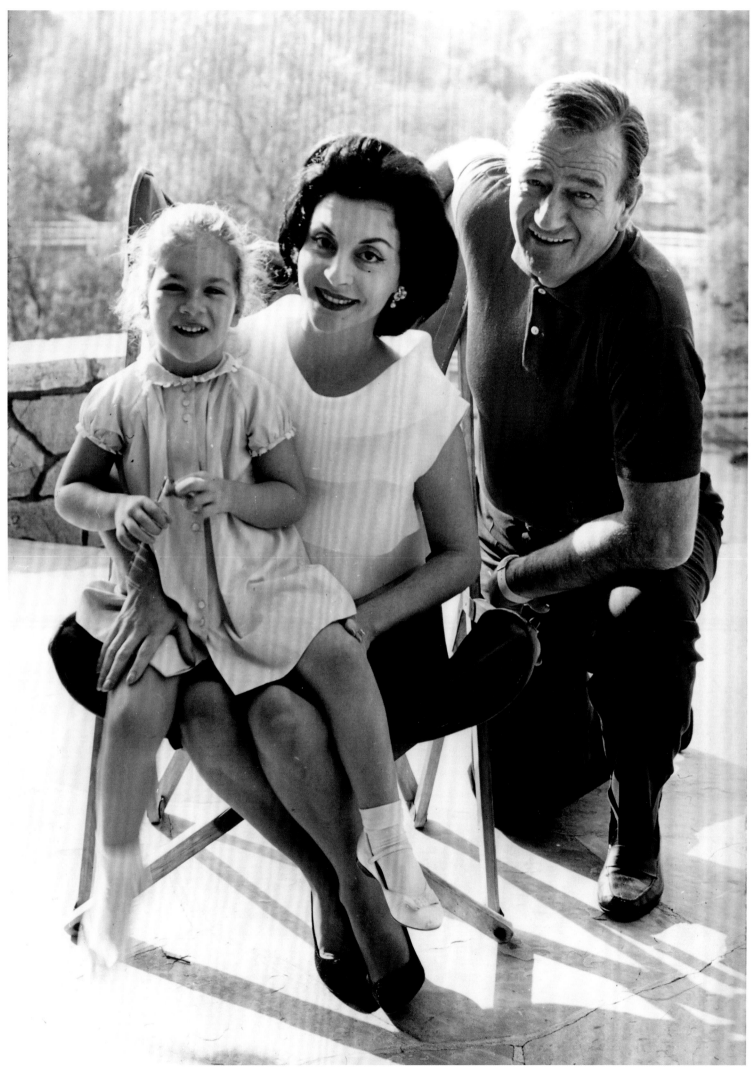

RIGHT Duke taking a portrait of himself with Pilar and little Aissa in the bath of their Encino home.

"In my acting I have to identify with something in the character. The big tough boy on the side of right – that's me. Simple themes. Save me from the nuances. All I do is sell sincerity and I've been selling the hell out of that ever since I started."

John Wayne

OPPOSITE PAGE John Wayne on the set of *El Dorado* (1966).

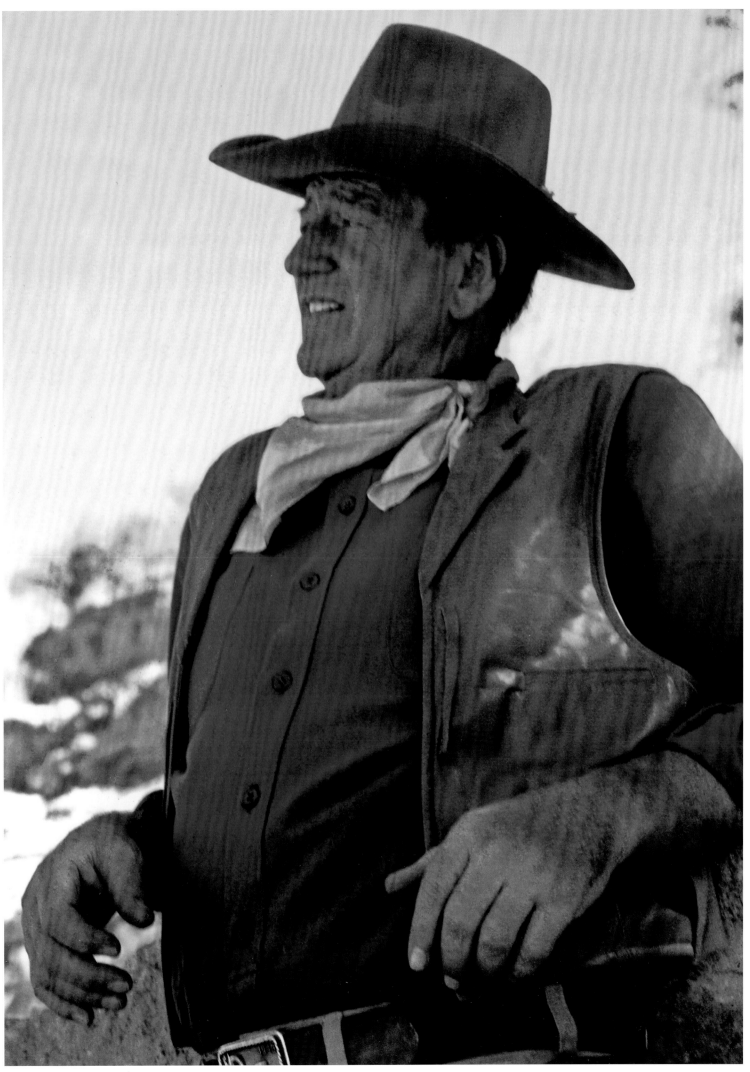

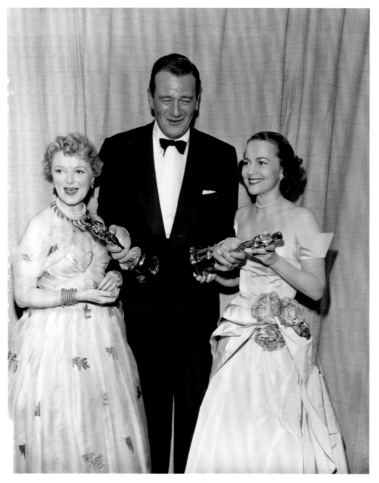

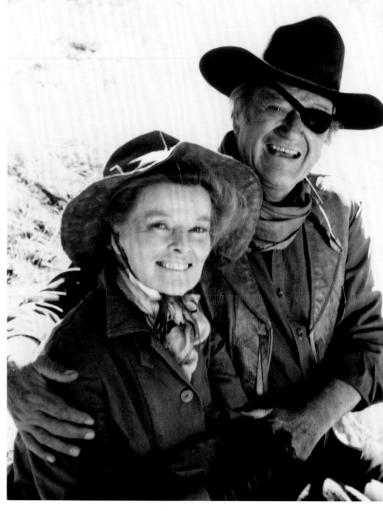

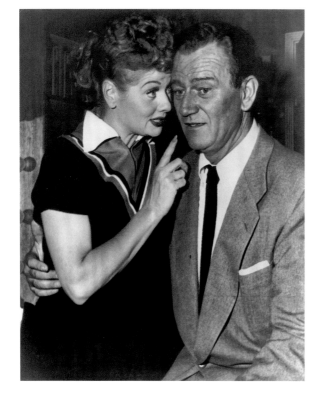

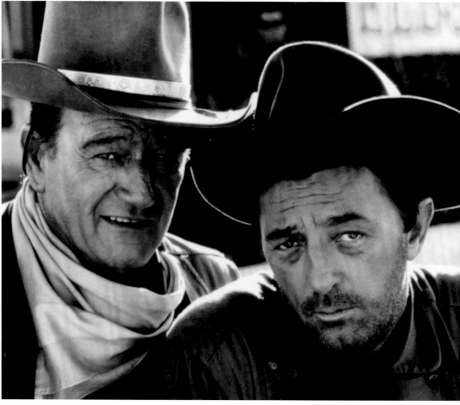

TOP LEFT John Wayne accepted Oscars for absentee winners John Ford for Best Director (*The Quiet Man*, 1952), and Gary Cooper for Best Actor (*High Noon*, 1952), at the 1953 Academy Awards Ceremony.

TOP RIGHT John Wayne with Katherine Hepburn in *Rooster Cogburn* (1975).

BOTTOM LEFT Lucille Ball with John Wayne in his guest appearance on *I Love Lucy* (1955).

BOTTOM RIGHT Robert Mitchum and John Wayne in Howard Hawk's *El Dorado* (1966).

ABOVE John Wayne and Chill
Wills breaking into song on
the set of *The Alamo* (1960).

RIGHT Aissa, Pilar, Patrick, and John Wayne on set at the Old Sharp's Ranch House (now preserved in the San Rafael State Natural Area) while filming *McLintock!* (1963).

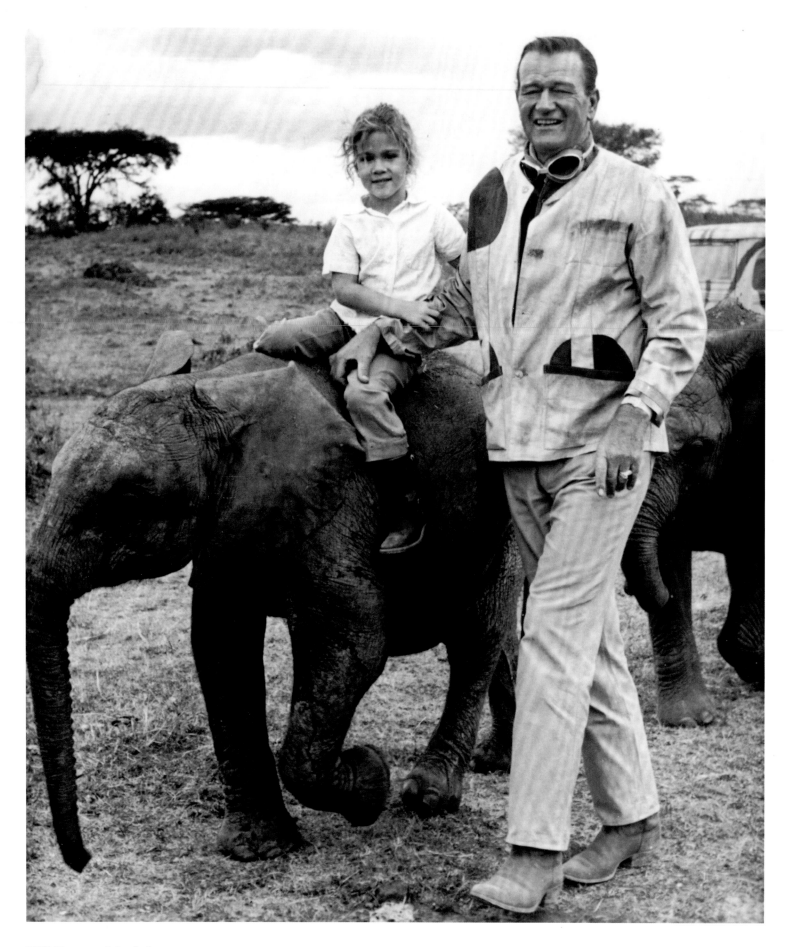

ABOVE Aissa atop a baby elephant with John Wayne while in Africa on the set of *Hatari!* (1962).

OPPOSITE PAGE, ABOVE Wayne, Aissa, and two of his granddaughters, Alicia and Anita.

OPPOSITE PAGE, BELOW Ethan Wayne saddled up next to his father on location.

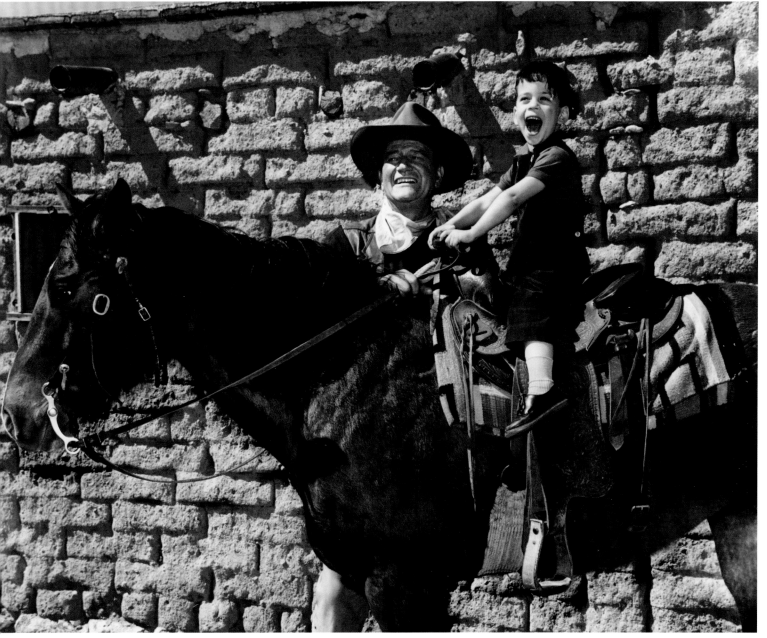

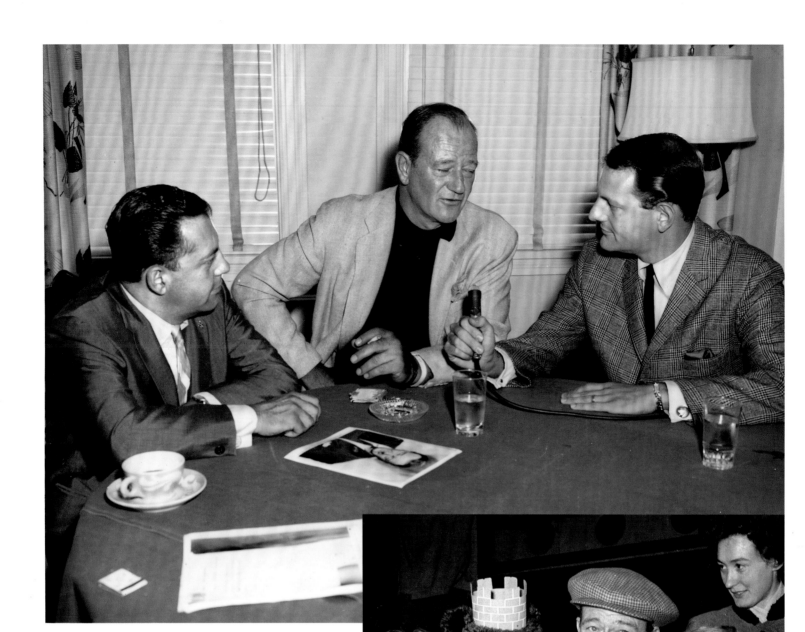

ABOVE John Wayne being interviewed in the 50s.

RIGHT John Wayne arriving at the airport in Berlin for the European premiere of *The Conqueror* (1956), being greeted by a boys choir, a Berliner bear, and beauty queens Inge Wax and Gitta Gorzelany.

OPPOSITE PAGE, ABOVE Duke with his little league team.

OPPOSITE PAGE, BELOW Wayne dining with screen goddess Jayne Mansfield.

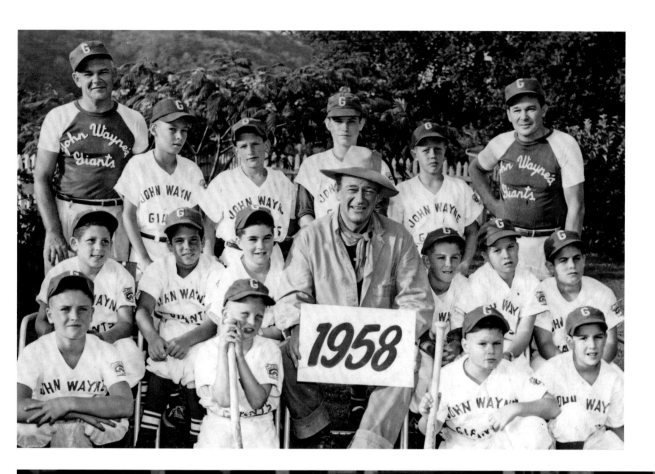

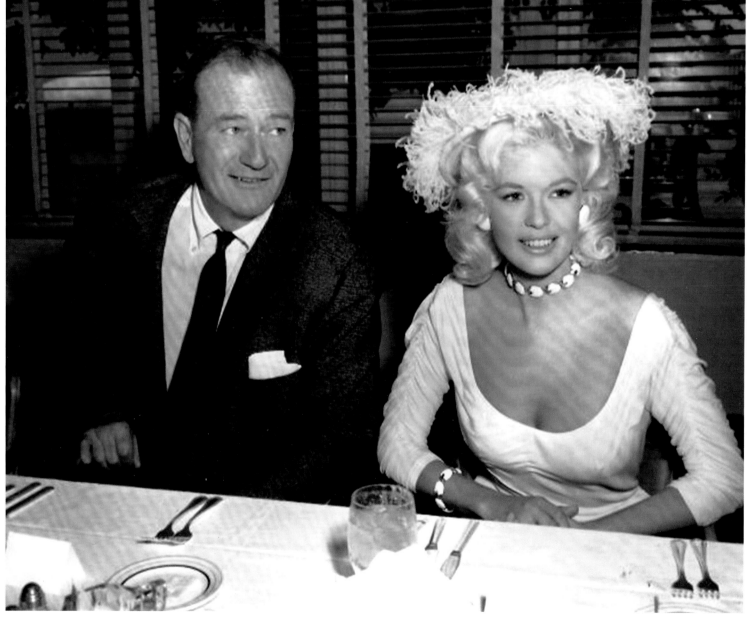

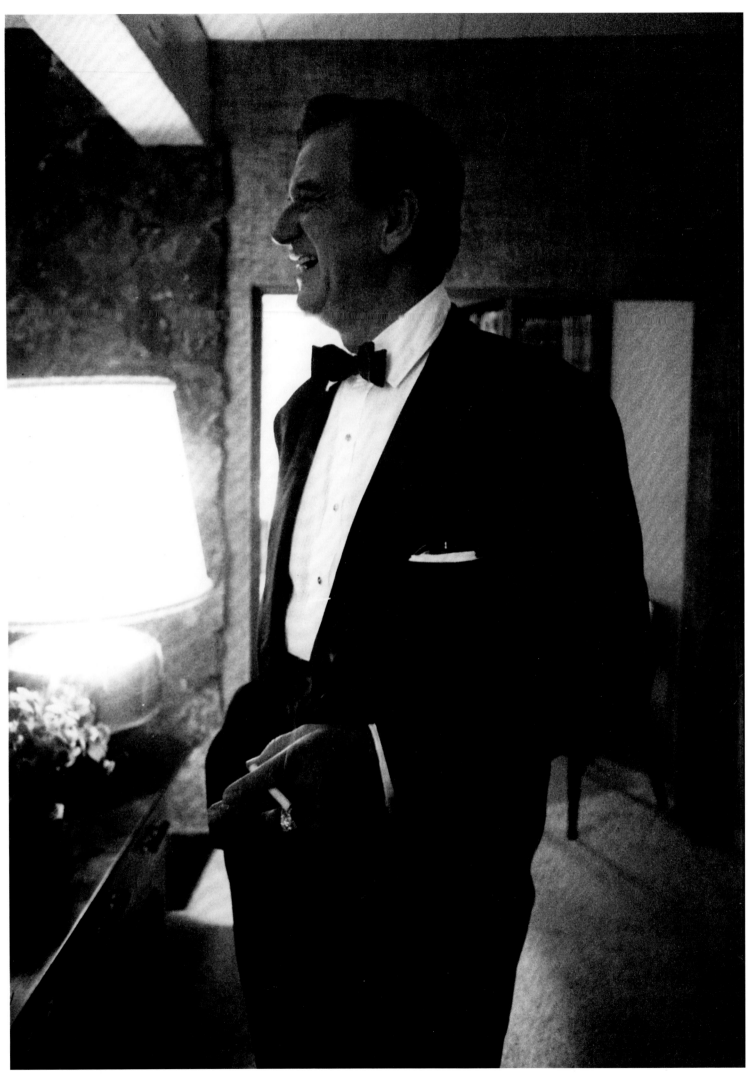

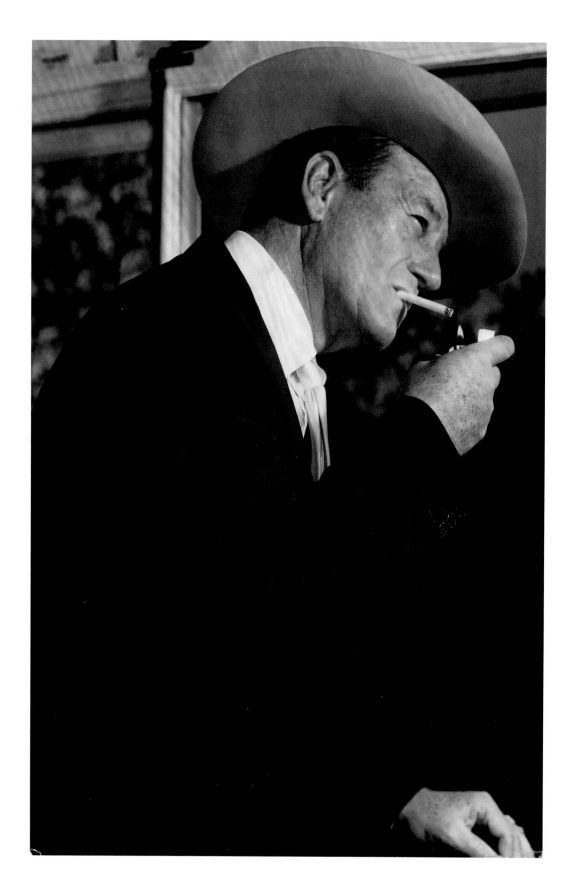

OPPOSITE PAGE John Wayne relaxing at home before a formal dinner.

LEFT John Wayne at the Savoy Hotel London prior to the film premiere of *The Alamo*, October 26, 1960. Wayne, an inveterate smoker, was diagnosed with lung cancer in 1964, and had a lung removed. He switched to cigars after that. He finally succumbed to the disease some 15 years later.

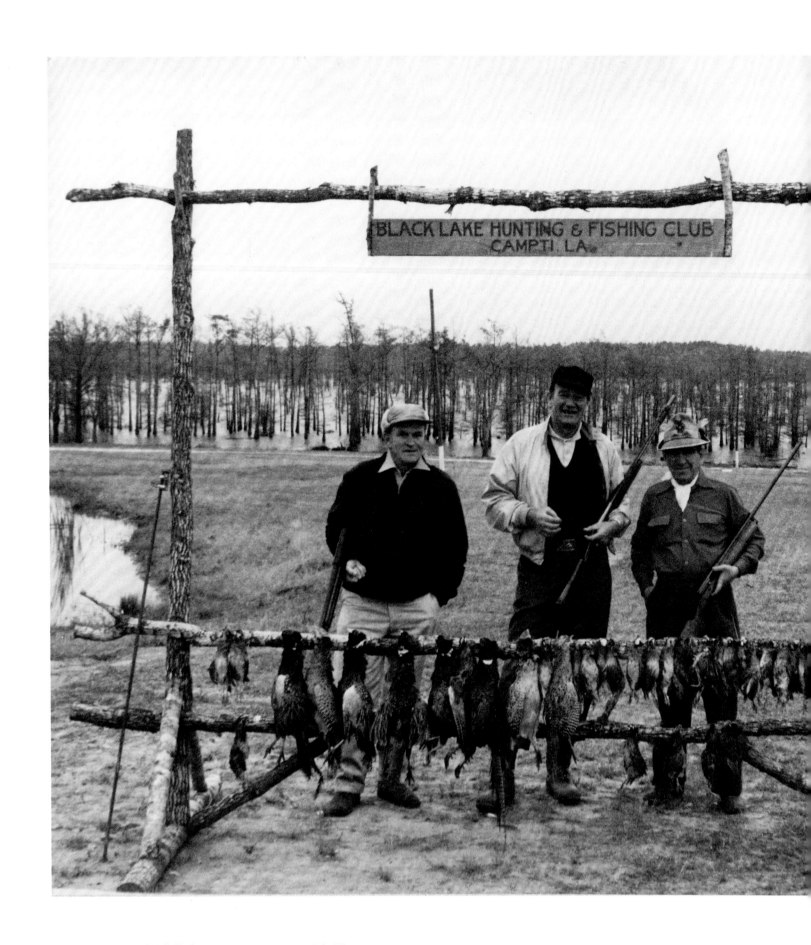

ABOVE John Wayne with Bill Clothier, the film's cameraman, and Web Overlander, the film's makeup artist, after a day of hunting while on location for *The Horse Soldiers* (1959) in Louisiana, on Thanksgiving Day.

OPPOSITE PAGE, ABOVE John Wayne on a hunting trip in Mexico, 1964.

OPPOSITE PAGE, BELOW John Wayne on Safari in Tanganyika, Africa while filming *Hatari!* (1962).

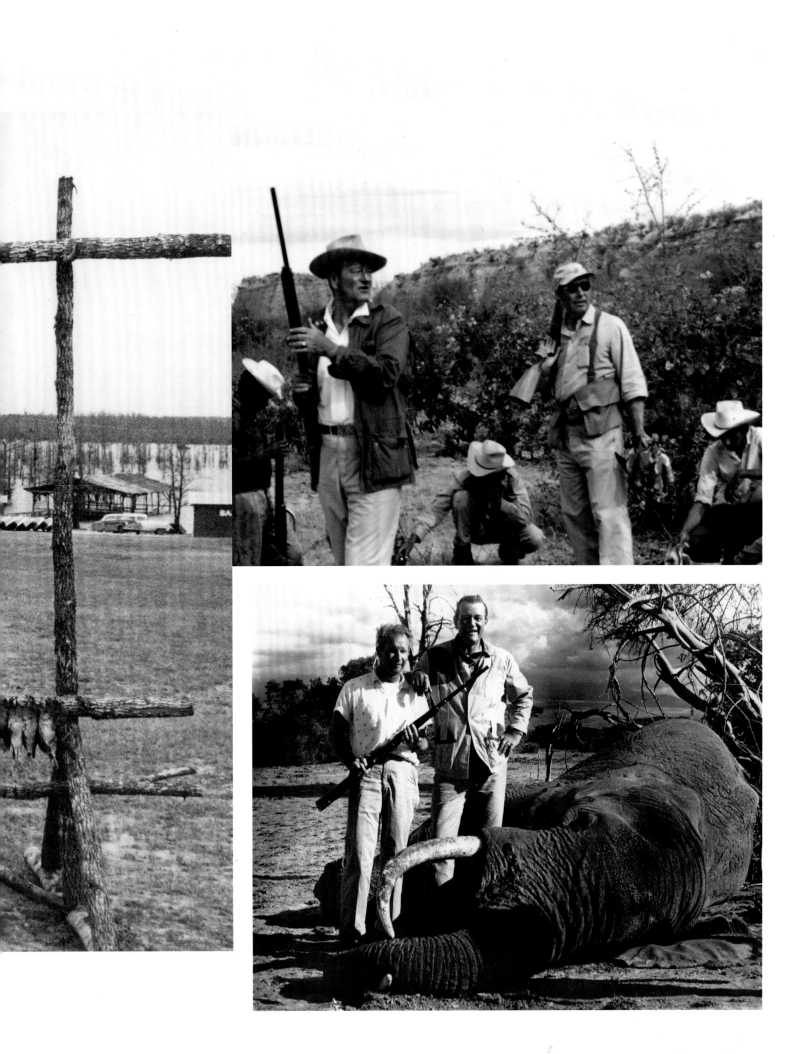

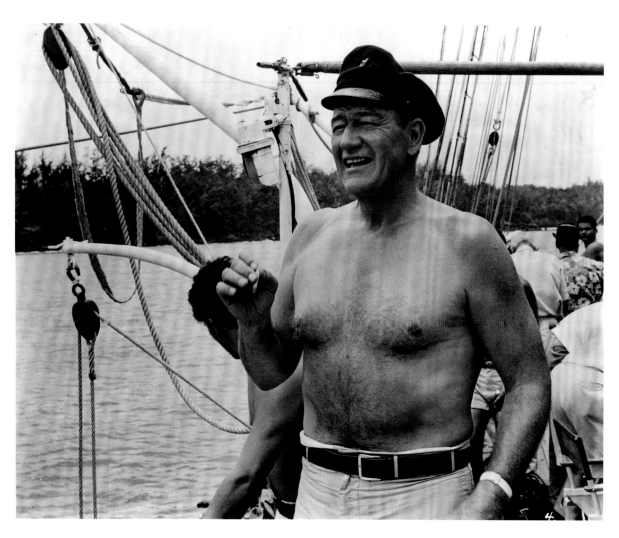

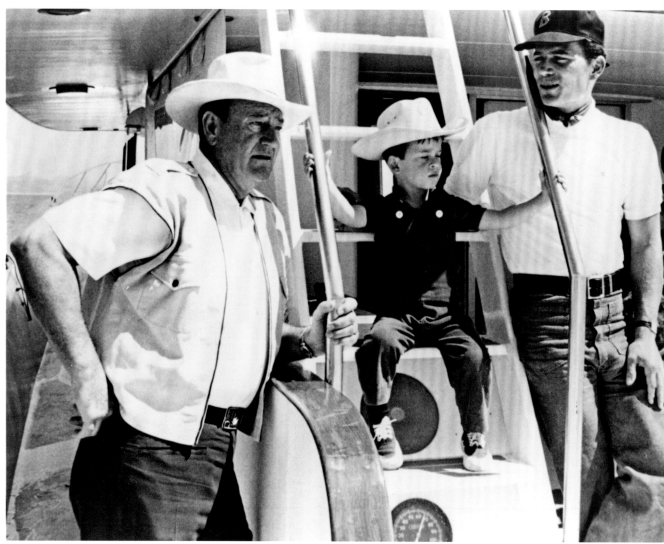

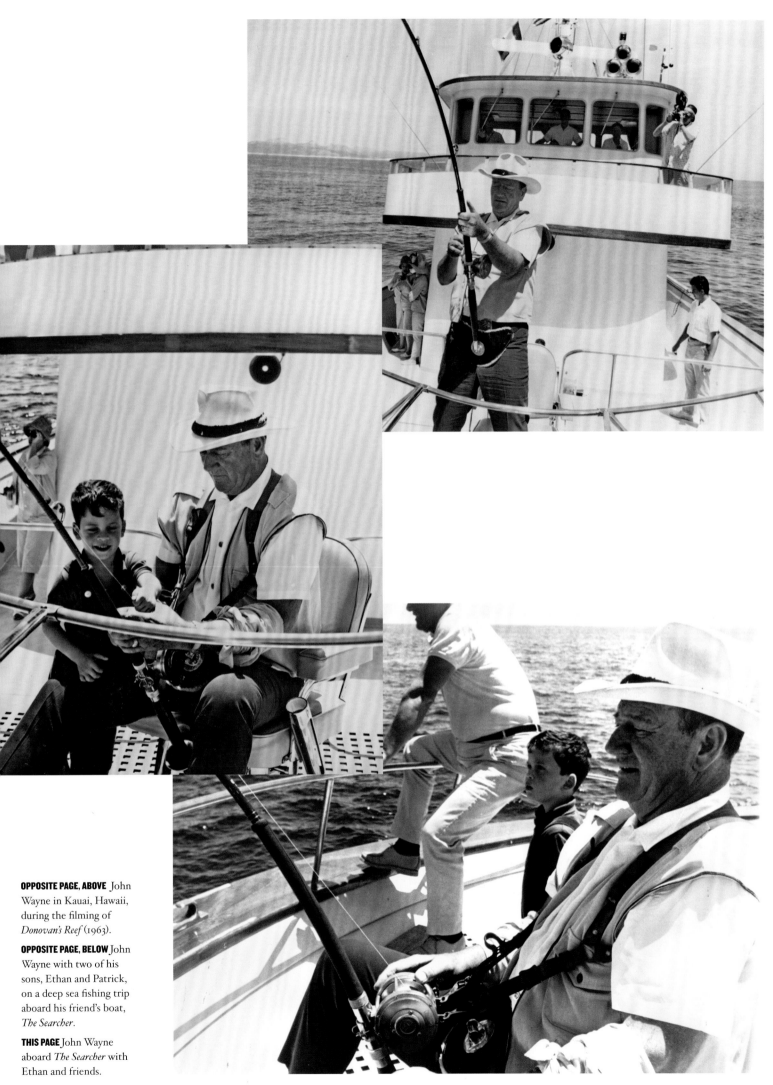

OPPOSITE PAGE, ABOVE John Wayne in Kauai, Hawaii, during the filming of *Donovan's Reef* (1963).

OPPOSITE PAGE, BELOW John Wayne with two of his sons, Ethan and Patrick, on a deep sea fishing trip aboard his friend's boat, *The Searcher*.

THIS PAGE John Wayne aboard *The Searcher* with Ethan and friends.

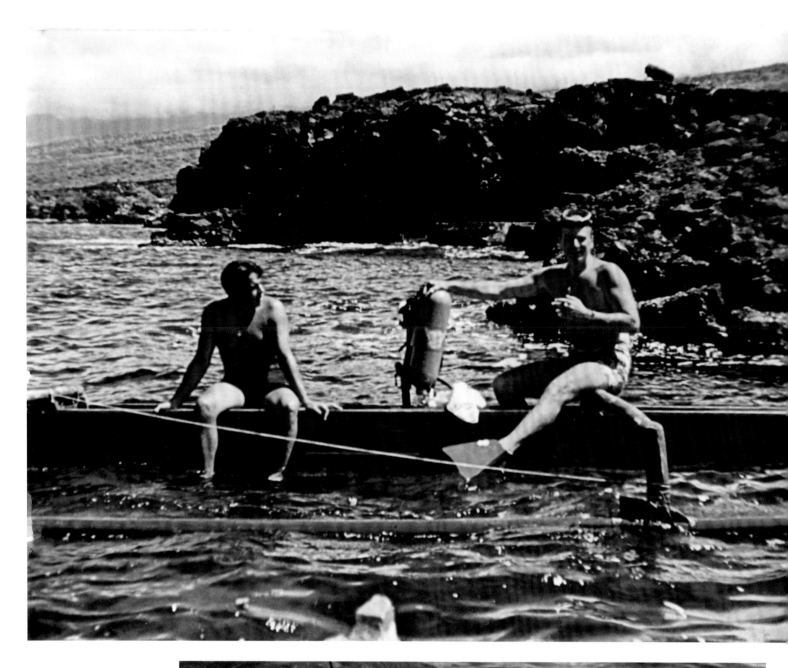

ABOVE John Wayne in an early pair of Churchill swimfins, diving off an outrigger in Kona, Hawaii, with an early Aqua-Lung.

RIGHT Diving in Hawaii.

OPPOSITE PAGE John Wayne in *Donovan's Reef* (1963) in Kauai, Hawaii. Wayne often stayed aboard his yacht during filming, and would swim to shore.

ABOVE A fan enclosed this candid snap with a note to Duke, one of tens of thousands of pieces of fan mail and memorabilia John Wayne received each year.

RIGHT John Wayne waterskiing in Acapulco.

OPPOSITE PAGE John Wayne in Hawaii.

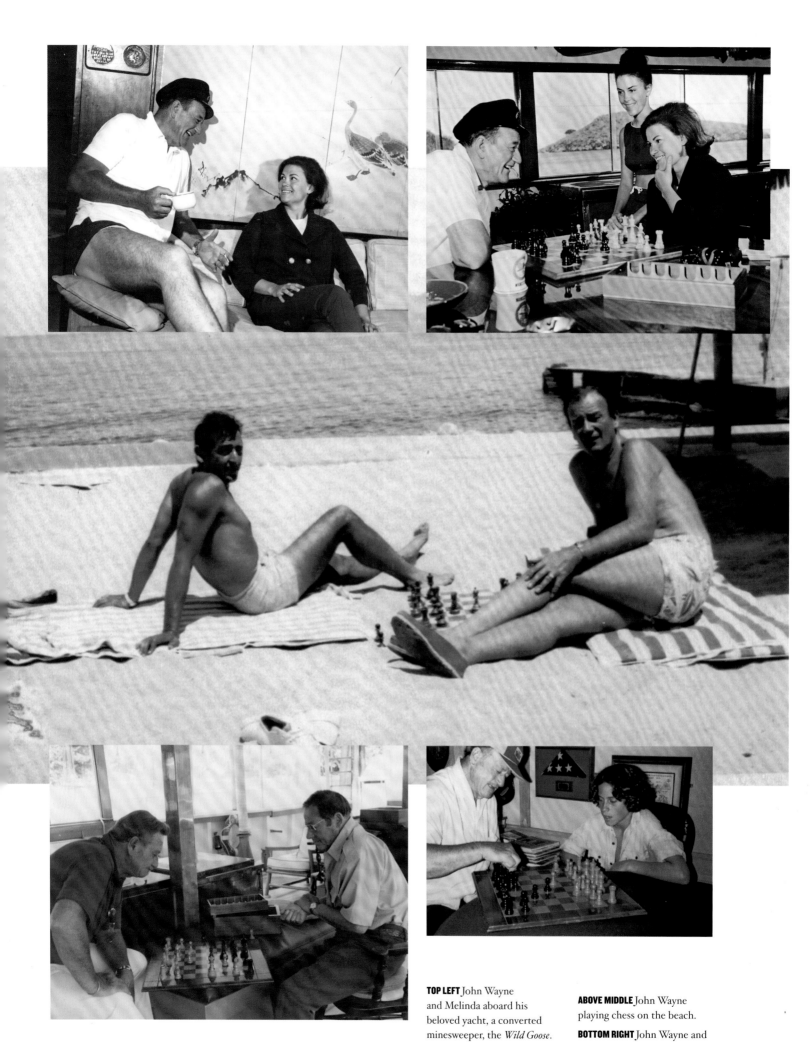

TOP LEFT John Wayne and Melinda aboard his beloved yacht, a converted minesweeper, the *Wild Goose*.

TOP RIGHT Duke with daughter Melinda and his daughter-in-law Peggy aboard the *Wild Goose* in Majorca, Spain.

ABOVE MIDDLE John Wayne playing chess on the beach.

BOTTOM RIGHT John Wayne and Ethan aboard the *Wild Goose*.

BOTTOM LEFT John Wayne with author and friend Ernest Gann aboard the *Wild Goose*.

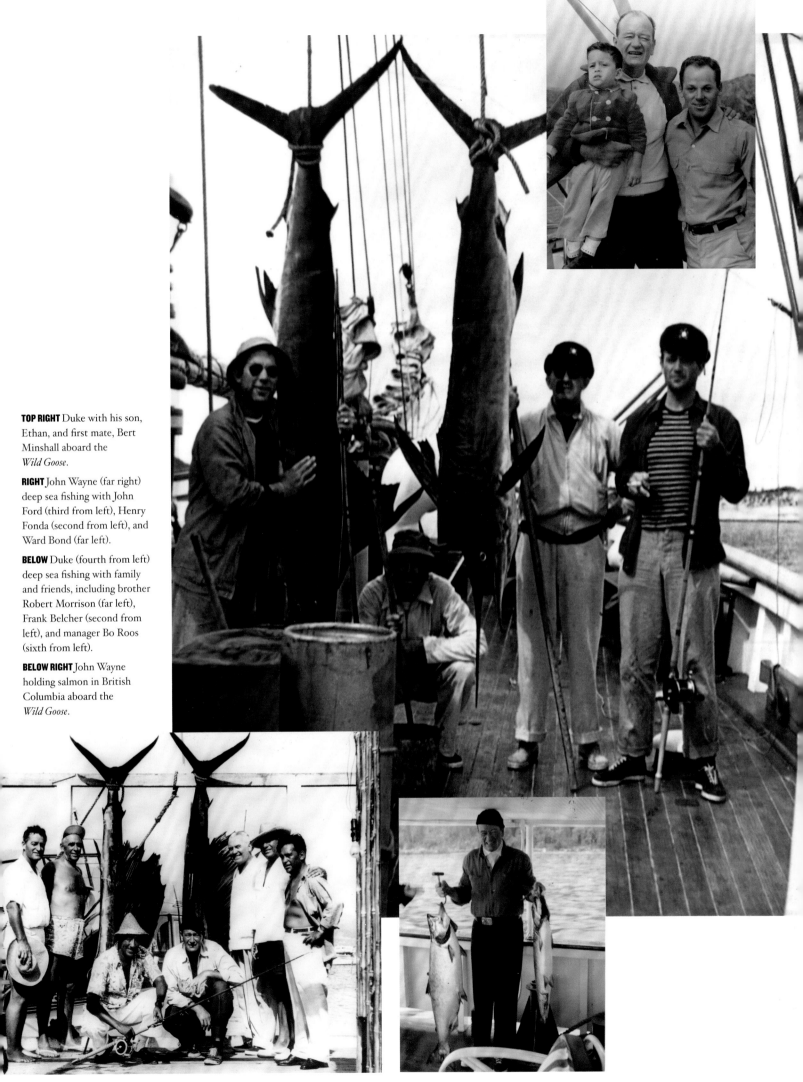

TOP RIGHT Duke with his son, Ethan, and first mate, Bert Minshall aboard the *Wild Goose*.

RIGHT John Wayne (far right) deep sea fishing with John Ford (third from left), Henry Fonda (second from left), and Ward Bond (far left).

BELOW Duke (fourth from left) deep sea fishing with family and friends, including brother Robert Morrison (far left), Frank Belcher (second from left), and manager Bo Roos (sixth from left).

BELOW RIGHT John Wayne holding salmon in British Columbia aboard the *Wild Goose*.

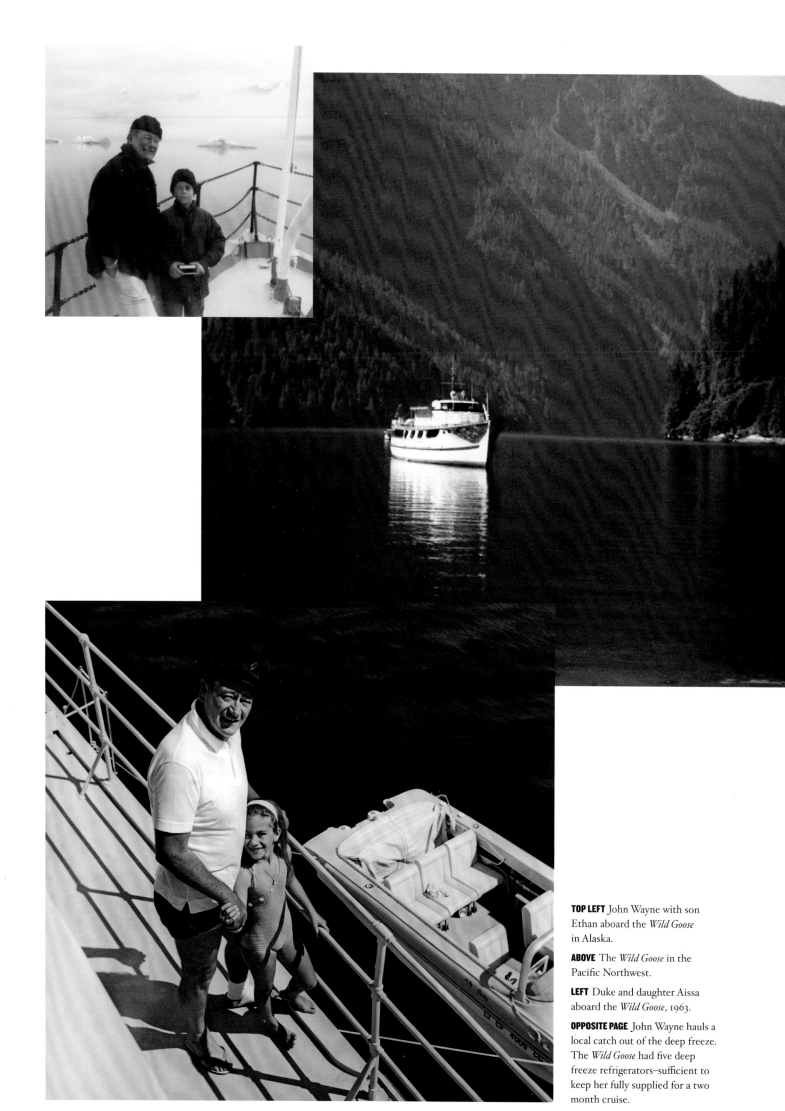

TOP LEFT John Wayne with son Ethan aboard the *Wild Goose* in Alaska.

ABOVE The *Wild Goose* in the Pacific Northwest.

LEFT Duke and daughter Aissa aboard the *Wild Goose*, 1963.

OPPOSITE PAGE John Wayne hauls a local catch out of the deep freeze. The *Wild Goose* had five deep freeze refrigerators–sufficient to keep her fully supplied for a two month cruise.

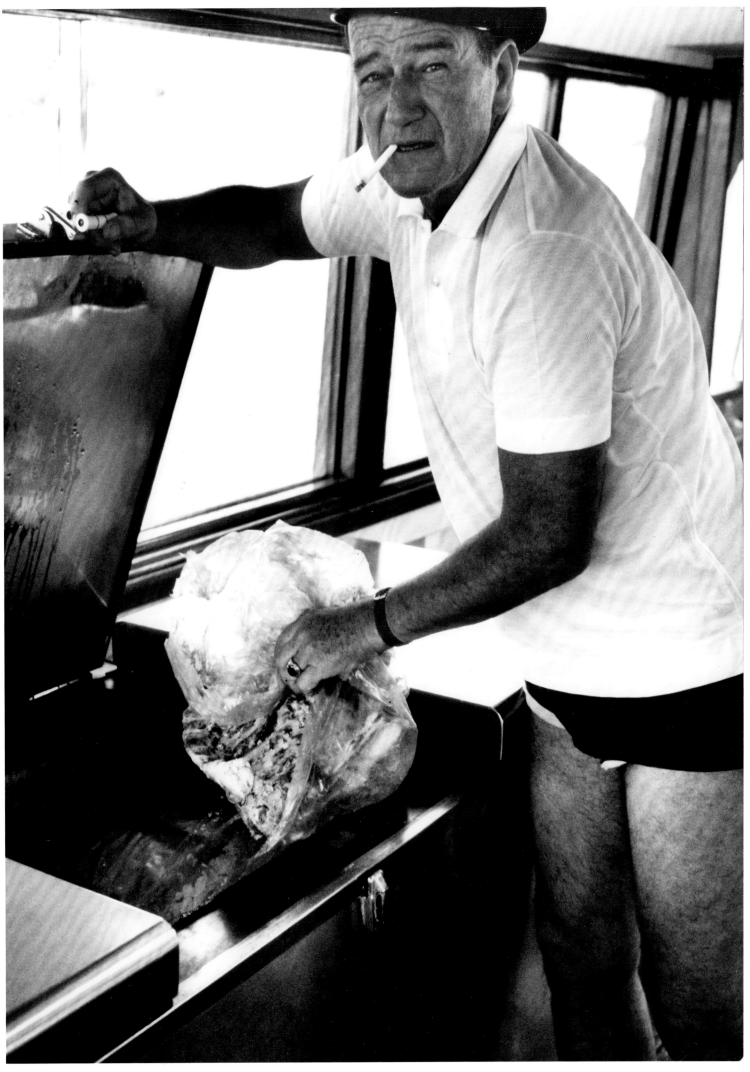

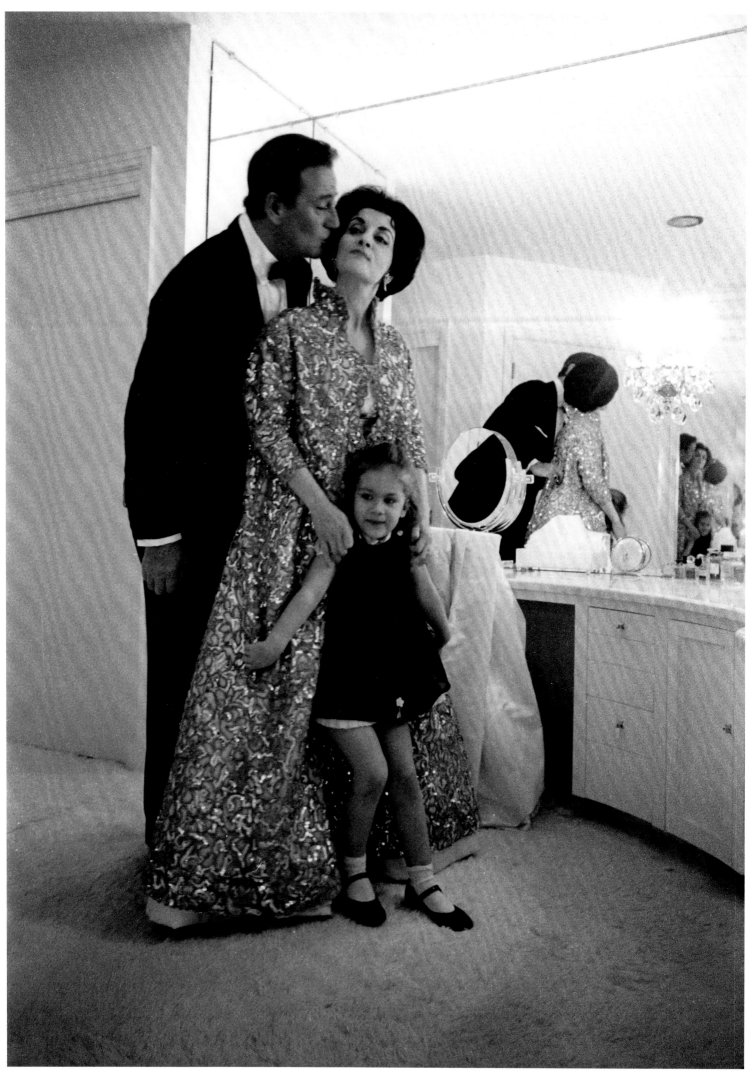

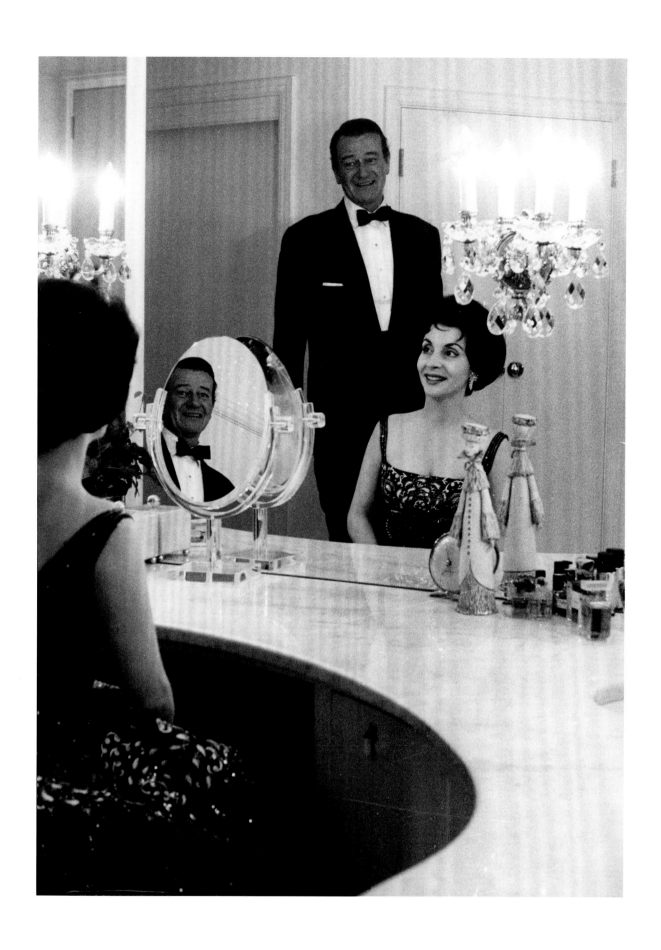

OPPOSITE PAGE Aissa, Pilar, and John
Wayne at home, in their master
dressing room.

ABOVE Pilar and John Wayne ready
for a formal event.

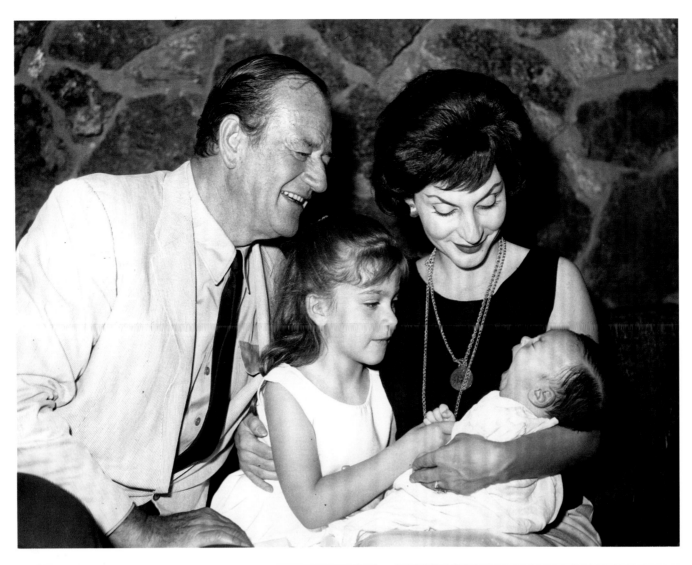

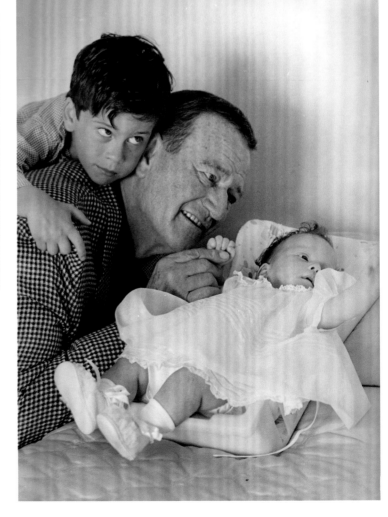

TOP AND ABOVE Newborn
Ethan Wayne with parents
and sister Aissa.

RIGHT Newborn Marisa
Wayne with father and
older brother Ethan.

OPPOSITE PAGE
John Wayne with his
newborn daughter Marisa.

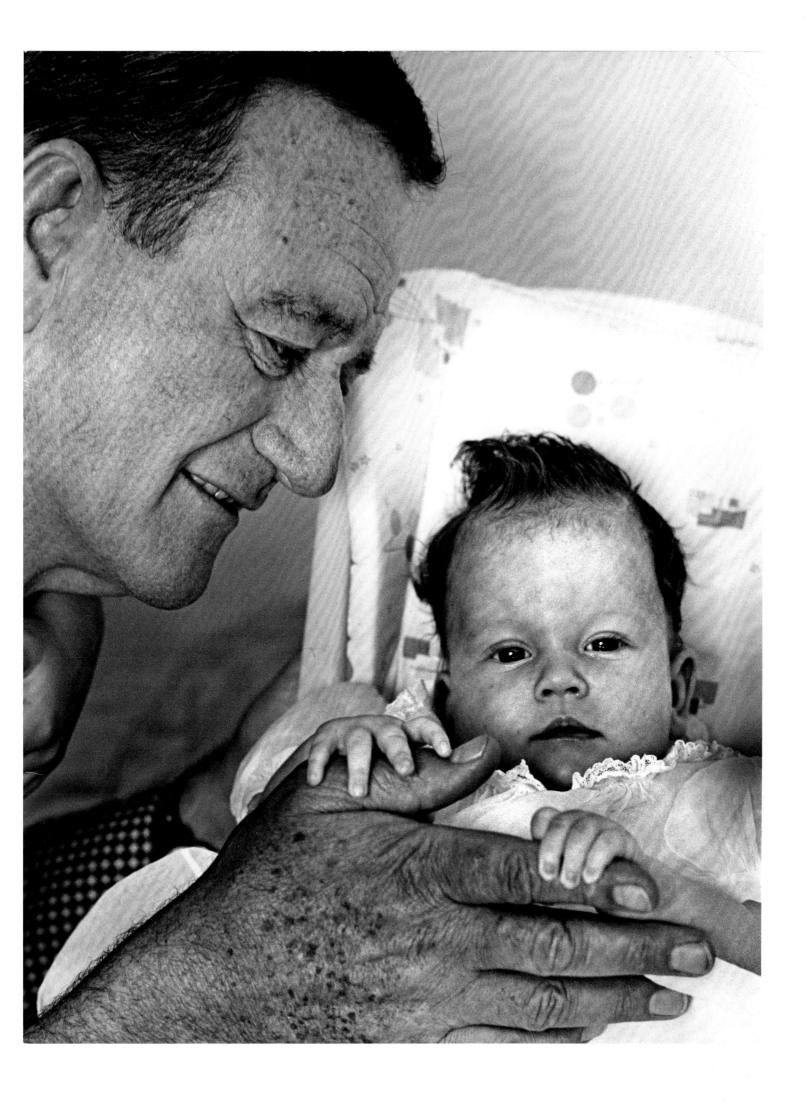

ABOVE Christmas morning Ethan Wayne and father tinker with a train engine.

RIGHT Duke assembling Ethan's Christmas present on Christmas morning.

OPPOSITE PAGE Pilar, Aissa, Ethan, and John Wayne on Christmas morning.

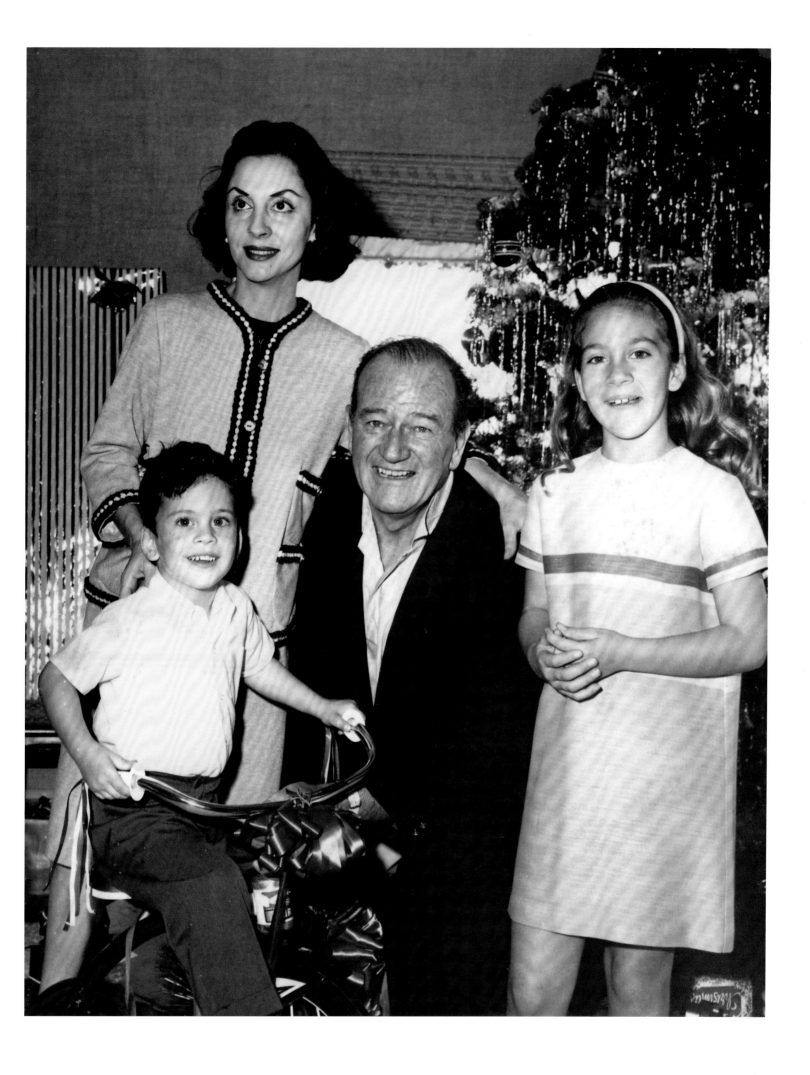

LEFT The leading men of Henry Hathaway's film, *The Sons of Katie Elder* (1965) – John Wayne, Dean Martin, Earl Holliman, and Michael Anderson, Jr.

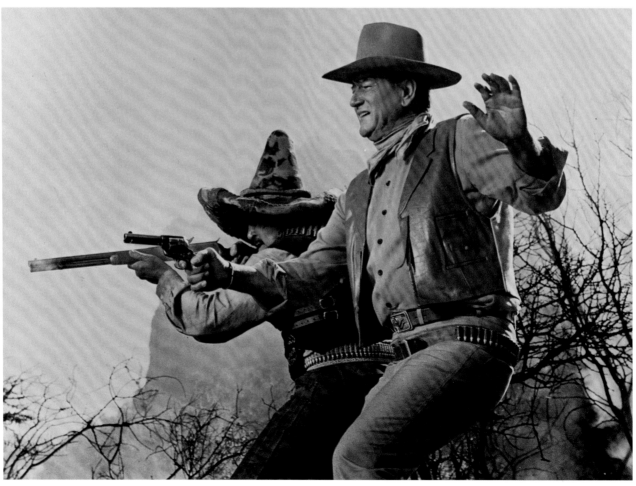

OPPOSITE PAGE, ABOVE John Wayne as Matt Masters in Henry Hathaway's *Circus World* (1964).

OPPOSITE PAGE, BELOW John Wayne in the film *The War Wagon* (1967).

LEFT John Wayne on the set of *Chisum* (1970).

BELOW Claudia Cardinale being rescued from a blazing fire by Duke in *Circus World* (1964).

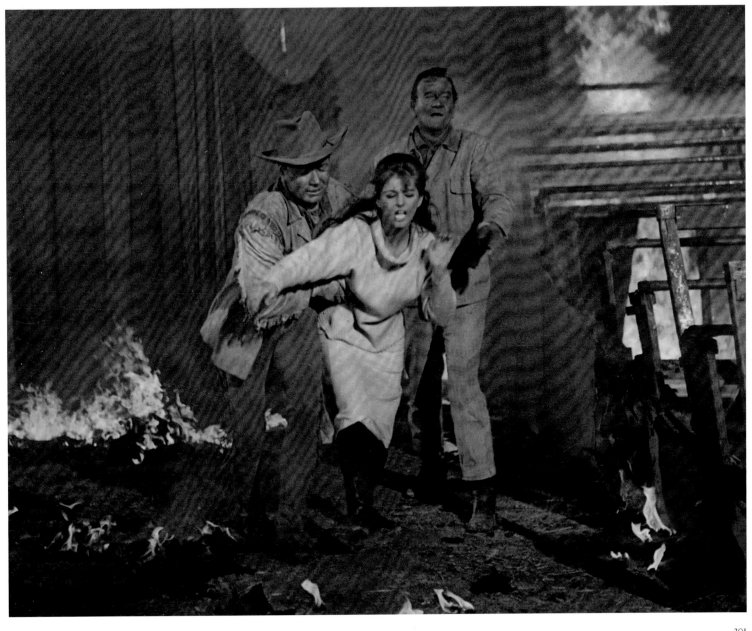

"Words are what men live by...words they say and mean."

John Wayne

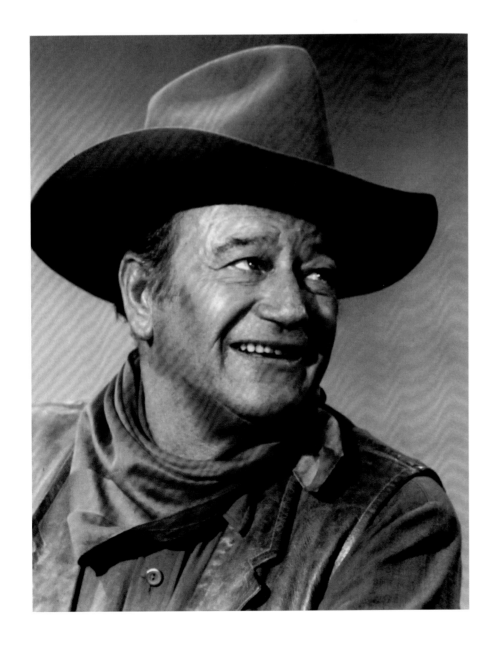

OPPOSITE PAGE Duke with youngest son Ethan on the set of *The War Wagon* (1967).

LEFT A Duke head shot from later in his career.

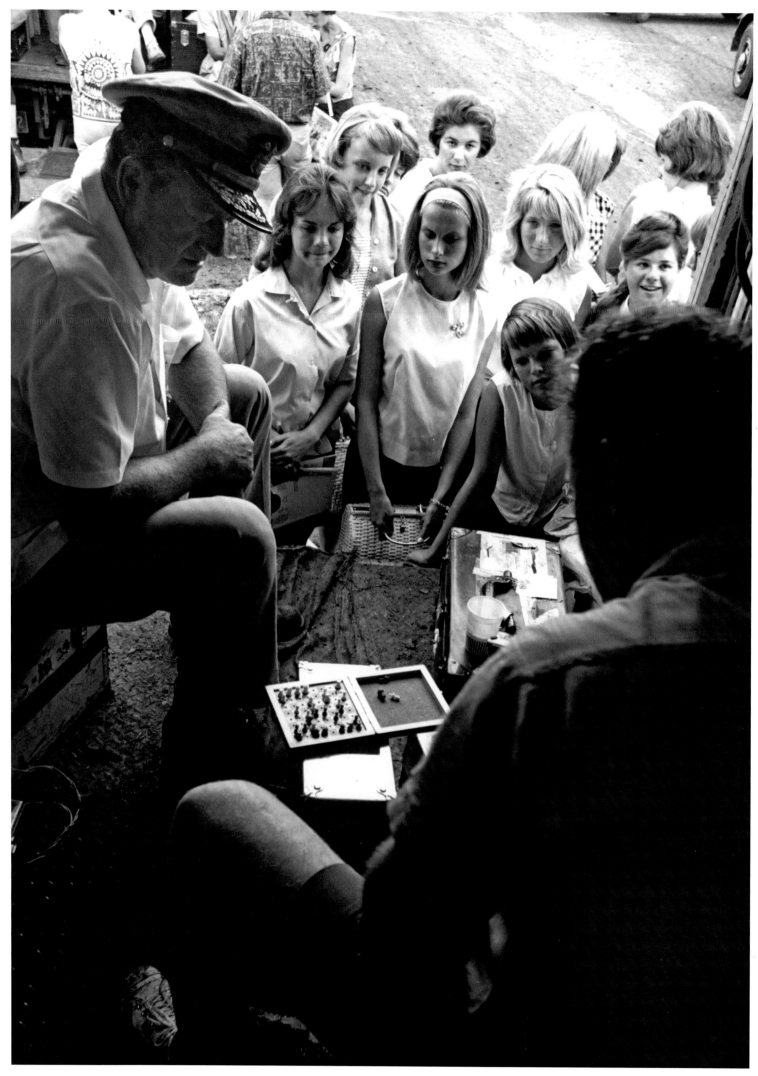

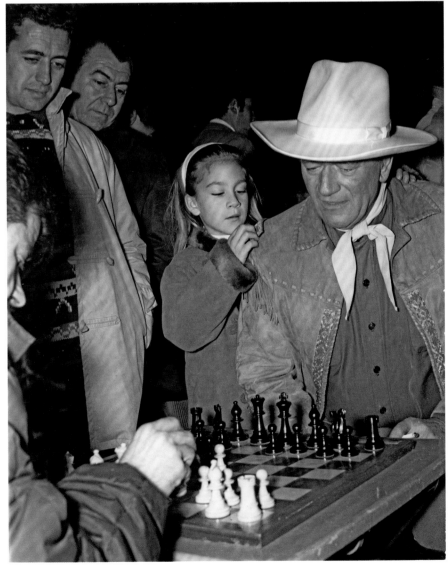

OPPOSITE PAGE Wayne playing chess with a film crew member as locals gawk.

ABOVE John Wayne with son Patrick and daughter Toni playing chess.

LEFT Duke enjoys his favorite game while daughter Aissa watches on the set of *Circus World* (1964).

"Tomorrow is the most important thing in life. Comes into us at midnight very clean. It's perfect when it arrives and it puts itself in our hands. It hopes we've learned something from yesterday."

John Wayne

OPPOSITE PAGE
Duke with son Ethan.

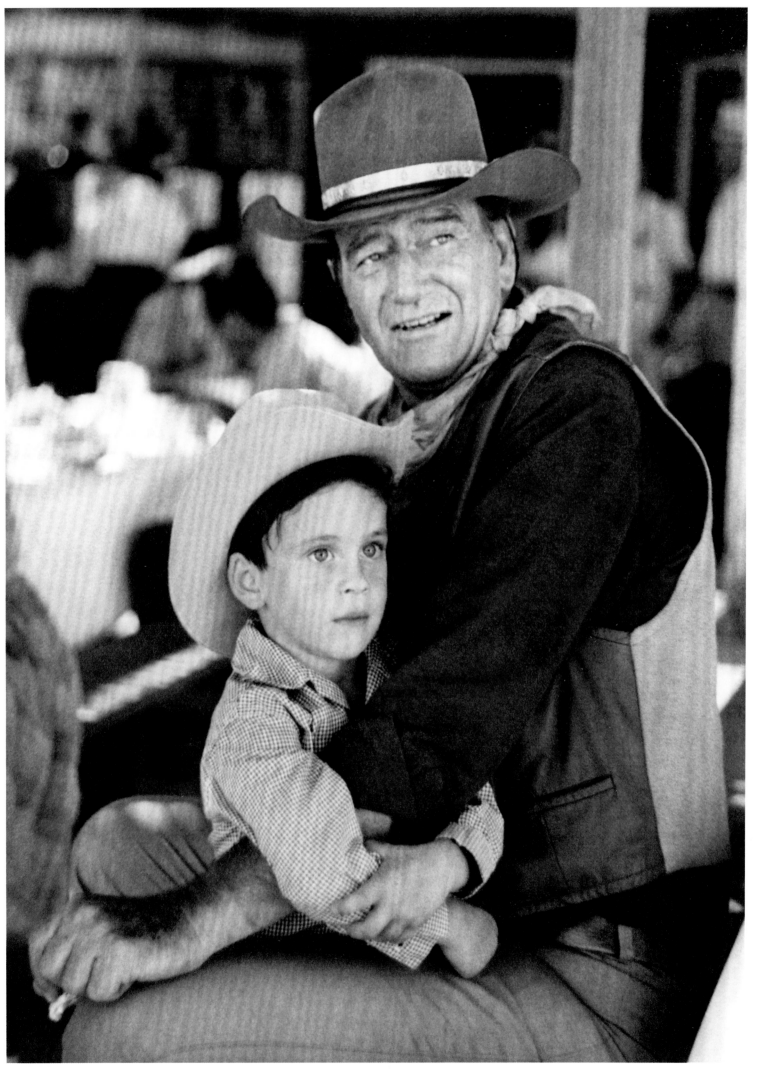

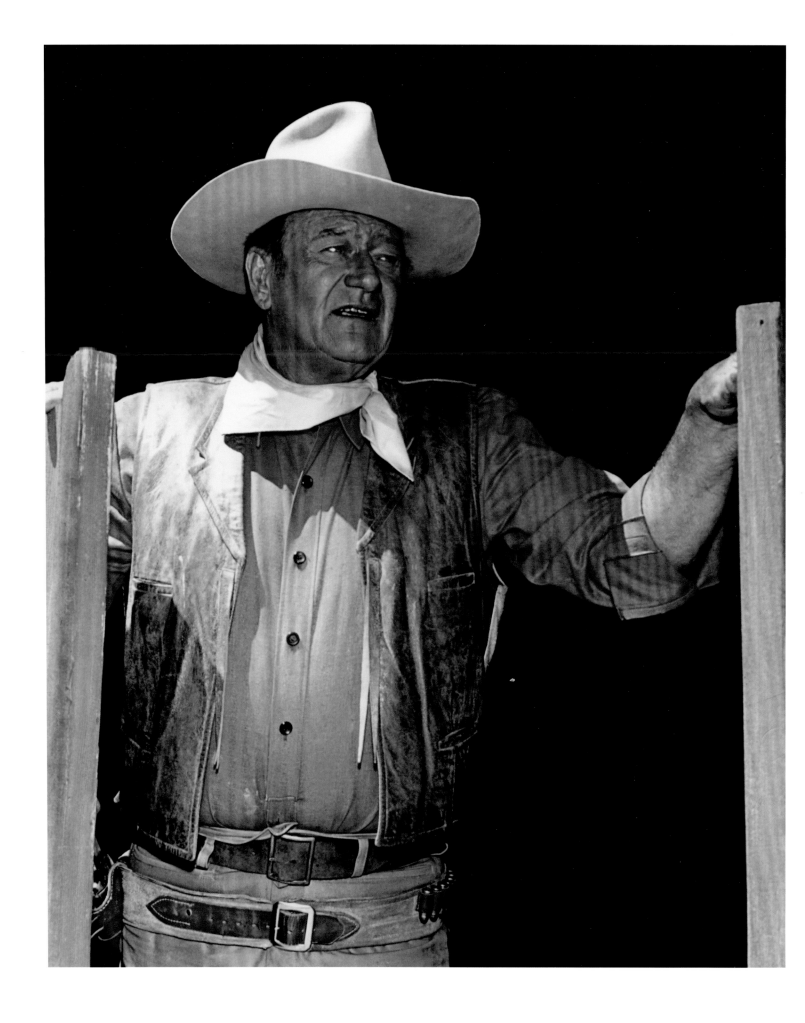

ABOVE Duke busting out of a
saloon on set.

OPPOSITE PAGE John Wayne in
The Cowboys (1972).

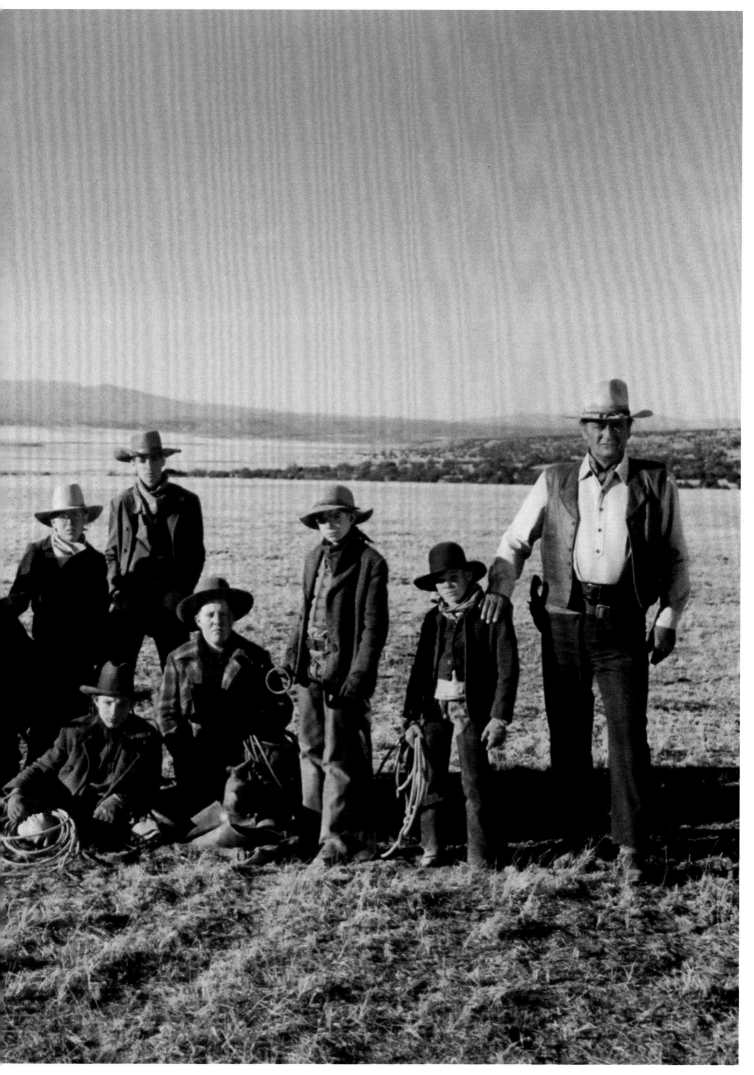

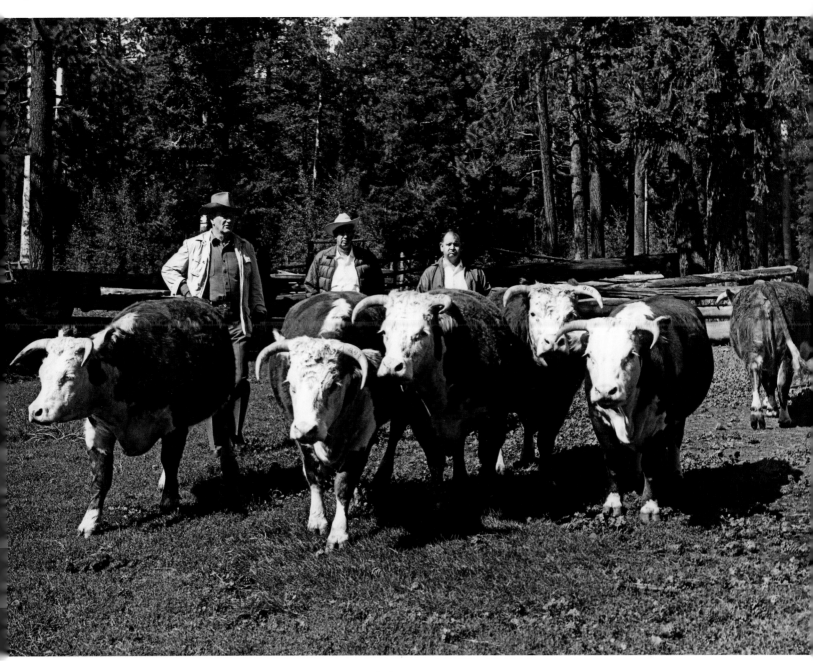

TOP John Wayne with his ranch hands Ken Reafsnyder and Louis Johnson at the 26 Bar Ranch he co–owned in Springerville, Arizona.

ABOVE John Wayne with Louis Johnson (far left) and two Hereford cattlemen.

ABOVE RIGHT John Wayne with grandson at his ranch's annual cattle sale.

OPPOSITE PAGE John Wayne and Jacquetta LeForce, the daughter of the ranch manager of 26 Bar Ranch.

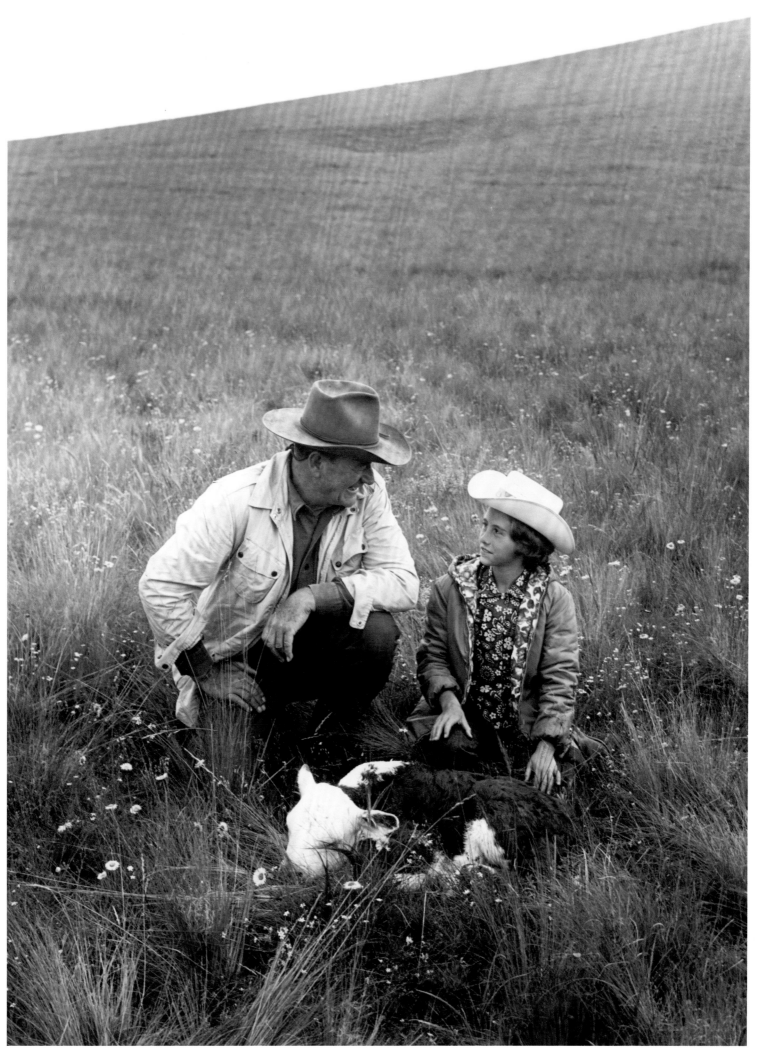

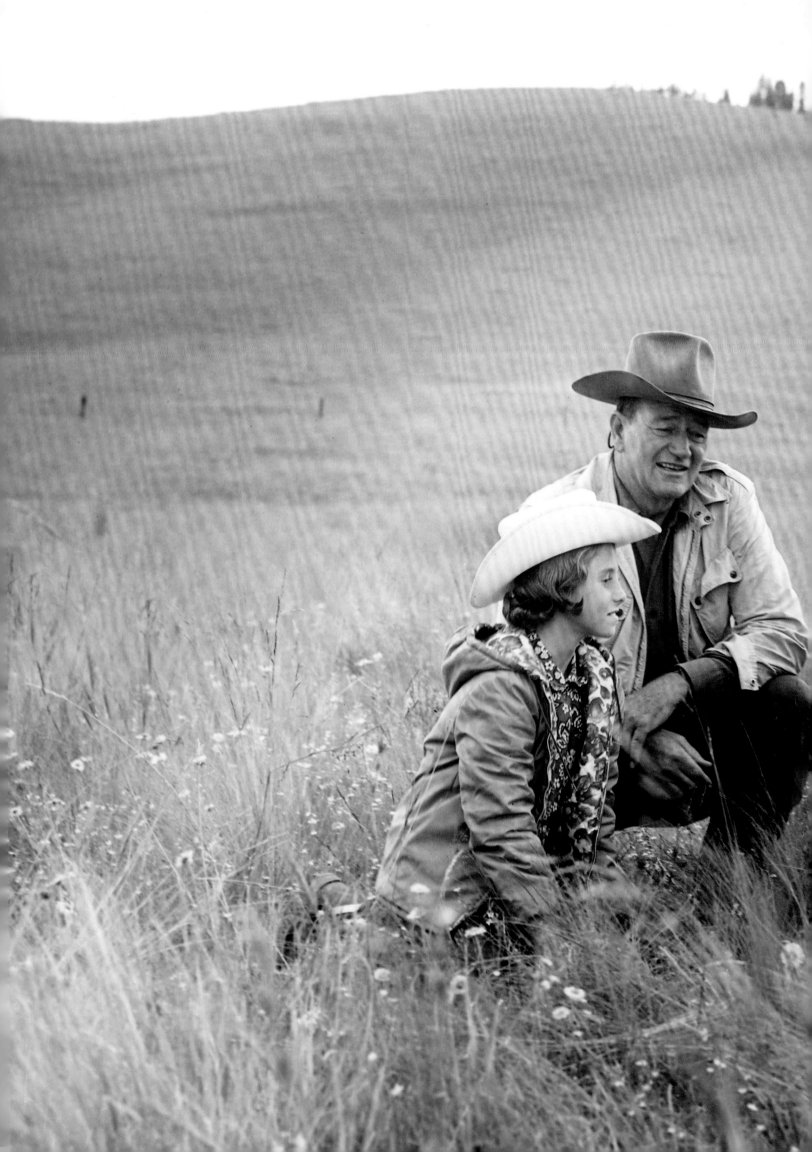

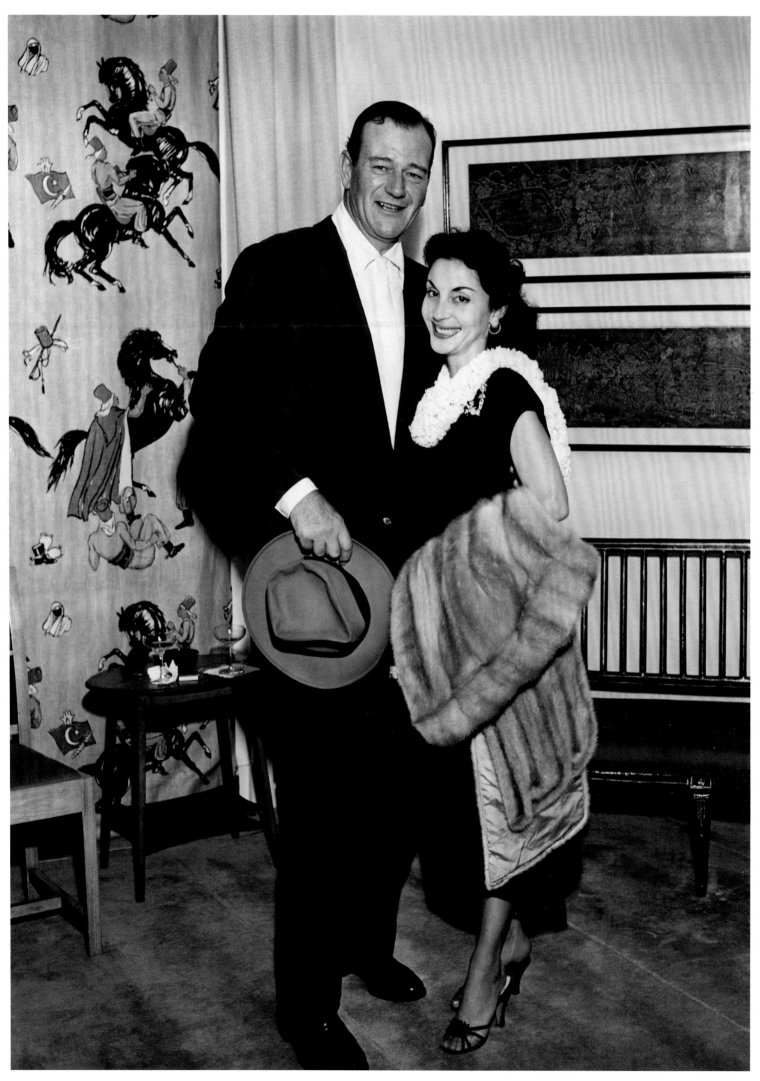

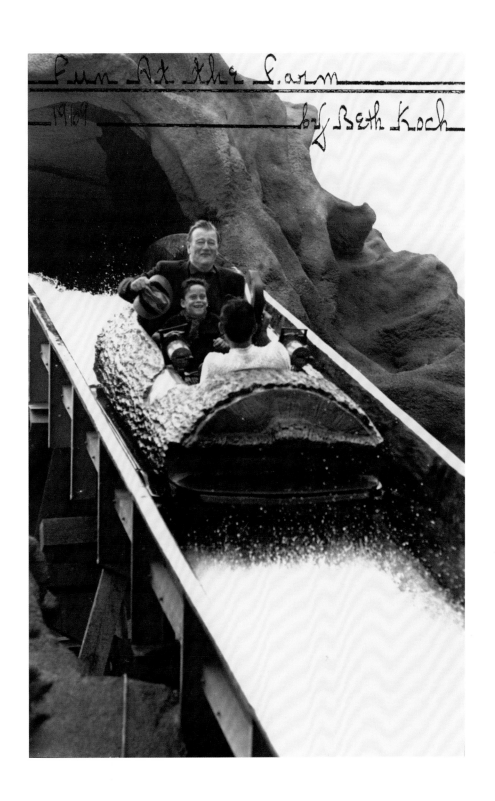

Fun At the Farm
1969
by Beth Koch

PREVIOUS SPREAD
John Wayne with son Patrick and Jacquetta LeForce at the ranch.

OPPOSITE PAGE John Wayne with Pilar.

ABOVE Duke with son Ethan at the opening of Knott's Berry Farm, the Log Ride.

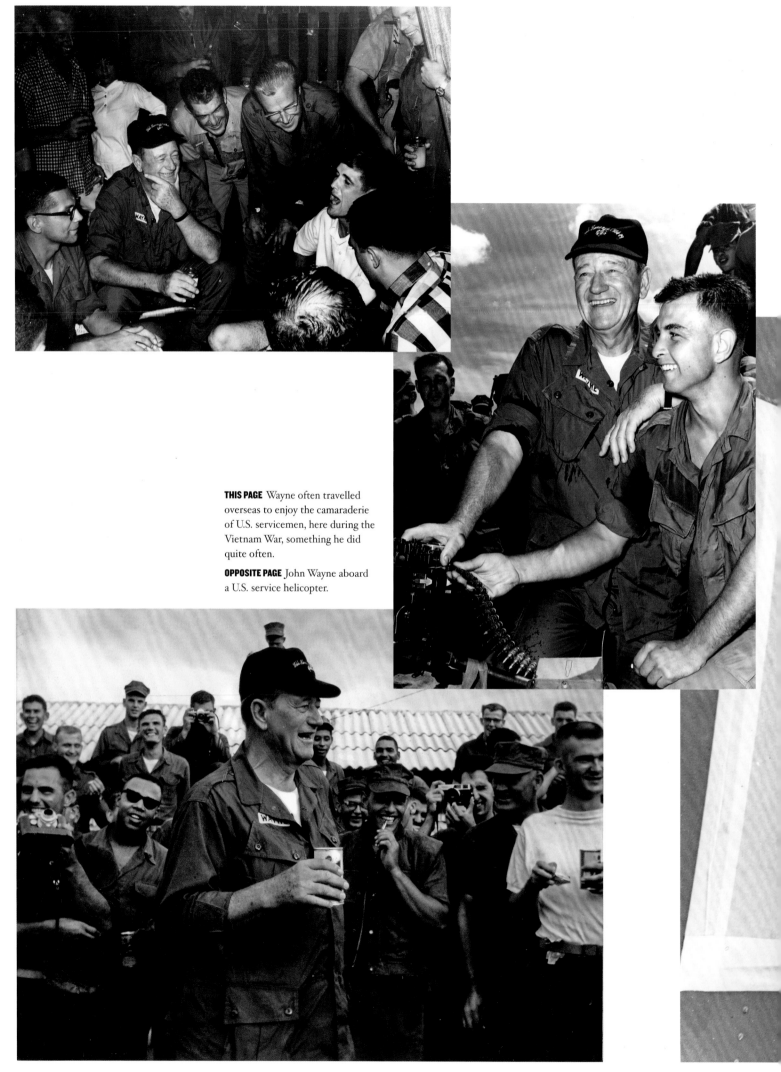

THIS PAGE Wayne often travelled overseas to enjoy the camaraderie of U.S. servicemen, here during the Vietnam War, something he did quite often.

OPPOSITE PAGE John Wayne aboard a U.S. service helicopter.

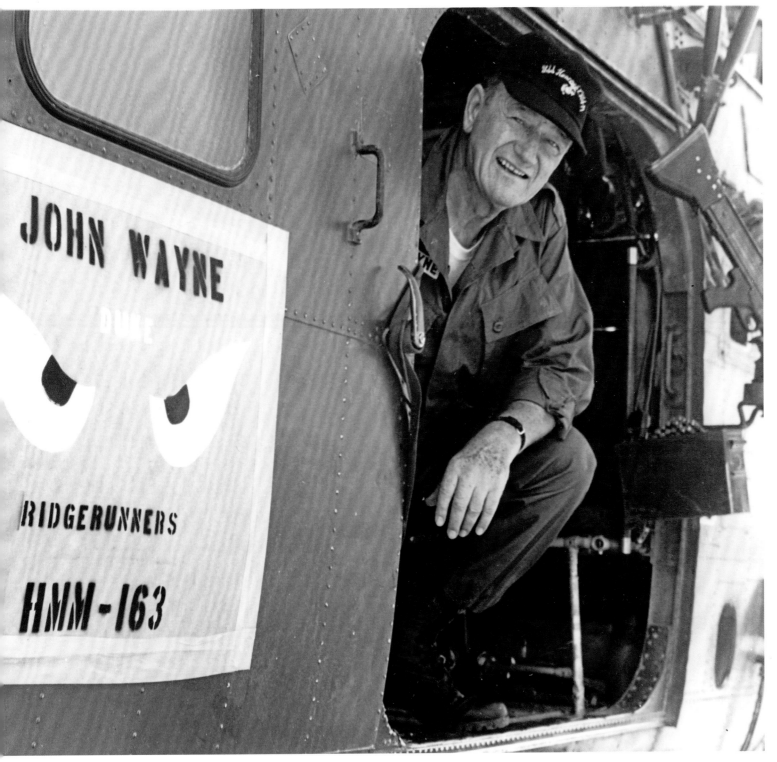

"I am an old-fashioned, honest-to-goodness, flag-waving patriot."

John Wayne

OPPOSITE PAGE John Wayne
with son Ethan in full military
costume behind the scenes
while filming *The Green Berets*
(1968).

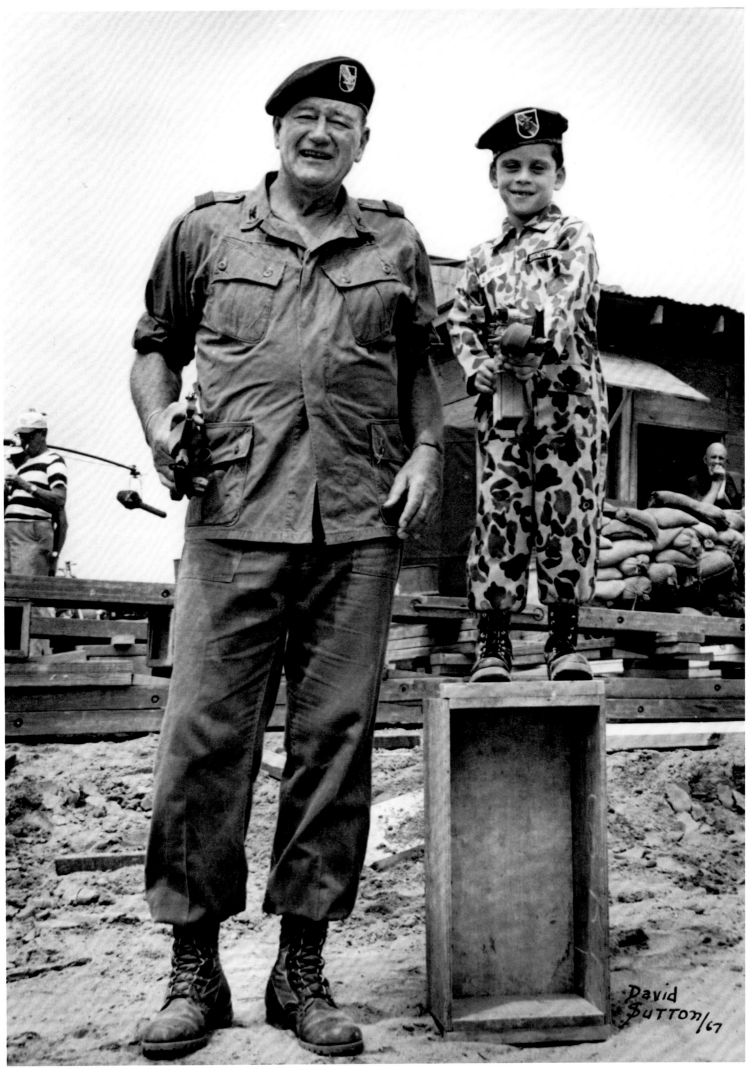

David Sutton/67

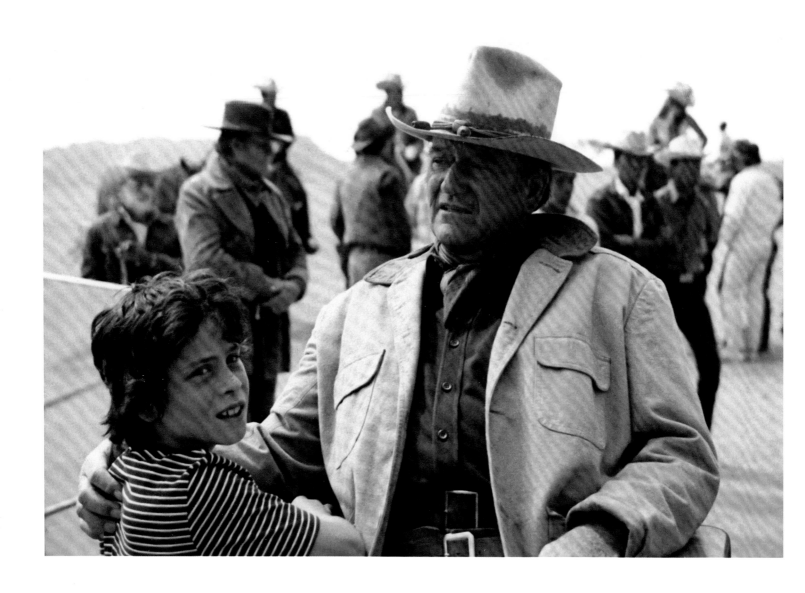

ABOVE John Wayne with
Ethan on the set of *The
Cowboys* (1972).

OPPOSITE PAGE Father and son
outdoors on three wheel
Honda ATC 90s in Santa Fe,
New Mexico while filming
The Cowboys (1972).

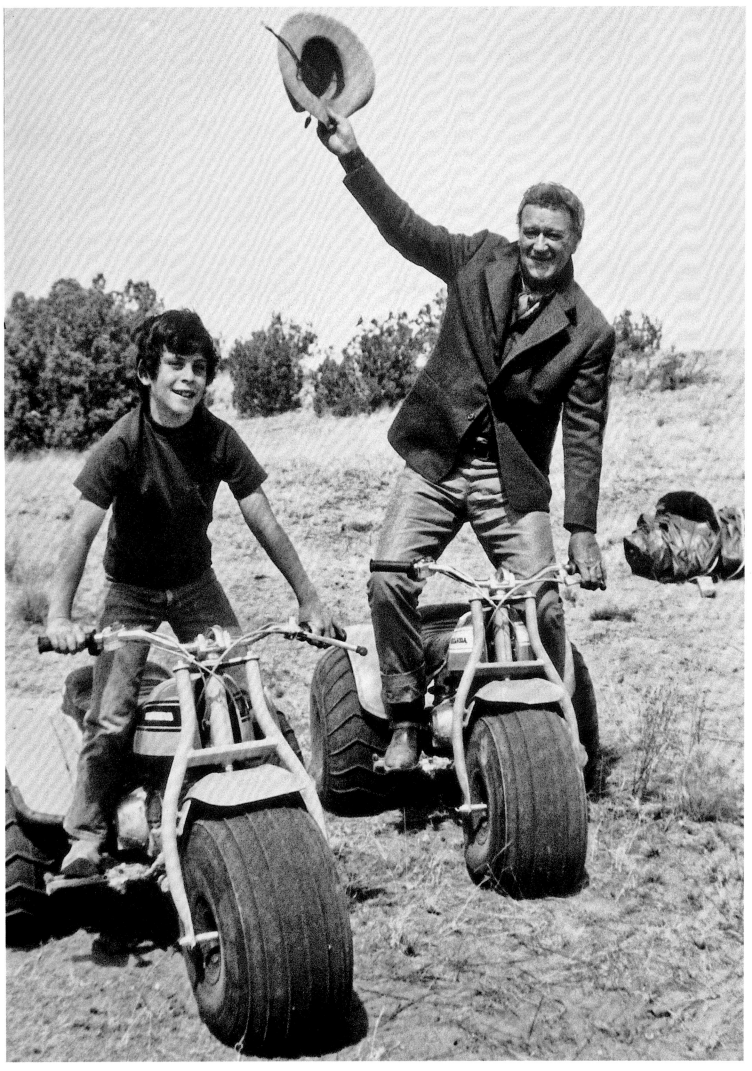

RON HOWARD

When I first met John Wayne it was in Carson City, Nevada. I'd been cast in *The Shootist*. A day or two before filming, I walked into the hotel, which was also a casino with a kind of western motif to the whole thing. The director Don Siegel was down in the lobby and he grabbed me and he said, "Oh, I want to take you up and introduce you to the Duke."

We walked by a magazine stand and *TV Guide* was among the magazines. It happened to be a week when Henry Winkler and I were on the cover, doing our Richie and Fonzie characters. And he grabbed it and bought it, and he said, "Duke will get a kick out of this." And I'm thinking, "Oh, man, will he? Geez, I don't know...do I want to lead with me in my letterman sweater for this serious dramatic western we're making?" But I didn't disagree.

We went upstairs and knocked on the door, and John Wayne was there, and he had a buddy over, playing chess with him or something. I came in, and we shook hands—

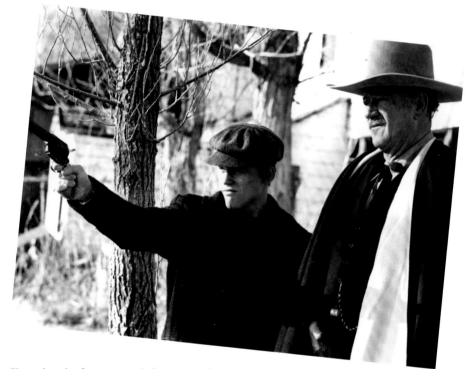

I'm a kind of average, 5'9" guy—and his hand completely enveloped mine. I really felt like I was ten-years-old all of a sudden. Don Siegel said, "This is Ron Howard, and take a look at this," and he showed him the *TV Guide* cover. Duke kind of looked at it at arms length so he could see it, and kind of looked at it, looked at me, looked back down at it, took a long pregnant pause, and then he looked up at me and said, "A big shot, huh?" And I thought, "Oh, man, I'm dead out of the gate here, so much for the *TV Guide* introduction," but, he laughed, and we sat down and talked for a while. "I really respect

ABOVE Ron Howard and John Wayne in *The Shootist* (1976).
OPPOSITE PAGE John Wayne in *The Shootist* (1976).

people who come out of TV," I remember him saying. He said that they didn't have TV in the 30s when he was doing the one-reelers, but he felt like it was the equivalent of that, and we wound up having a good working relationship.

There was friction between Don Siegel and John Wayne, but he never dragged me into the middle of that in any way. He let me have a good relationship with Don. He could have poisoned it if he wanted to, if he was a petty guy, but he wasn't. He had his own differences but that was between he and Don. Don Siegel was an A-list director; John Wayne was a major superstar. I'm not a person who enjoys tension, but it was interesting for me to see the way the two men navigated their differences and still made a really fine movie, and made it on schedule. It was a good learning experience for me on the most practical level. I'd never really seen a situation like that.

One thing that impressed me at the time, and was reassuring in a way, was that as much of a legend as John Wayne was in my industry, his process of showing up to work, participating in the movie, giving it his all—it was ordinary, very workmanlike. One of the things that clearly differentiated him was that, in his seventies, with nothing to prove, he was working as hard for the story and for the audience and for his own personal sense of self respect probably as he ever had, maybe harder.

It was so interesting for me to see him go from just learning the lines to suddenly shaping a John Wayne performance. I would watch movies in the theaters, and on TV, and I kind of figured this was his natural demeanor and he was applying it to the roles. He was that kind of a star. He was a huge personality and that is what he offered the audience—applying his sensibility, his stature, his personality to a character. And the way the lines were delivered, the pauses—those little characteristic John Wayne hitches—I

used to wonder if those were just moments where he was forgetting his lines for a second and then he'd carry on. But in person, I saw him rebalancing and refining the way he was going to deliver a line. He'd do it once and he'd say, "Let me try it again," and he'd do it again and he'd actually put that hitch into it—and suddenly the line just had more power and more impact. I was twenty-one—he called me "old twenty-one" all the time—and I just found the whole experience very revealing and gratifying because it just kept reminding me that great application of the fundamentals was something reliable, and that you can depend upon it. Here's a big movie star John Wayne, still depending on the same fundamentals that I'd seen around a number of other great actors, including Andy Griffith who had a very different style and a different tone but worked similarly... John Wayne gave me confidence; there I was doing a movie with one of the greatest movie stars of all time, and he was treating me with respect and including me in his process in a way that was a big boost. We talked about directing...he had directed *The Alamo*, and I had not yet directed professionally; I'd only made short films, but I was working very hard to direct a movie. I made *The Shootist* when I was twenty-one, and my first professional directing job came when I was twenty-three. So there I was, on the brink of making that transition, and I talked to him about that. I remember him talking about John Ford, and Ford's handling of emotion, and that he subscribed to a theory that you never wanted to give the audience a hundred percent of an emotional catharsis as an actor. You always need to hold back a certain amount of emotion so that the audience can sort of internalize it and complete it themselves. That was a Ford idea that John Wayne absorbed and personified, and passed on to me as a budding director and as an actor.

The thing that I really picked up from John Wayne was the idea of simple, unsentimental truth being a very humanizing quality. I've

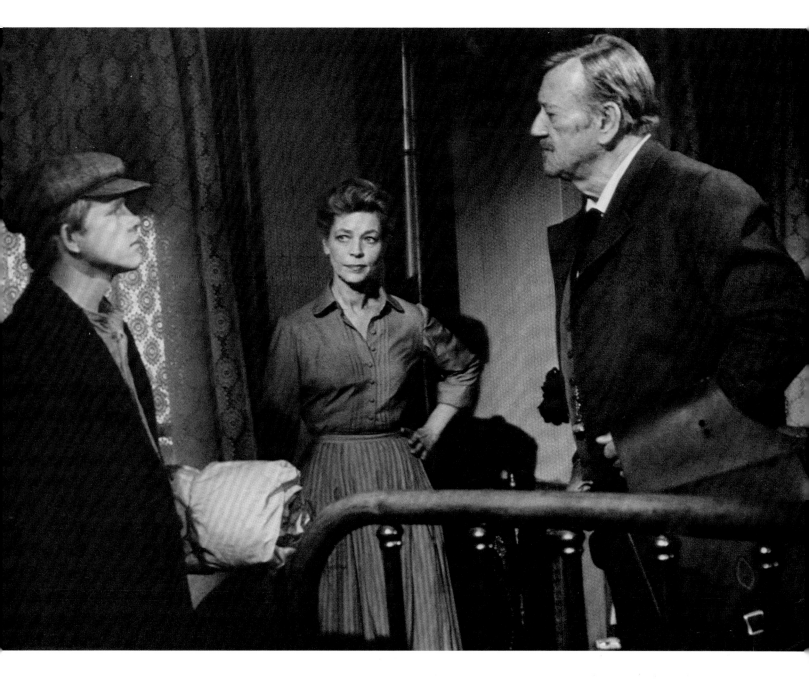

been working on a project that led me to look back at *The Searchers*. John Wayne plays a real son-of-a-bitch, and yet your heart goes out to him. At the height of his career John Wayne knew who he was, and he knew his characters' drawbacks weren't damaging him in the audience's eyes, they were helping him. It's very interesting to me that that kind of simple strength and that willingness to be unsentimental, to be unlikable in moments, is something you can trust the audience with and still let the character earn their affection, their emotional connection.

movie star standards how negative and flawed he would allow his characters to be— particularly working in the action genre. I think that his sort of action hero was much more relatable, artful, and carried with it a lot more humanity than the sort of pure action heroes in films today.

ABOVE Ron Howard, Lauren Bacall, and John Wayne on the set of *The Shootist* (1976).

When I look back at other John Wayne performances, it's startling even by modern

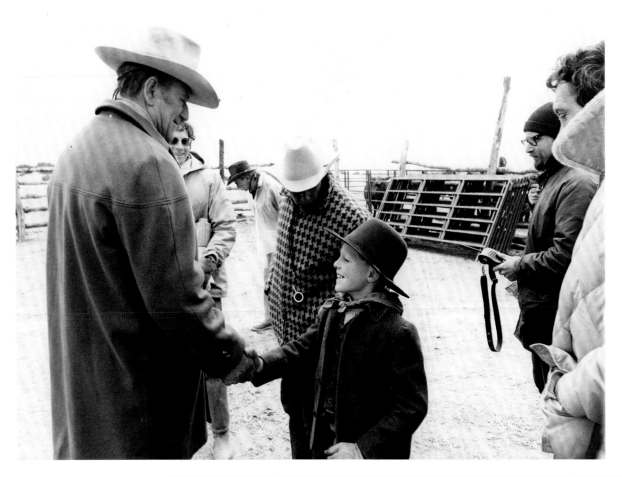

ABOVE John Wayne on the set of *The Cowboys* (1972).

RIGHT Duke introduces Ethan to New York Jets quarterback Joe Namath.

OPPOSITE PAGE John Wayne with some younger fans on the set of *The Cowboys* (1972).

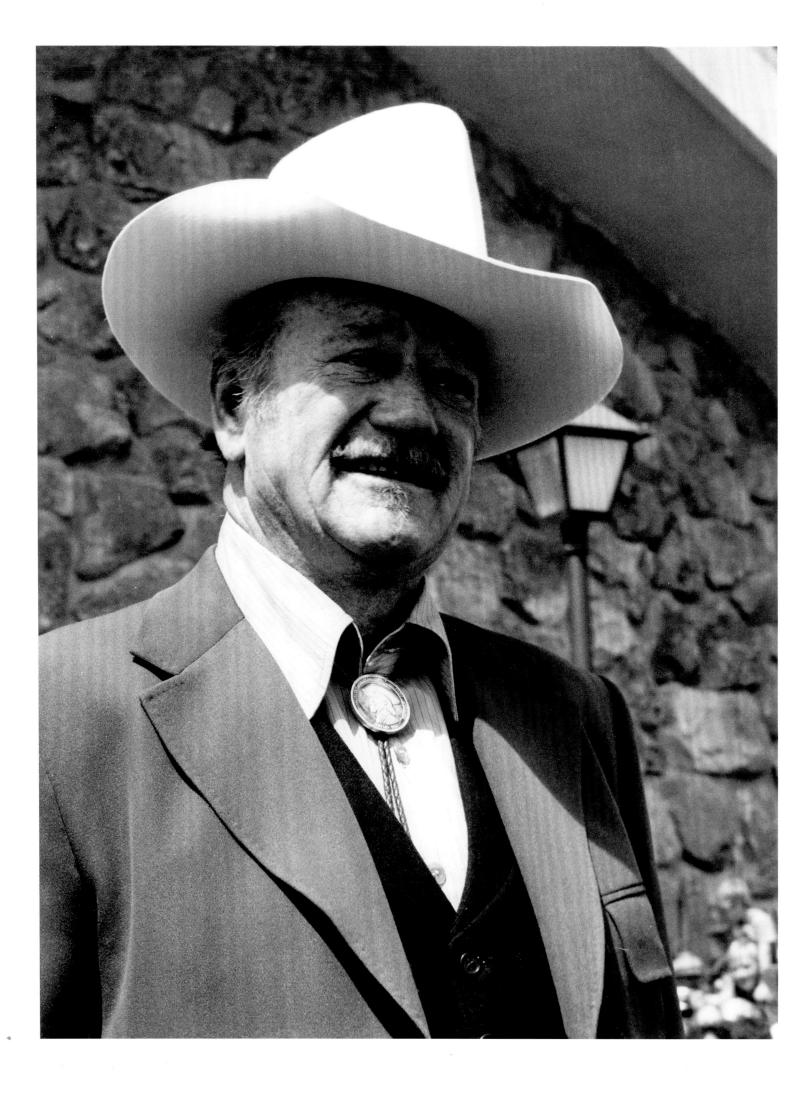

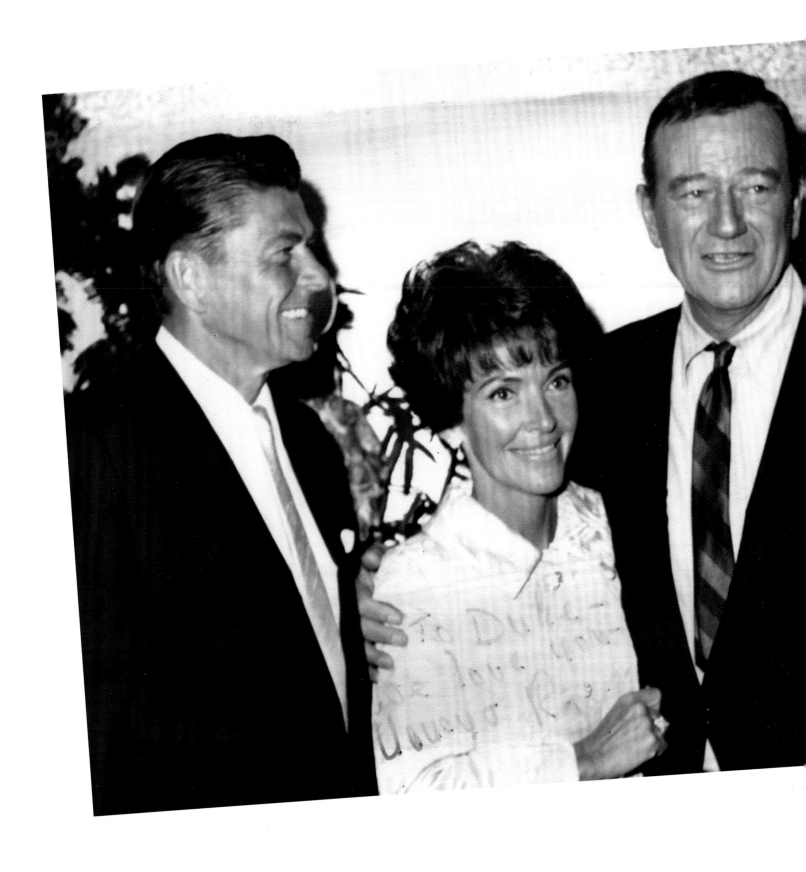

ABOVE This personalized photo of then-governor Ronald Reagan, wife Nancy, and John Wayne, dedicated to Duke by Nancy occupied a prominent spot in Duke's study.

Unforgettable John Wayne

RONALD REAGAN

Reprinted with permission from Reader's Digest.

We called him Duke, and he was every bit the giant off screen he was on. Everything about him—his stature, his style, his convictions—conveyed enduring strength, and no one who observed his struggle in those final days could doubt that strength was real. Yet there was more. To my wife, Nancy, "Duke Wayne was the most gentle, tender person I ever knew."

In 1960, as president of the Screen Actors' Guild, I was deeply embroiled in a bitter labor dispute between the Guild and the motion picture industry. When we called a strike, the film industry unleashed a series of stinging personal attacks on me—criticism my wife found difficult to take.

At 7:30 one morning the phone rang and Nancy heard Duke's booming voice: "I've been readin' what these damn columnists are saying about Ron. He can take care of himself, but I've been worrying about how all this is affecting you." Virtually every morning until the strike was settled several weeks later, he phoned her. When a mass meeting was called to discuss settlement terms, he left a dinner party so that he could escort Nancy and sit at her side. It was, she said, like being next to a force bigger than life.

Countless others were also touched by his strength. Although it would take the critics 40 years to recognize what John Wayne was, the movie-going public knew all along. In this country and around the world, Duke was the most popular box office star of all time. For an incredible 25 years he was rated at or around the top in box office appeal. His films grossed $700 million—a record no performer in Hollywood has come close to matching. Yet John Wayne was more than an actor; he was a force around which films were made. As Elizabeth Taylor Warner stated last May when testifying in favor of the special gold medal Congress struck for him: "He gave the whole world the image of what an American should be."

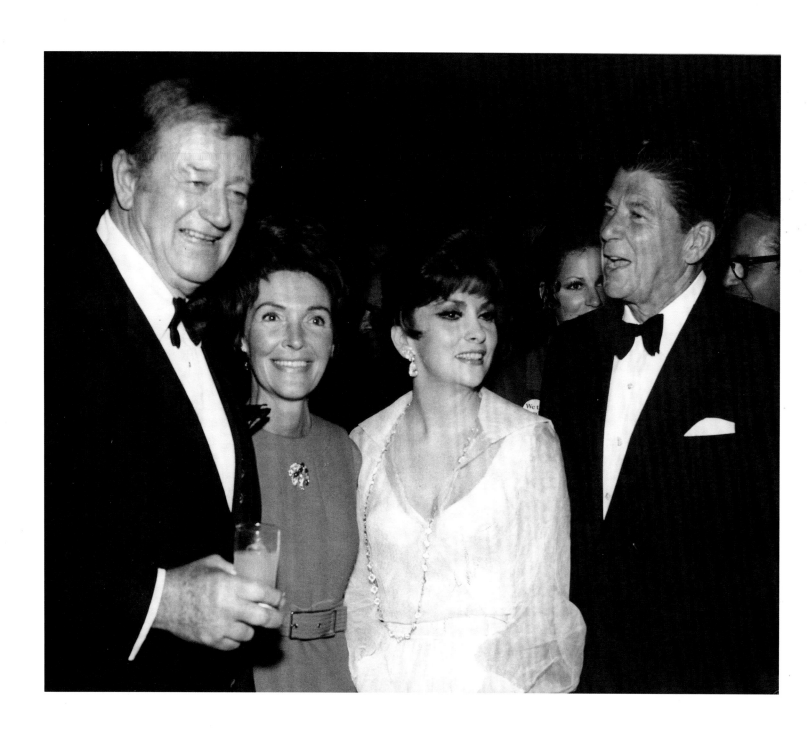

ABOVE John Wayne, Nancy Reagan, Gina Lollobrigida, and Ronald Reagan.

OPPOSITE PAGE John Wayne with Dean Martin.

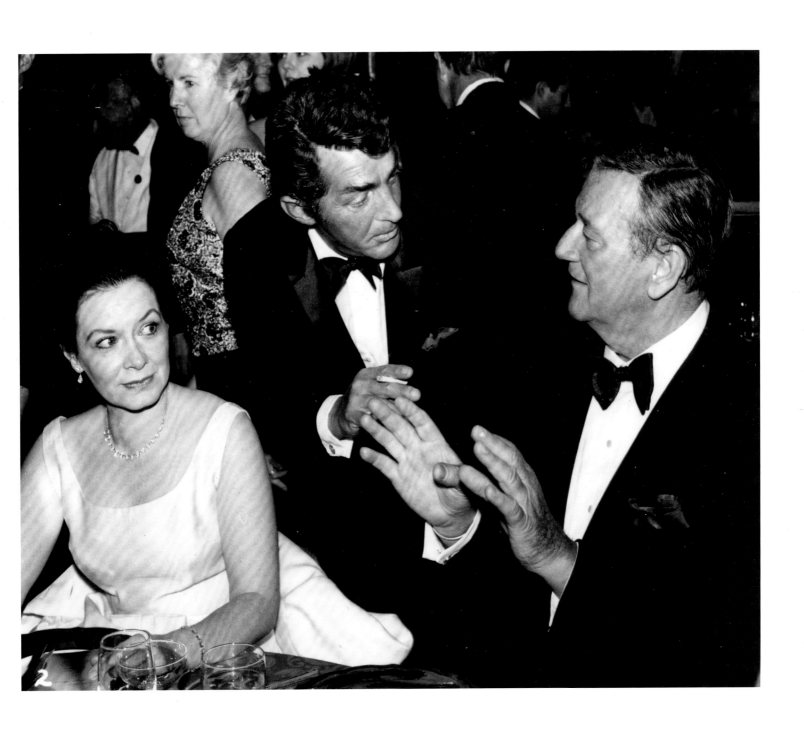

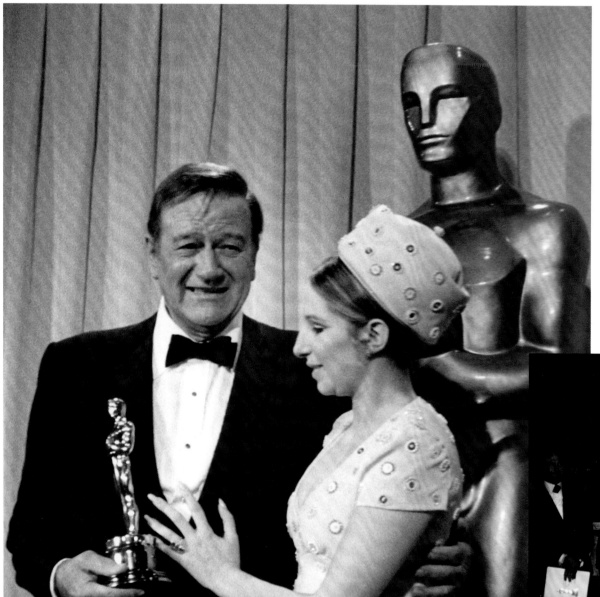

TOP ROW Fan snapshots of the 42nd Annual Academy Awards ceremony, aired on April 7, 1970.

OPPOSITE PAGE, LEFT Barbra Streisand presented John Wayne with the Best Actor statuette for his portrayal of U.S. Marshall, Rooster Cogburn, in *True Grit* (1969), 42nd Annual Academy Awards.

CENTER Wayne signing autographs after his win for Best Actor at the Academy Awards, 1970.

OPPOSITE PAGE, RIGHT John Wayne with his Best Actor Oscar.

BOTTOM LEFT John Wayne with Pilar shortly after his recognition by the American Academy of Motion Picture Arts and Sciences.

BOTTOM RIGHT Ethan Wayne holding his father's Best Actor Oscar statuette.

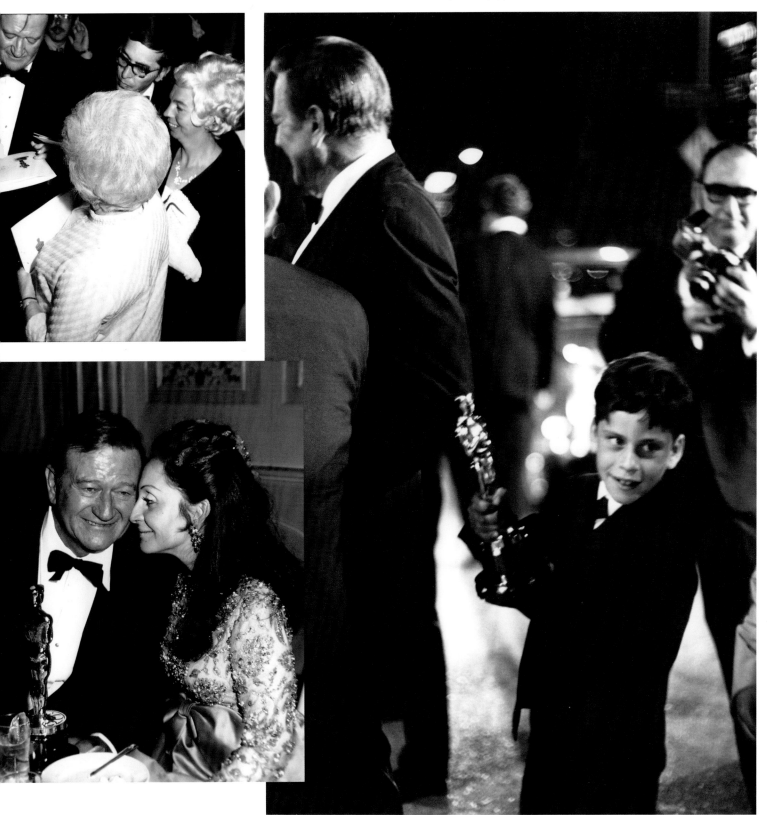

"He gave the whole world the image of what an American should be."

Elizabeth Taylor

OPPOSITE PAGE John Wayne pictured embracing his dear friend Elizabeth Taylor.

238

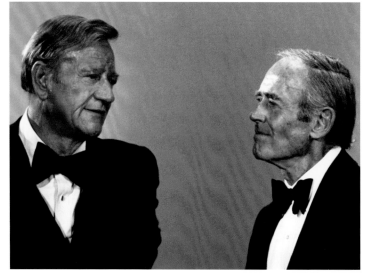

THIS PAGE John Wayne and co-stars from the "General Electric All-Star Anniversary" on ABC, which aired September 29, 1978.

ABOVE John Wayne with Lucille Ball.

ABOVE RIGHT Wayne with *Three's Company* stars Suzanne Somers and John Ritter.

RIGHT John Wayne and Henry Fonda.

FAR RIGHT John Wayne with Cheryl Ladd.

BELOW Duke with television series *Little House on the Prarie* leading man, Michael Landon.

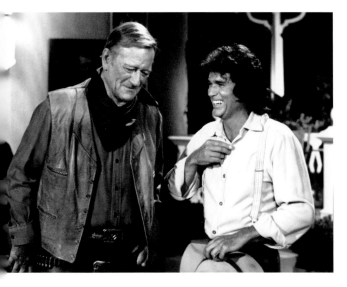

RIGHT John Wayne with the stars of television series *Laverne & Shirley*, Penny Marshall and Cindy Williams.

OPPOSITE PAGE John Wayne celebrating his Best Actor win.

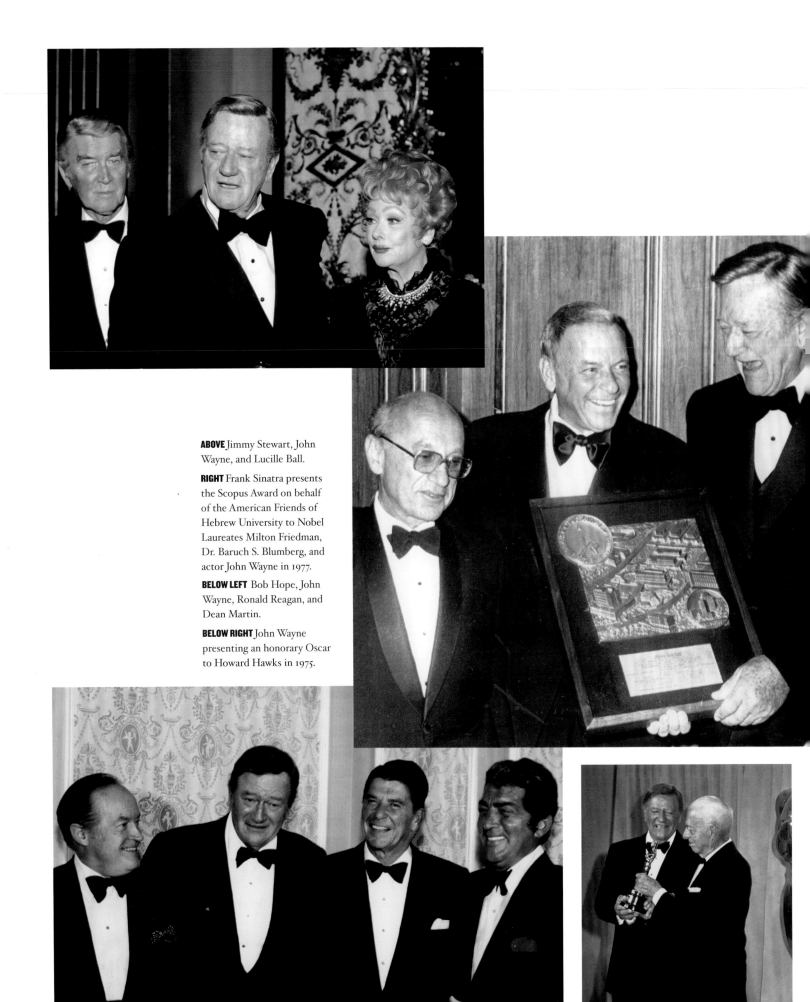

ABOVE Jimmy Stewart, John Wayne, and Lucille Ball.

RIGHT Frank Sinatra presents the Scopus Award on behalf of the American Friends of Hebrew University to Nobel Laureates Milton Friedman, Dr. Baruch S. Blumberg, and actor John Wayne in 1977.

BELOW LEFT Bob Hope, John Wayne, Ronald Reagan, and Dean Martin.

BELOW RIGHT John Wayne presenting an honorary Oscar to Howard Hawks in 1975.

TOP John Wayne campaigning with Gerald Ford.

CENTER Duke being awarded an honorary doctorate from the University of Southern California, 1968.

LEFT John Wayne with Robert Fellows and William Wellman.

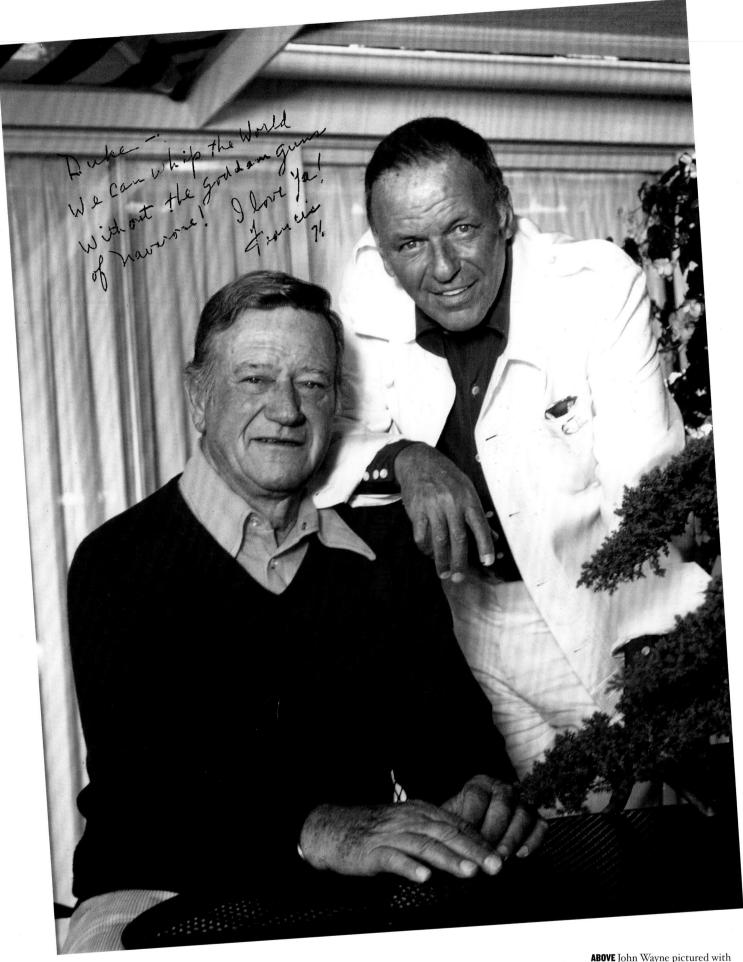

Duke —
We can whip the World
without the Goddam Guns
of Navarone! I love ya!
Francis 76

ABOVE John Wayne pictured with longtime friend Frank Sinatra in Newport Beach. This picture is autographed to Duke from Sinatra and was framed and on display in Wayne's study.

OPPOSITE PAGE A little less formal...

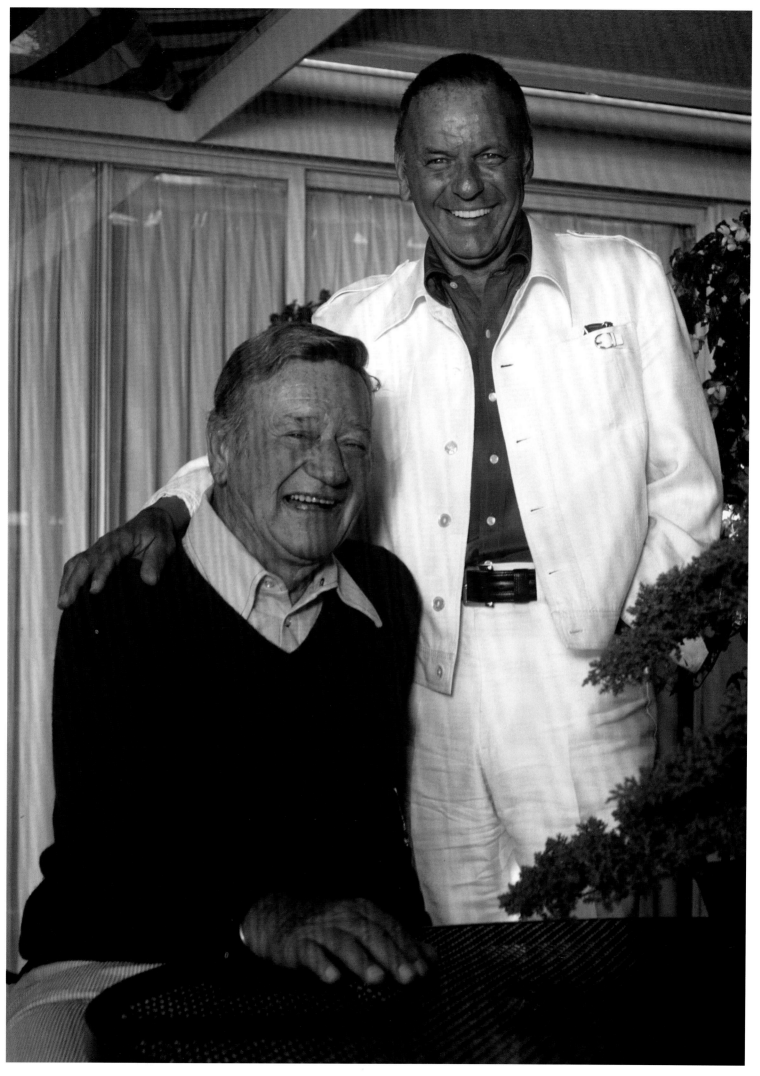

RIGHT Duke with Pilar and
Aissa catamaran sailing
in Hawaii.

246

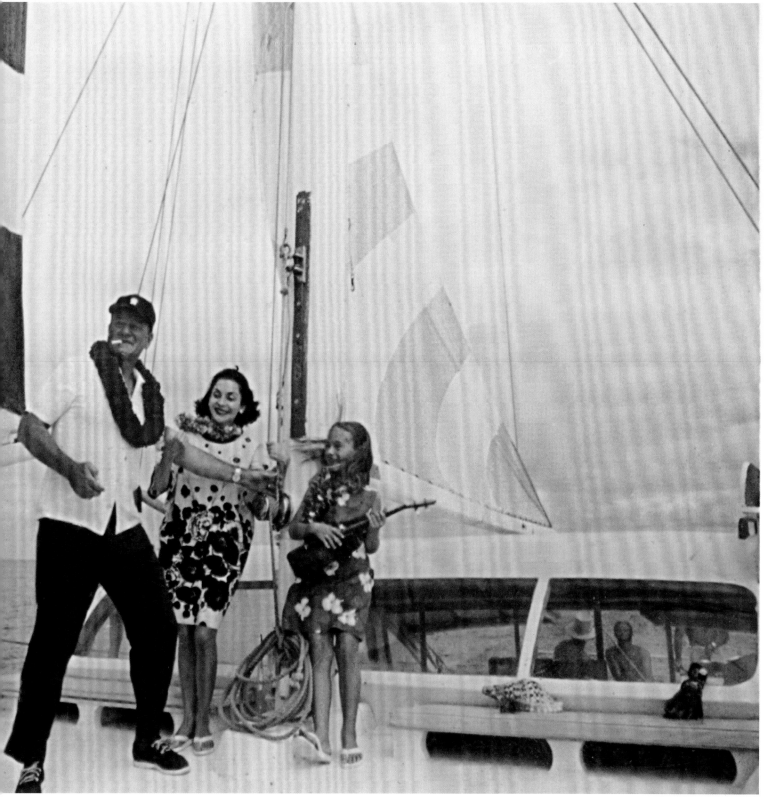

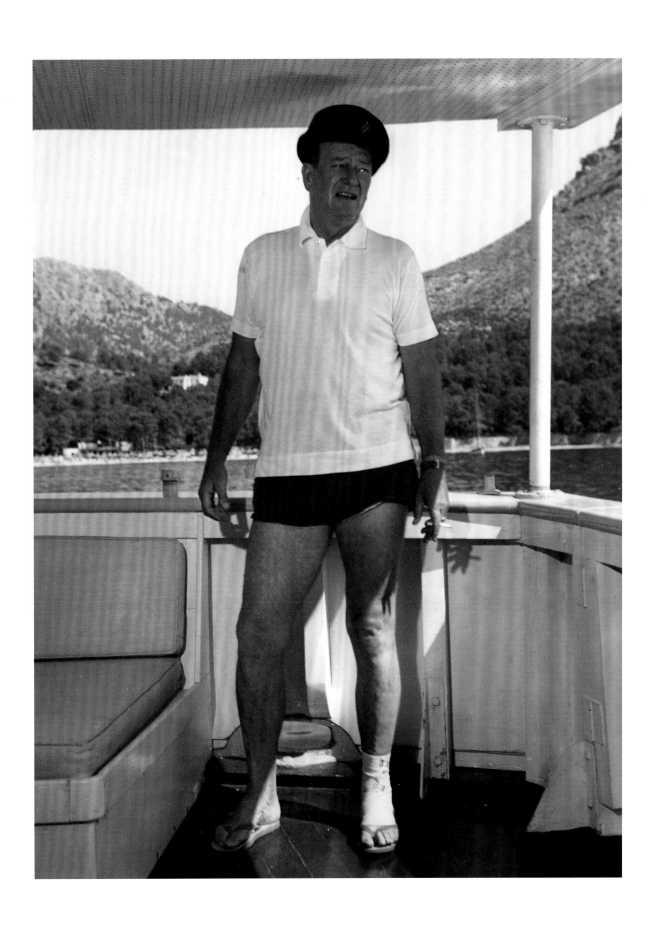

OPPOSITE PAGE John Wayne with
Ethan looking over the bow of
the *Wild Goose* at her berth in
Newport Beach.

ABOVE John Wayne on the deck
of the *Wild Goose* off the coast
of Majorca.

249

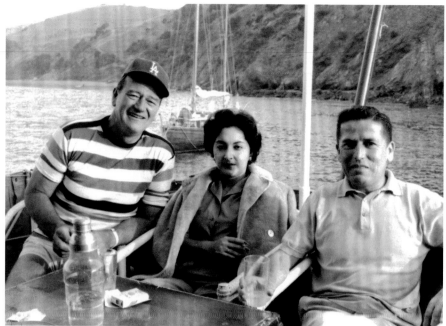

THIS PAGE John Wayne spent a majority of his free time boating.

ABOVE Pilar, son-in-law Don LaCava, and Duke campaigning for Barry Goldwater aboard the *Wild Goose*.

ABOVE RIGHT John Wayne with Pilar's sister, Marcela, and brother, Augusto, aboard the *Wild Goose* at Catalina Island.

RIGHT Pilar swimming alongside the *Wild Goose*.

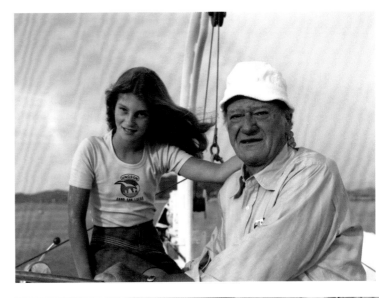

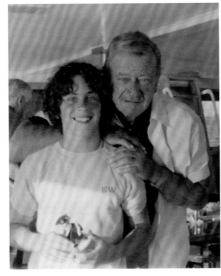

ABOVE Duke at sea on the *Wild Goose*.

ABOVE RIGHT John Wayne with daughter Marisa.

RIGHT Wayne with Ethan.

FAR RIGHT John Wayne in the wheel house.

BOTTOM RIGHT
Wayne with Marisa.

BELOW John Wayne with daughter Marisa, sons Ethan and Patrick, and the Captain of the *Wild Goose*, Pete Stein.

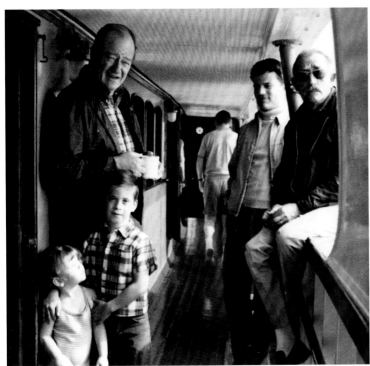

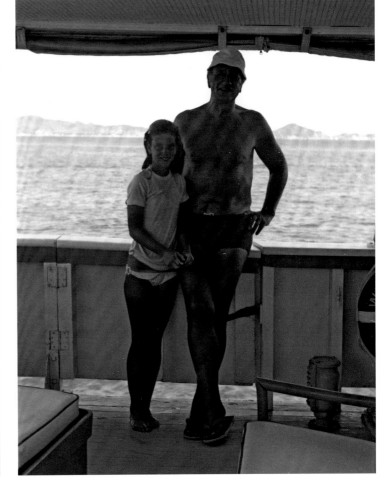

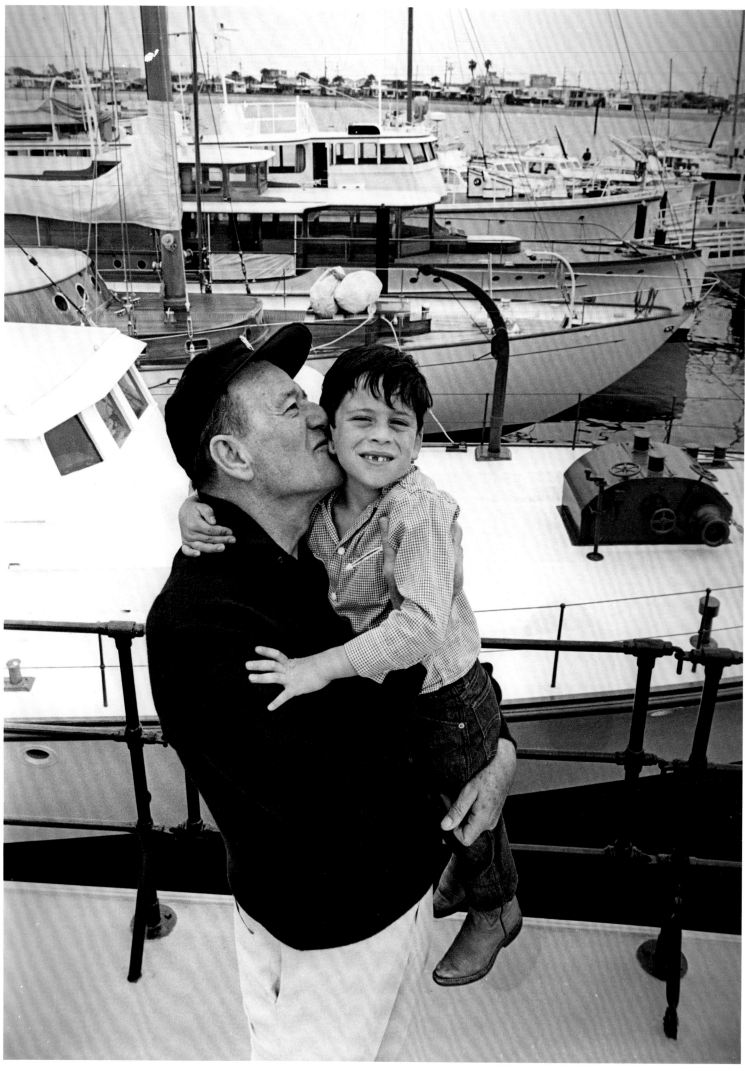

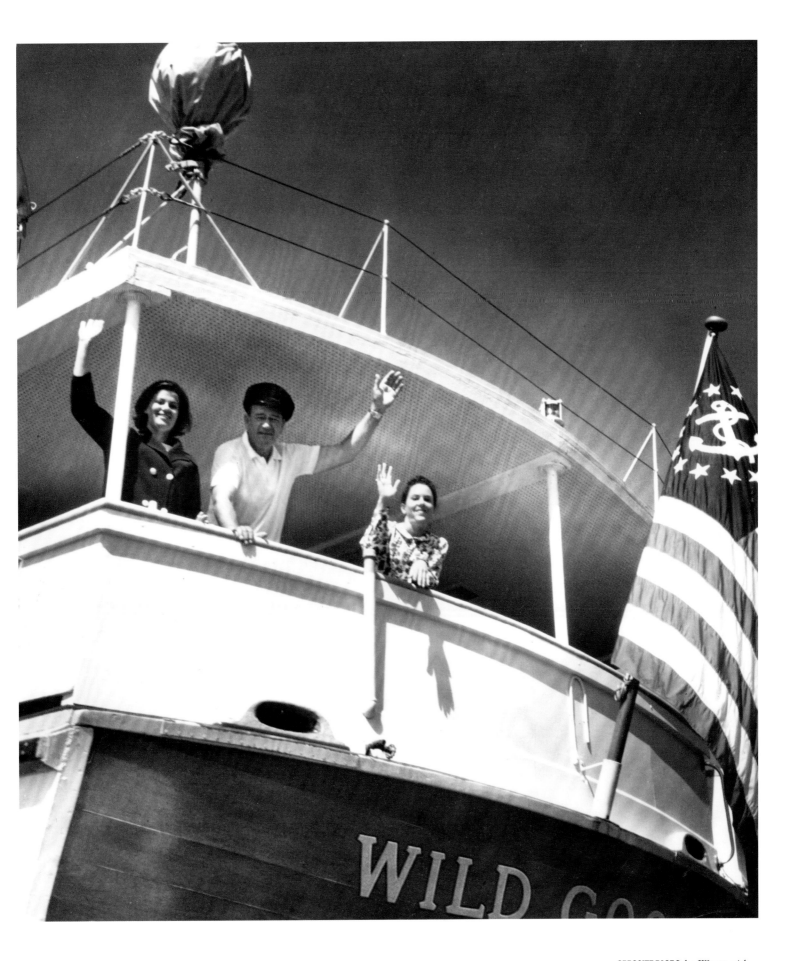

WILD GO

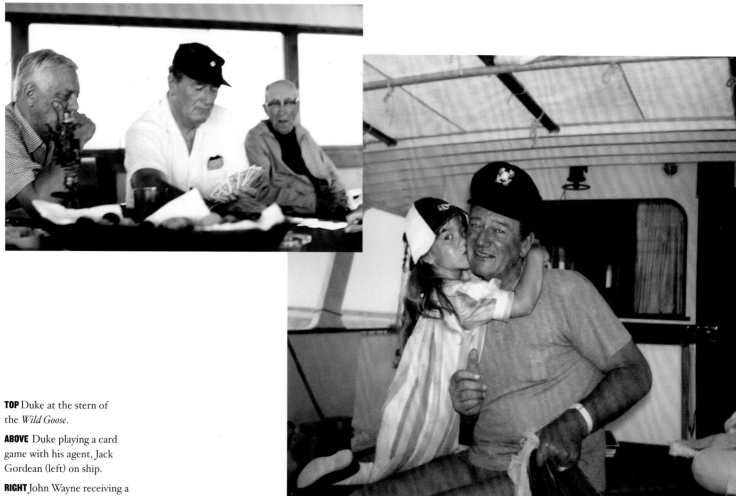

TOP Duke at the stern of the *Wild Goose*.

ABOVE Duke playing a card game with his agent, Jack Gordean (left) on ship.

RIGHT John Wayne receiving a kiss from Aissa.

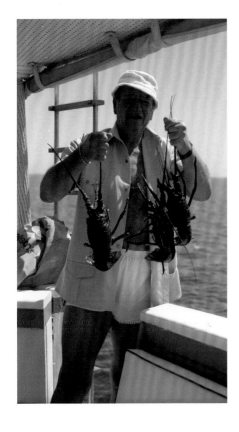

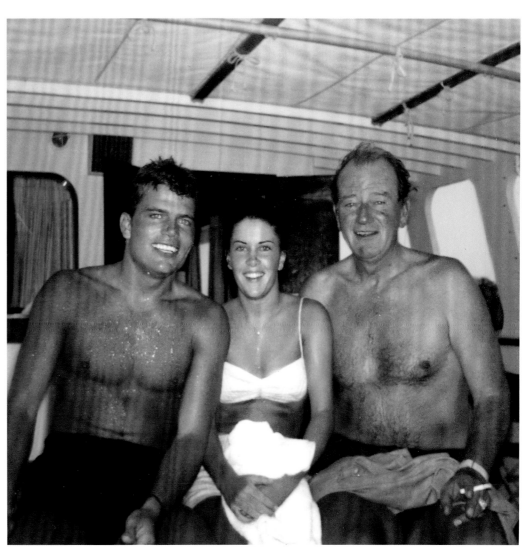

ABOVE John Wayne with
fresh lobsters.

RIGHT John Wayne, Patrick,
and daughter-in-law Peggy.

BELOW John Wayne with Marisa
outside the wheelhouse.

ABOVE John Wayne aboard the
Wild Goose in Mexico.

OPPOSITE PAGE Wayne helming
the *Wild Goose*.

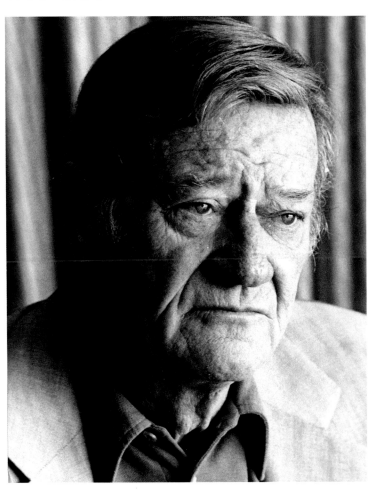

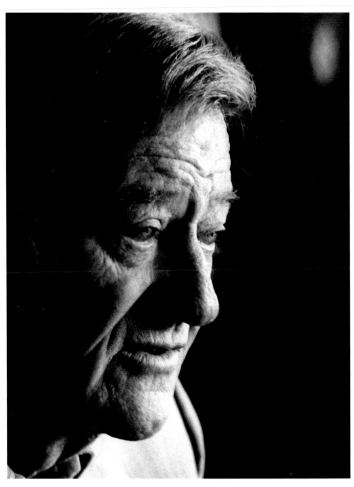

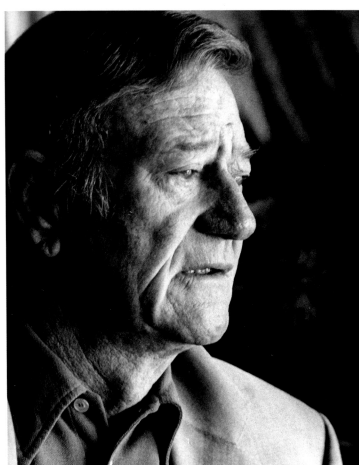

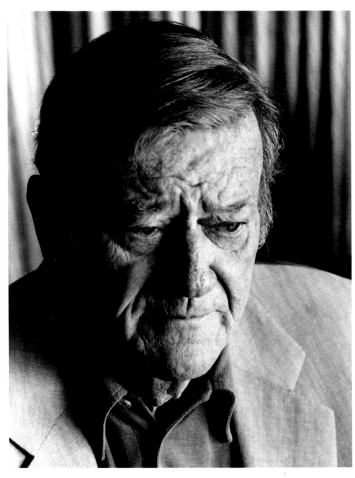

THIS SPREAD A series of
interview photographs from
Playboy magazine.

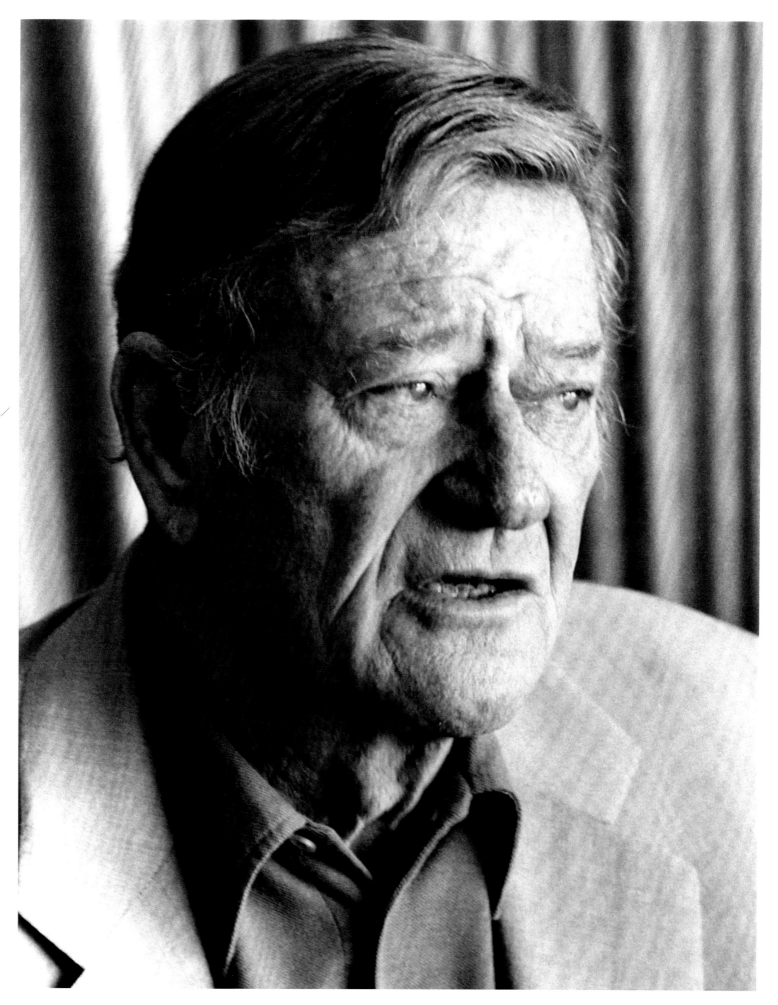

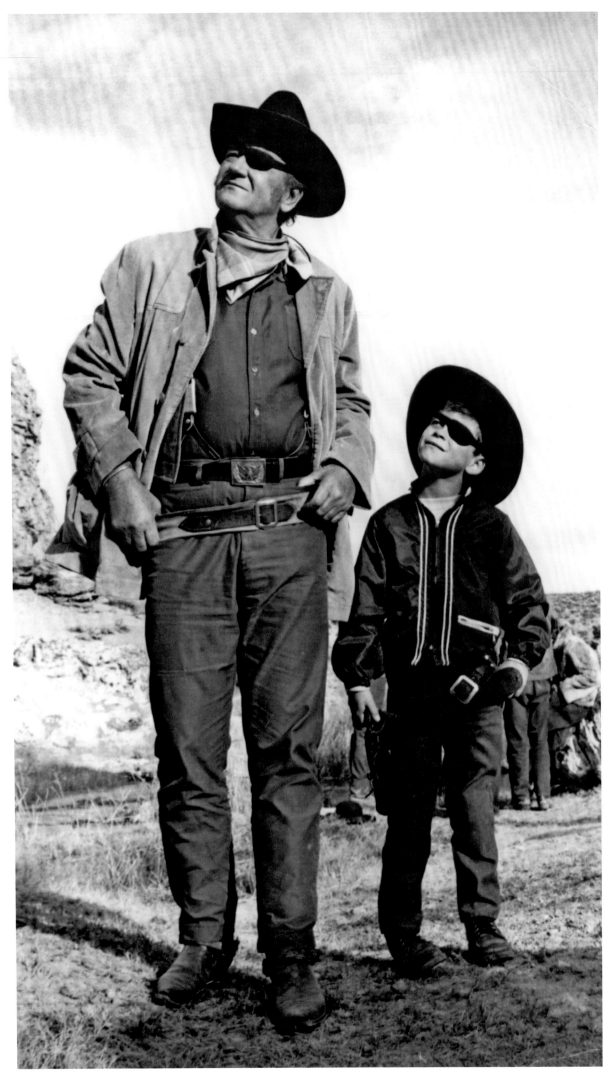

OPPOSITE PAGE John Wayne and Ethan in matching eye patches on the set of *True Grit* (1969).

TOP John Wayne at home with Ethan and Marisa.

ABOVE Duke with daughter Marisa and granddaughter Laura.

LEFT John Wayne with Marisa.

RIGHT Duke with Marisa.

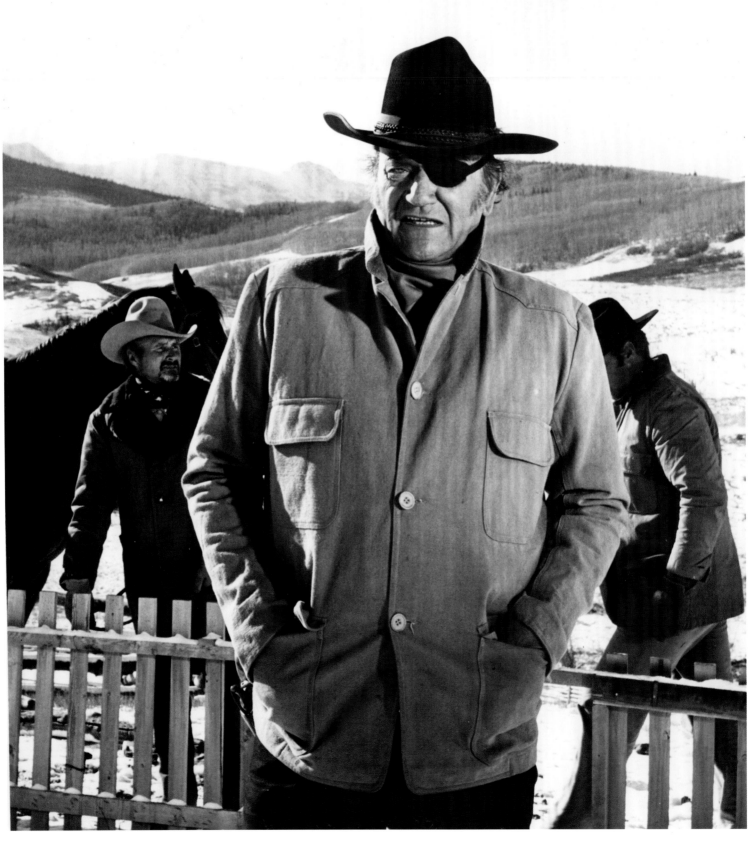

OPPOSITE PAGE John Wayne as Rooster Cogburn, Wayne's only Oscar-winning role, in Henry Hathaway's film, *True Grit* (1969).

RIGHT
Duke with grandson, Peter.

FAR RIGHT John Wayne immersed in a game of chess.

BELOW
Duke with grandson, Chris.

BOTTOM Duke attended countless public celebrations, making hundreds of personal appearances throughout his career; he was always appreciative of his fans.

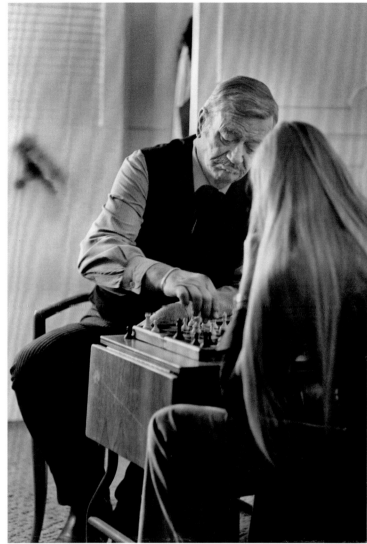

ABOVE John Wayne with son Patrick, daughter Marisa, daughter Toni, granddaughters Anita and Brigid, and grandsons David, Danny, Peter, Chris, and Kevin while filming *The Shootist* (1976).

RIGHT Duke with daughter Marisa on the set of *The Shootist* (1976). John Wayne signed this picture for Marisa.

OPPOSITE PAGE John Wayne wearing a Western costume riding in the tender from the *Wild Goose* to a commercial shoot, one of his last jobs.

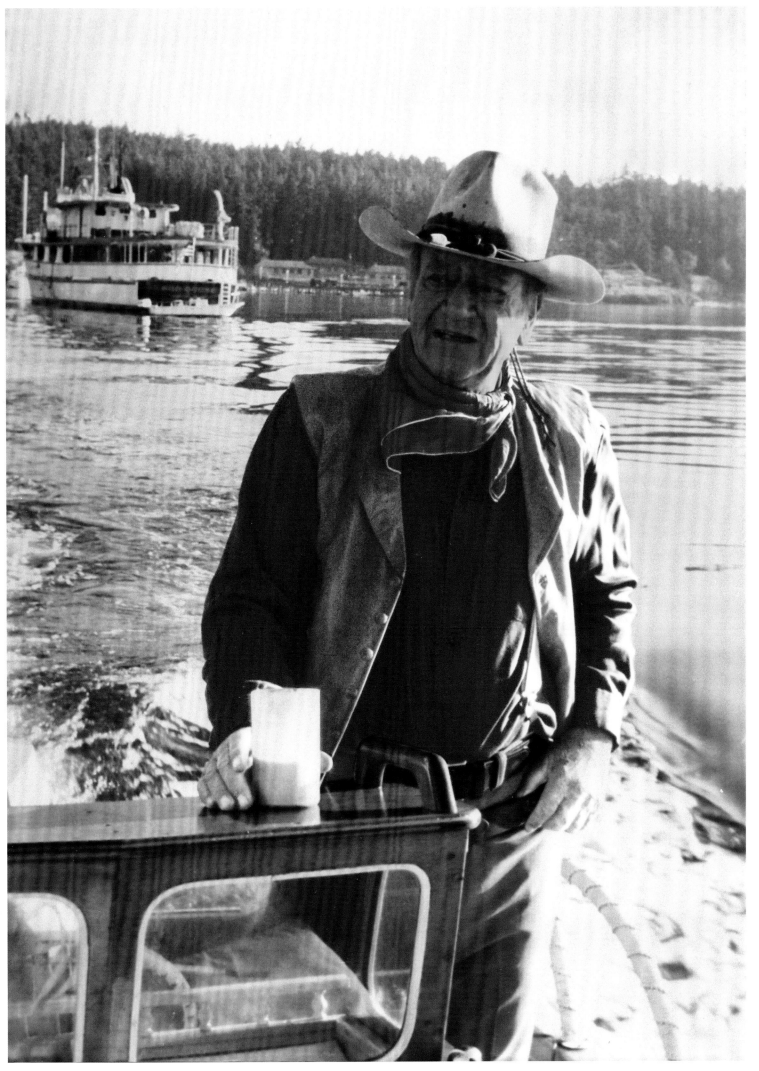

265

"Feo, Fuerte y Formal"

[Ugly, Strong and Dignified]

John Wayne's motto

308 SOUTH BRISTOL AVENUE
LOS ANGELES, CALIFORNIA 90049

MY CHOICE OF THE 5 BEST MOTION PICTURE ACTORS OF ALL TIME:

1. Spencer Tracy
2. Elizabeth Taylor
3. Kathrine Hepburn
4. Laurence Olivier
5. Lionel Barrymore

Signed: _John Wayne_

THE PEOPLE'S ALMANAC

308 SOUTH BRISTOL AVENUE
LOS ANGELES, CALIFORNIA 90049

MY CHOICE OF THE 5 BEST MOTION PICTURES OF ALL TIME:

1. A Man for All Seasons
2. Gone with the Wind
3. The Four Horsemen of the Apocalypse
4. The Searchers
5. The Quiet Man

Signed: _John Wayne_

CREDITS

The publisher would like to thank Brian Christopher Cummings for assistance in annotating the pictorial content, and John Wayne Enterprises, custodian of the John Wayne Archives, for unfettered access to their private and personal collection.

OPPOSITE PAGE John Wayne on set of *The Cowboys* (1972).

JOHN WAYNE

The Legend and the Man

An Exclusive Look Inside Duke's Archive

Published in the United States by powerHouse Books,
a division of powerHouse Cultural Entertainment, Inc.
37 Main Street, Brooklyn, NY 11201-1021
telephone 212 604 9074, fax 212 366 5247
e-mail: johnwayne@powerHouseBooks.com
website: www.powerHouseBooks.com

First edition, 2012

Library of Congress Control Number: 2012944830

Hardcover ISBN 978-1-57687-590-2

Designed by Francesca Richer / Krzysztof Poluchowicz

Printed and bound through Asia Pacific Offset

A complete catalog of powerHouse Books and Limited Editions is available
upon request; please call, write, or visit our website.

10 9 8 7 6 5 4 3 2

Printed and bound in China

Western Wayne

JOHN WAYNE

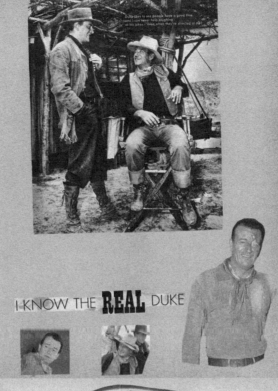

I KNOW THE **REAL** DUKE

BIG JOHN

John Wayne

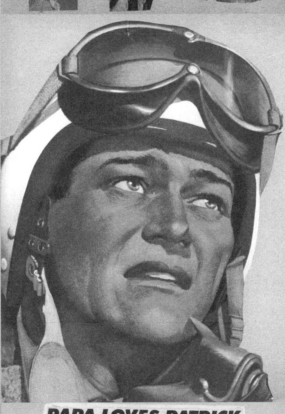

THE CONQUEROR

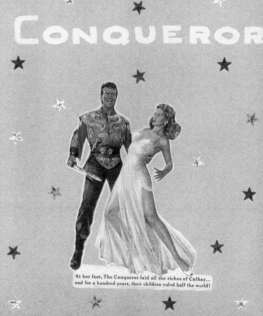

At her feet, The Conqueror laid all the riches of Cathay...
and for a hundred years, their children ruled half the world!

PAPA LOVES PATRICK

Pat Wayne is the proud son
of a proud man.
He was brought up
to do his best—
even if it means
competing with his father

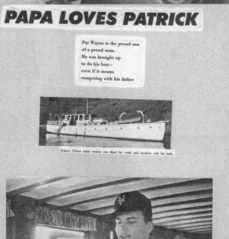

Duke's 72-foot cabin cruiser was ideal for week-end vacation with his kids.

A turn at the wheel thrills 16-year-old Pat. He and Duke had just returned from Utah where they made The Searchers.

JOHN WAYNE MAN OF PARTS

He has worn all kinds of costumes in his movie roles,
from dusty frontier clothes to dazzling oriental garb

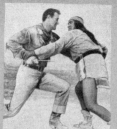

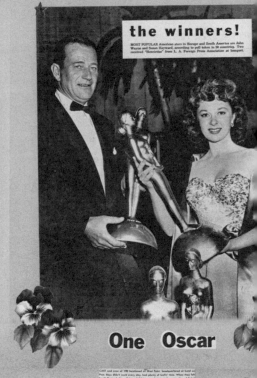

the winners!

One Oscar

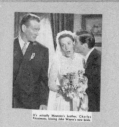

JOHN
WAYNE

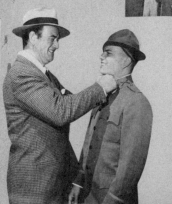

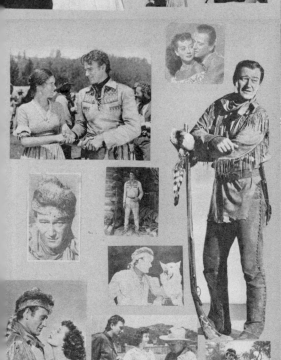

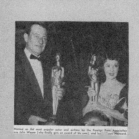

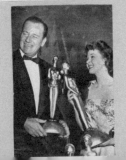

HIS MIGHT
URE AT ITS